# MARINE PAINTING IN OIL

# MARINE PAINTING IN OIL BY E. JOHN ROBINSON

WATSON-GUPTILL PUBLICATIONS/NEW YORK

PITMAN PUBLISHING/LONDON

*This book is dedicated to my wife June*
*and our daughters, who are the most important of all*

First published 1973 in the United States and Canada by Watson-Guptill Publications,
a division of Billboard Publications, Inc.,
1515 Broadway, New York, N.Y. 10036

Published simultaneously in Great Britain by Sir Isaac Pitman & Sons Ltd.,
39 Parker Street, Kingsway, London WC2B 5PB
U.K. ISBN 0-273-00408-5

Library of Congress Cataloging in Publication Data
Robinson, E. John, 1932—
    Marine Painting in oil.
    Bibliography: p.
    1. Marine painting—Technique. I. Title
ND1370.R62    751.4'5    73-9504
ISBN 0-8230-3007-5

Manufactured in Japan

First Printing, 1973
Second Printing, 1975
Third Printing, 1977
Fourth Printing, 1978

*Acknowledgments*

Initially, I wish to thank Dr. Robert Banister for giving me my first set of paints and encouraging me to continue painting. Also, I wish to thank my mother and sister, who helped to replace those paints so many times. More recently, I wish to thank Elizabeth Paine, who saw my manuscript as a book; Richard Szumsky and Lee Burleson for their superior photography; and Ruth Carlson, whose gallery has been so important in my career as an artist. Of course, this book could not have been completed without the great editing of Lois Miller and the assistance of the fantastic staff at Watson-Guptill Publications.

# CONTENTS

# INTRODUCTION

My intention in writing this book is to provide the student of seascape painting in oil with a handbook of information on the subject and how to approach it, to give him a firm background in marine painting, and possibly to create in him a desire to learn more. However, there's no substitute for first-hand knowledge of the sea. Although books and the work of other artists may inspire you to run to your easel, they offer no guarantee that you'll produce a satisfactory painting.

Whenever possible, I advise you to seek out the real teacher—the sea itself. Study it for hours and make notes and sketches. Teach yourself to watch for one element at a time by blocking out the rest of the panorama. Follow a distant ripple with your eyes; watch as it develops from swell to breaker and finally becomes froth on the beach. Watch only the corner of the curl on a dozen or so breakers, and note all the aspects of the transparent area of the wave. Smell the salty air and listen to the music of the moving water. Let the moods of the sea be your moods, and watch for your moods in the sea.

Meanwhile, refer constantly to this book! It includes a host of observations and study suggestions. It deals first with all the technical information you'll need to create a painting of the sea, then presents a description of several specific types of seascapes. Although this book contains the observations of only one artist— which constitute neither the final word on painting the sea nor necessarily the best approach—don't throw away any idea until you've tried it at least several times.

As you learn and experiment, try to avoid the most difficult of all stumbling blocks— goal-seeking. In other words, don't compound your learning difficulties by expecting to create a masterpiece each time you put your brush to canvas, or by trying to put together more elements than you've learned to work with comfortably. Practice each lesson separately and on scrap material. Above all, don't expect to create great paintings by copying the ones in this book, or any others. While they may give you ideas and information initially, they're no substitute for your own creations.

I can't stress strongly enough the importance of studying and experimenting on your own, rather than relying on what others have done. Of course, every artist must grow from some beginning, which is usually a period of learning the mechanics and imitating teachers and other artists. Some schools actually ask students to copy the styles and techniques of old masters as early exercises. But the next stage of growth is more individualized; the student has mastered the mechanics and begins to create paintings based on his knowledge and on what he sees in nature. While this is still essentially a period of imitation, it's the imitation of nature as the student is learning to see it, rather than an imitation of the work of other artists. It is at this stage that the artist begins to emerge as an individual.

The third stage is even more reflective of the artist as an individual; his paintings become "self-portraits" regardless of the subject matter. In this stage, the external scene becomes secondary to the moods or emotions of the artist—hence the development and use of themes. Then, the art form truly becomes a means of communication and self-expression for the artist.

However, remember that the artist can't proceed from one stage of development to another overnight. Many never progress beyond the second stage, yet they produce beautiful work. Others never go beyond the first stage for one reason or another. Those who do break into the third stage are the innovators and experimentors. In a few cases, such artists have made history.

I hope the material in this book will help you develop as an artist and will inspire you to grow. Though traditional in approach, this material by no means excludes the possibility of trying and using other approaches. There is room in this world for all forms of art, from the most realistic through the most contemporary to those yet to be conceived. Tolerance of other approaches is just as important as growth itself, because meaningful growth can occur only when each artist is allowed to work as an individual.

Though you may not care for other forms of art or other styles of painting, you should grant others the right to create as they will. Then, too, you should avoid degrading that which you have not learned to do. Many an artist has a rude awakening when he attempts something he had previously considered simple or easy. Skill is required for success in far more areas than you may realize.

As a student, you'll need to study the anatomy of the sea in order to better understand your subject. Once you develop skill in painting your subject, you'll begin to express yourself and communicate your ideas. As you study, remember that self-understanding is as important as an understanding of your subject—so rather than saying "happy painting," I'll simply wish you "happy reflecting"!

# CHAPTER 1
# STUDIO AND OUTDOOR MATERIALS

It is not uncommon for an unsuspecting person to discover the less peaceful side of an artist when he touches the artist's favorite brush or puts an exploring finger into his palette. Perhaps the ensuing explosion has something to do with the term "artistic temperament," but the fact remains that an artist's materials and tools are individually his. Like his paintings, materials reflect the artist's personality and are the result of painstaking trial and error. Each item finds its place among the others only after the most exacting experimentation.

The materials you use will not only reflect you as an individual but will also greatly effect your technique. For example, do you remember your elementary school days, when the class used watercolor paints in tin containers and painted on very thin paper? The paints were so hard that you could hardly apply them, the paper resembled rolling hills once it was wet, and the brush lost its hair! Such inappropriate materials probably discourage more potential artists than any other single factor!

The materials I recommend in this chapter for both studio and outdoor painting are those I've found to be best suited to my own painting needs. Of course, there are many other materials and tools available, but a limit should be drawn somewhere. I've seen eager students come to class with the most elaborate kits, the latest in new (and improved!) mediums, and the most dazzling array of pigments to be found anywhere. And I've watched the amount of materials dwindle daily until each student carried only what he'd found to be essential. So, simply experiment and develop your own set of materials by process of elimination. I suggest that you try the materials described here, compare them to others, and then decide what works best for you.

## Easel

My studio easel is quite large and heavy (Figure 1). I built it as a combination table and easel, and the added weight of the table keeps it from wobbling. Since I never place my canvas so that it slants backward, I made the upright support bars of the easel stationary. These are quite tall and can hold a canvas 4 feet high if necessary. I've also added several "convenience" features to my easel, including a plastic container nailed to the side to hold my brushes, a shelf to hold my paints and extra brushes within easy reach, and a drawer for extra supplies. I can either sit or stand at this easel, and if I put casters on it I can move it around the studio to place it in better light.

## Palette

There are many types of palettes, and you should try to find the one best suited to your needs. I use the disposable kind that holds a pad of paper. When the top sheet is dirty, I simply tear it off and go on to use a clean one. If, like other artists, you don't care for the pure white of the paper on this type of palette, you can experiment to find a type you prefer. One artist I know uses a piece of marble, another a clear piece of plate glass over a sheet of gray paper. Others use the old wooden type of palette or a piece of Presdwood, which is composed of compressed wood fibers and can be bought at most lumberyards.

Whatever you use, remember to keep your

palette clean. A chunk of dried pigment or, worse yet, several nubbins of dried paint accidentally picked up on your brush can ruin a passage that was meant to be smooth.

## Color

Although the selection of colors used for seascape painting is mainly up to the individual, some colors are better suited than others to painting the effects of water and the surrounding atmosphere. When you choose your palette, remember that you're working with a transparent subject and that you'll obtain better results if you use pigments that are also transparent.

For example, manganese blue and ultramarine blue are more transparent than cerulean blue or cobalt blue. Viridian green and sap green are more transparent than terre verde or olive green. Of course, the phthalo colors and Prussian blue are the most transparent of all, but controlling them is another matter. I'll provide a complete discussion of color and how to use it, as well as a description of my own palette, in Chapter 6.

## Color Arrangement

You can arrange colors on your palette in any order that works best for you. Some teachers require their students to arrange the pigments according to the color wheel (see page 79). While this arrangement may help you learn how to mix colors, it may not be the handiest order in all cases.

I arrange my colors in a line-up (Figure 2) similar to that of the color wheel. At the bot-

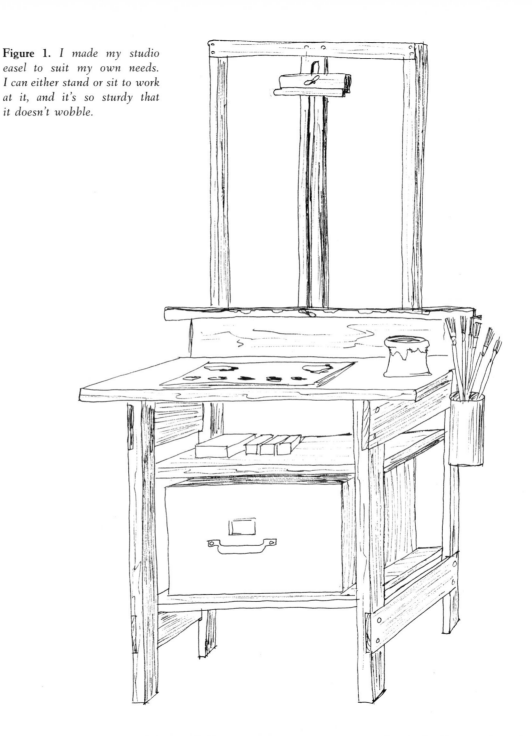

**Figure 1.** *I made my studio easel to suit my own needs. I can either stand or sit to work at it, and it's so sturdy that it doesn't wobble.*

tom of my palette, from left to right, I place brown, blue, green, yellow, and red. In each of the two upper corners of the palette, I put a sizable pile of white paint. I mix the white paint from the pile on the left only with cool colors—blues and greens—and add white paint from the pile on the right only to warm colors —yellows and reds.

I prefer this arrangement to any other because I often mix adjacent colors and lighten them with paint taken from the nearest pile of white. Also, this arrangement leaves the entire central area of the palette free for mixing color. Even this arrangement is not the final word, but I would be thoroughly confused if I suddenly changed it after working with it for so many years.

## Mediums

Centuries ago, the painting masters ground their own pigments from the earth and from elements such as bone, rock, and various chemicals. To give these pigments a fluid consistency for painting, they added a medium such as linseed oil or poppy oil. Because these oils dried when they were exposed to air, the painters of the time kept more oil handy as they worked, and reached for it continually to keep their pigments fresh.

Today, many unknowing artists still keep little cups of oil on their palettes and still reach for it every time they mix paint. Unfortunately for them, they've been misguided by a tradition that's no longer necessary. Modern oil pigments are already ground in a medium, usually linseed oil, by the manufacturer and then sealed in airtight tubes to keep the oil from drying.

The pigments we use today are permanent (their colors do not fade under normal conditions), and they do not need freshening as long as they are recently squeezed from the tube. (Of course, if the paint is allowed to set in the air for any length of time, the oil already in it will form a surface skin that no amount of fresh medium or thinner will remove or soften.)

Oil mediums should not be used to thin paint, because they weaken the tinting power of the pigment. And although the technique of glazing sometimes requires the use of oil, the paint is more often mixed with varnish or drier. So, except for their infrequent use in glazing, mediums are not necessary in either mixing or applying paint.

## Thinners

Unlike mediums, thinners such as turpentine can be very useful in diluting paint straight from the tube, as well as for cleaning brushes and thinning mixtures of paint to the consistency of thin washes. However, the use of thinner is also unnecessarily influenced by tradition. For example, many commercial palettes come with two little cups—one for oil and one for thinner. While I think it's fine to have turpentine handy for thinning paint, I object to the cup. The amount of thinner it holds may be enough to thin paint, but it isn't enough to clean a single brush properly. Since I use thinner primarily to clean my brushes, this arrangement does not suit my purposes.

What you should use for thinner is debatable. Traditionally, spirits of gum turpentine have been used. Today, you can buy lemon-

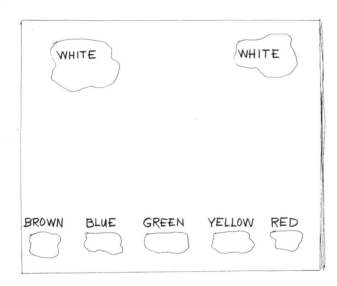

**Figure 2.** *Color arrangements are a very personal matter. I like this particular arrangement because I'm accustomed to it. One pile of white is for lightening cool colors, the other is for lightening warm colors.*

scented, unscented, and a host of other types of thinners—which is a boon if you don't like the odor or the price of turpentine. I use what is commonly called "cleaning solvent," which I buy at gas stations for somewhere around fifty cents a gallon. To my knowledge, it does not discolor pigments, cause the canvas to rot, or destroy the lungs any more than turpentine and other traditional thinners do. In fact, it has very little odor—and every artist should know enough to have adequate ventilation in his studio whenever his painting materials are out.

## Brushes

I've often heard students comment after watching my demonstrations that my brushes were "educated." While this was a comment intended for fun, there is a certain degree of truth in it. Brushes are an extension of the painter's hand. Each painter holds and uses his brushes differently from every other painter, and with use his brushes take on certain characteristics or shapes that make it easier to control them.

Painters become accustomed to using particular types of brushes as well. The brush he uses often depends upon the type of work he's doing at the moment. There are times when the edge of a foam area can be softened only by using a long-bristled brush, the glitter of light only by a tiny watercolor brush or a small, long-haired bristle brush. On the other hand, there may be times when only a short-bristled brush will achieve the textural effect necessary.

Regardless of the brand, oil brushes can be divided into three types: brights, rounds, and filberts (Figure 3). The bright is a flat, short-

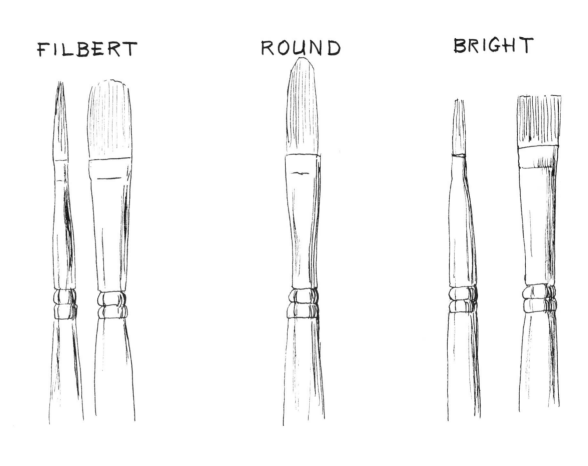

**Figure 3.** *These are the brushes most commonly used in oil painting. I prefer filberts because they're flexible; unlike brights, they don't leave too much texture on the canvas.*

13

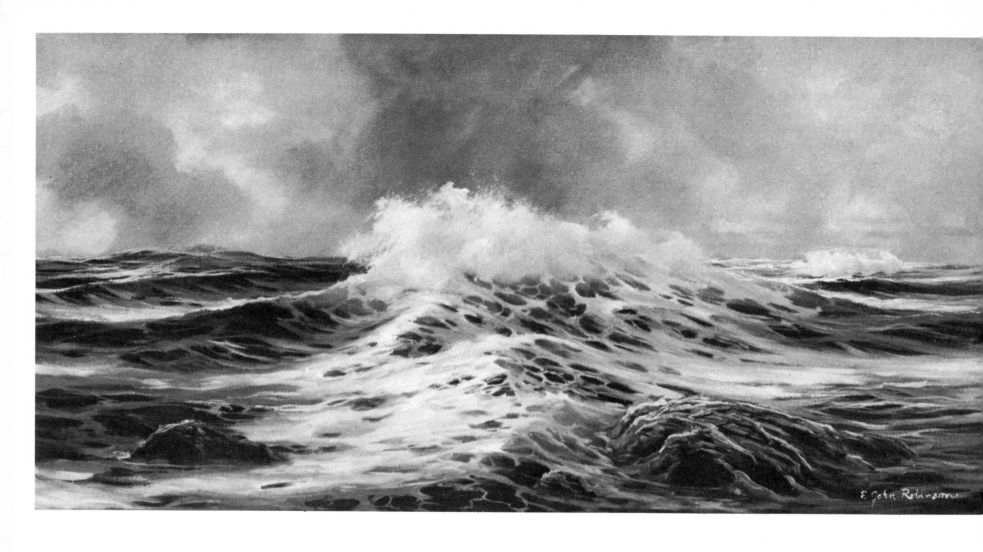

**Storm Weather.** *Oil on canvas, 24" x 48". Mass foam patterns and areas of light and shadow define the contours of the water and swells in this painting and also lead the eye to the wave at the center of interest.*

haired brush with sharp corners. The round is usually a medium-length brush and resembles the earliest brushes in style. The filbert is a long-bristled, flat brush with rounded corners. There is also an extra long filbert of the same description. These are all made from hog hair bristles. Nylon brushes have been developed for use with acrylic paints, but the bristle brushes are still the favorite for use with oil. Of course, there are a few artists who still use nothing but the finest sable brushes, but their techniques require the soft touch available only with such brushes.

Here again, you should experiment until you find the brushes best suited to your needs and technique. I use standard length filberts for most of my work. My technique is to scrub paint well into the canvas for the underpainting and then to apply it more heavily for the overpainting and detail work. A bright is not suitable for this technique, because its sharp corners leave textures and brushmarks in areas I would rather make smooth. On the other hand, filberts leave no marks because their corners are rounded. Also, because the bristles of filberts are long, they hold a good amount of paint, making it possible for me to work in one area for a long time before I have to go back to the palette for more paint. Although rounds do about the same job as filberts, they're limited because, unlike flat filberts, they have no thin edge that can be used for line work.

In addition to filberts in sizes #2, #4, #6, #8, #10, and #12, I also use tiny watercolor and sable oil brushes for small line and texture work. #0, #00, and #1 all work well for adding glitter, sparkle, cracks in rocks, and many other small detail touches.

For hazing, or softening edges, most artists' supply stores carry special hazing brushes. Unfortunately, the prices are often quite special as well. I find that a 1½″ or 2″ flat varnish brush made of pig bristle does the same job as a hazing brush for under a dollar (Figure 4). If you buy a hazing brush, remember that it's meant to be used only for softening edges, not for painting.

### Cleaning Brushes

Cleaning brushes is not something you do only when your painting is complete or when you're through painting for the day. It's something you should do constantly while painting, especially when you're using the wet-in-wet technique. For example, suppose you want to add a clean white line over a green background that's still wet. You can simply load your brush with white paint and drag it over the surface of the green paint. But you will leave a clean line only if you stop frequently and clean off the brush any green you may have picked up in the process.

I recommend that you clean your brushes in a jar or jug of thinner (Figure 5). The jar should hold about a cup of thinner, which will be enough to thin your paints as well as clean your brushes. A piece of screening or perforated metal should be inserted a little above the halfway point between the top and bottom of the jar. The holes in the insert will allow the pigment to sink to the bottom of the jar as you rinse it out of your brushes, and the insert itself will keep you from digging into the sediment every time you clean a brush.

Artists' supply stores carry this type of brush-

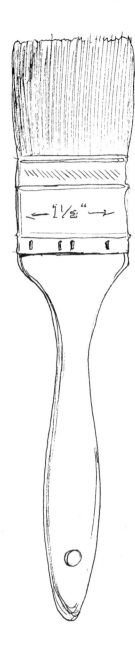

**Figure 4.** *Why pay more? As long as it's pig bristle and not too thick, an inexpensive varnish brush is all that's necessary for hazing, or softening edges.*

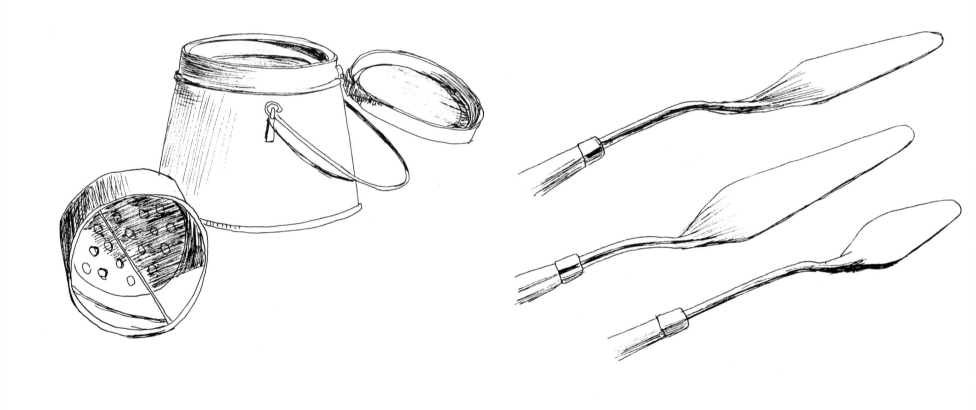

**Figure 5.** *Whether you make your brush-cleaning equipment from tin cans or buy it ready-made, use it frequently. Nothing destroys the purity and effect of a color more quickly than the age-old disease, "dirty brush"!*

**Figure 6.** *Like brushes, painting and palette knives are a matter of personal preference. I use medium and small knives for both painting and for mixing colors. I often use knives to create sharp-edged texture on rocks.*

cleaning jar, but you can make one easily from two tin or aluminum cans of different sizes. Simply punch holes in the bottom of the smaller can, attach wires to the upper rim, and hang the small can inside the large can by fastening the wires to the upper rim of the larger can. Then fill the large can with thinner until there's at least an inch of liquid above the holes in the inner can.

To clean a brush, I wipe off as much excess paint as possible, whip the brush back and forth in the cleaning jar, wipe it dry, and continue painting. I've lost interest in wiping my brushes with rags for two reasons. First, I'm always running out of them, and rags are at a premium around my house. Second, I hold the rags in my hands and end up with more paint on myself than is desirable in a domestic situation. My solution to the rag problem is to use paper towels. I fold up three or four towels and keep them in a handy place beside the palette, with the edge of the cleaning jar over one corner to hold them down. Like the peel-off palette, paper towels are nicely disposable.

You should also clean the jar out periodically —but remember that you can also use the residue at the bottom. Since this sediment is usually an accumulation of the colors used in a particular painting, it's usually related in color to that painting and is therefore ideal for staining the frame to match it.

## Knives

Painting and palette knives should also be the artist's own choice. I use a medium-size palette knife for mixing pigments, and I have a few small painting knives, which I use to create textures on rocks (Figure 6). The painting knives vary in size from 1″ to 2½″ long, and come in several widths and angles. For those artists who wish to paint entirely with knives, a more complete set would be necessary.

## Using Brushes and Knives

When I paint, students often ask me what number brush I'm using at the moment. I steadfastly give the same answer each time: "The brush that does the best job in this area." This remark is not meant to be flippant, and I always add that the number of the brush isn't as important as the *size*. For example, if I'm underpainting a large area that will later be textured or altered, I use a large brush simply to get the job done quickly. Obviously, I would not use the same brush to apply delicate cracks on a rock; nor would a tiny line brush be of any use in painting a broad sweep of clear sky.

Perhaps what I sense when students ask such questions is a desire for a formula, a way to apply paint as the teacher does. In the first place, I don't like formulas. And in the second place, I think each artist should develop his own working methods, his own way of using his materials. And the same philosophy applies to the use of painting knives. Only by individual experimentation can you learn how to apply paint the way you want to apply it—and your way may be very different from mine.

## Canvas

If you like a springy feel in your painting surface, canvas is the thing to use. I prefer it to other painting surfaces because I like its spring and fairly rough texture, and because it's suited to a wide variety of techniques. True, some artists don't care for its white or near-white surface, but you can tone it in just a few minutes by underpainting a thin wash of color.

The texture of canvas varies from almost none at all to the heavy, fibrous texture found in jute. I personally like the medium texture. It has enough texture to "grab" the pigment, but not so much that it detracts from the painting or becomes too noticeable in smoothly painted areas.

Canvas is available in artists' supply stores in a variety of standard sizes, as well as by the roll. You can buy it pre-primed and pre-stretched, or you can prime and stretch it yourself. Unprimed canvas is inexpensive and can be primed easily with a coat or two of gesso.

Stretching canvas can be a tricky procedure, but most rolls of canvas include directions or guidelines that produce good results when followed. To make stretching canvas easier, use a pair of wide-grip canvas pliers and a tack or staple gun (Figure 7).

Whether you buy cotton or linen canvas is up to you. Frankly, I think cotton is quite suitable, as well as less expensive, and I recommend it for all students' and artists' work unless it's going to be entered in an important show or be exhibited in one of the better galleries. (Some museums and galleries won't accept paintings done on cotton canvas.) Linen canvas isn't necessarily a better painting surface, but it's said to outlast cotton by many years.

Canvas board, which is canvas mounted on board, is also commonly available, but I recommend that you use it only for experiments.

Canvas board has a tendency to warp, has no spring, and is unacceptable in many galleries and museums.

## Hardboard

You can create many unnecessary frustrations for yourself if you use materials that aren't compatible with your technique. For example, if you use heavy impasto brush or knife work, you don't really need stretched canvas for your painting surface; hardboard would be quite suitable. Also, if you use painting knives to create impasto textures, the rough surface of the canvas may get in your way and the knife may catch on the texture, whereas the relatively smooth texture of hardboard is well suited to this technique.

Hardboard is made by compressing wood fibers into a solid sheet. It is usually textured on one side and smooth on the other. I've never cared for the textured side because I find it too mechanical in appearance, but many artists use it. In any case, hardboard should be primed. A coat or two of white gesso is ideal for this, and the smooth side of the hardboard can be textured by applying the gesso with an ordinary paint roller. This leaves stipples in the gesso that create a more interesting texture. Remember that hardboard can warp unless it's primed on both sides. Also, if you prefer a springy surface, you should use canvas.

## Artificial Light

The source and color of the light in your studio will be as individual as your materials. I know artists who believe they must have the latest "daylight-colored" lights on the market and others, like me, who use simple light globes meant for households. I use an outdoor or garden-type floodlight that covers even my largest canvases with light. It can't be called "daylight," but then, what can? The color of daylight is a combination of the atmosphere and the position of the sun, as changeable as the sea itself.

I also have a large skylight in my studio, but it doesn't face far enough to the north to admit constant light at the correct angles, so the sun shines on my canvas at certain times of the year. (The skylight also leaks!)

The best guide to use in selecting an artificial light is to look for one that does not cast a noticeable color on the canvas. In other words, a neutral light, neither too yellow nor too blue, is the most desirable. It should be placed over the shoulder opposite the arm you use to paint, high enough so that it does not cast shadows on the canvas or palette.

Other forms of artificial light are also available. The floodlamps used by photographers are a good source of studio light, and many artists also use fluorescent lights. You'll get used to whatever you use, just as you can wear sunglasses to paint outdoors with little effect on your painting. (Just don't take the sunglasses off part-way through the painting unless you give your eyes a chance to become adjusted to the change in the light.)

The only time that light creates a noticeable change in the color of a painting is when a studio painting is taken outdoors or a field painting is brought indoors. Yellow-tinted artificial light makes field paintings appear warmer, and outdoor light makes studio paint-

**Figure 7.** *If you stretch your own canvas, do yourself a favor and use canvas pliers and a tack gun. They'll make quick work of the job and save your hands from being punctured by tacks.*

ings seem weak or washed-out. But then, except in outdoor shows, who hangs paintings outside?

## Field Kit

Someone once remarked that you can always tell a teacher from his students because the students always have the best equipment. This is not entirely accurate, because teachers also know which are the best brands of paints and other materials, but it nearly always proves true in regard to field kits or paintboxes. For example, I pack all my materials in an old briefcase when I'm going to work outdoors. While I carry the briefcase directly to my painting site, set up my materials, and begin working, my students often make two or even three trips before they're ready to set up their equipment.

I've found that the following materials are all I need for painting outdoors (Figure 8). They're the same as those I use in my studio, but on a smaller scale.

18″ fold-up tripod easel

Canvas (pre-primed)

Disposable-type palette

Studio-size tubes of oil paint (red, green, blue, brown, and two yellows)

Large tube of white oil paint

Plastic bottle of thinner

Brushes ( #2, #6, #8, #10, a small liner brush, and a soft varnish brush)

Brush-cleaning pot

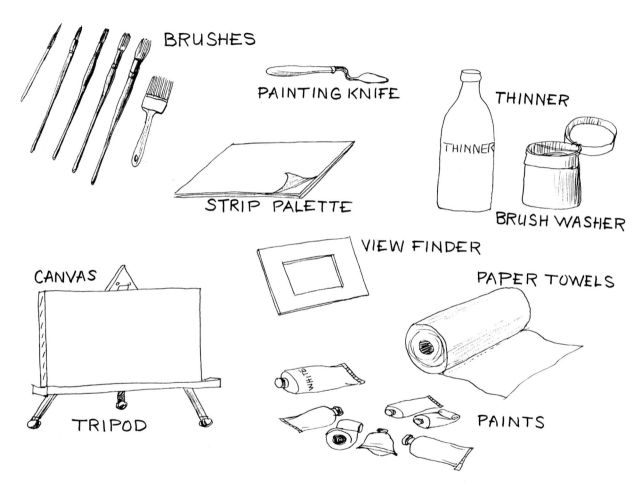

**Figure 8.** *These are the items I carry in my field kit, which is an old, battered briefcase. You may prefer to include some other materials, such as rags instead of paper towels, but for the sake of convenience, keep it simple!*

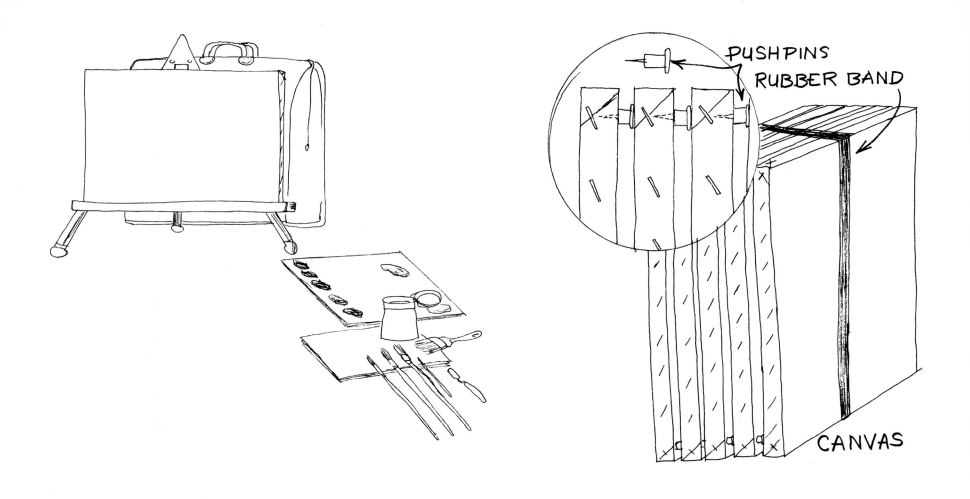

PUSHPINS
RUBBER BAND
CANVAS

**Figure 9.** *This is the way I set up my field kit. I squat on the ground, put the canvas in front of me, and back it up with the briefcase to protect it from the wind. Because I'm right-handed, I line up my paints and brushes on my right.*

**Figure 10.** *This is a convenient and inexpensive way to carry several wet canvases. I simply stick a pushpin in each corner and fasten all the canvases together with a large rubber band.*

Paper towels

Palette knife

View finder

I am still able to sit (or squat) on the ground Indian-fashion, but a small fold-up stool or chair would not add much more weight or bulk to your kit. If you prefer to stand, you can eliminate the stool, but you'll then need a taller easel and will have to either hold your palette or use a painting kit with fold-up legs so that you can set it at the correct height. I generally sit on the ground with my canvas in front of me and my palette beside me (Figure 9). I place my brushes on paper towels next to the cleaning pot and put my kit behind the tripod easel. This is a safety measure in that it prevents the wind from flipping the canvas over and also stops the sun from shining through the legs of the easel into my eyes. Like my paints and painting tools, my selection of field equipment is the result of trial and error. I've found that easels taller than 18″ are either too flimsy or too heavy to carry, stools are too unsteady on the rugged rocks by the sea, and sun umbrellas are too much of a signpost for the curious.

A 12″ by 16″ canvas is an ideal size for sketching in oil and is less likely to be a wind-catcher than the larger ones. Of course, my kit holds only one of these canvases, but I can either go back to the car for more or carry the larger sizes separately.

In carrying several canvases, the problem is to keep them separated so that the painting surfaces aren't disturbed. A simple way to do this is to put one pushpin at each of the four corners of each canvas, then stack the canvases and secure them together with a large rubber band or piece of rope (Figure 10). The pushpins stand out from the corners of the canvases, creating about a half-inch space between the front of one canvas and the back of the canvas stacked on top of it. This method works very well when all the canvases are the same size. The pushpins in the frame of each canvas touch only the frame of the next one. Other and more elaborate devices for carrying canvases are available in most artists' supply stores, but I haven't found them necessary.

## Movie Camera

Other than actual painting equipment, there's one device I strongly recommend for students of seascape painting—the movie camera. There are many times when the most active sea is accompanied by the worst weather for outdoor painting, and you may need a dry way to study its activity.

I've learned much from the movies I've taken of the sea. I use a camera with a slow-motion dial and a zoom lens. I can stand safely back from the activity and film action quite a distance from me. In my studio, I project the films onto a screen and study each frame. For example, I can watch an open-sea swell as it grows into a ground swell, a breaker, and finally collapses into foam. (My projector also has a heat shield, which allows me to keep it running for some time.)

I don't recommend that you copy any single frame but, rather, study the film for information and inspiration. At first, you may film only breakers or foam bursts, but you'll soon be trying less for the spectacular and more for the details. You'll start taking footage of water as it spills off a rock, of foam patterns, wave curls, and a lot of other details of the sea that you may have missed by concentrating on the larger, more dramatic pieces of action.

While movie-making is very expensive, it is certainly worthwhile, especially for those who don't live right on the shore. Moreover, the "still," or snapshot, camera almost always misses the right moment, while the movie camera catches them all. My only word of caution here is: don't become dependent on films. Nothing can really match outdoor painting for color or inspiration. And never trust the sea! Stand back from the action unless you want to become a part of it!

It's a breathtaking sight when great swells of dark water rise up from the surface of the ocean, tip over, and crash against the beaches and rocks. Tons of water cascade over the rocks, crashing into backwashes and filling the air with thunder. The foam boils and gushes into a frothy mass that fingers its way up the beach, and the air above is heavy with moisture. This inspiring scene has sent thousands of painters rushing to their easels. But is inspiration all the artist needs to create a good painting of the sea? Is it enough to be in awe of the ocean, the bursting foam, and the fiery sunset —or is an understanding of the causes and effects of these phenomena also necessary?

The answer to these questions should be obvious, especially in regard to a subject as complex as the sea. Unless you know what causes these effects before you begin to paint them, you will probably be at a loss as to how to describe them accurately. Too often, I've seen students try to paint a breaking wave without understanding why it breaks. The result usually causes some degree of frustration and anger. The foam looks like just so much paint on the canvas, the wave is shaped like the back of an elephant, and the breaking seems to occur without being brought about by either rock or wave. So let's spend some time learning *why* the sea behaves as it does before we dash to the easel to paint it.

## Origin of Waves

The plunging breaker at the shore is actually the result of action that took place far out at sea. What we witness is the last thrust of an energy cycle that began many hours earlier.

Somewhere at sea, energy in the form of wind, cross currents, or other forces of nature is transferred to the water. The effect is similar to what happens when you drop a pebble into a pool, causing concentric circles of ripples to move outward from that point until they reach the water's edge. In that case, the energy transferred to the water begins with your effort to lift the pebble and release it. At sea, energy from a variety of natural forces is constantly transferred to the water to create ripples that become large swells, which in turn move outward until they reach an edge—the shores of the world's continents.

Strangely enough, it is the *energy,* not the surface water, that moves. The surface of the ocean is like a skin that merely stretches as the orb of energy rolls along just below it. Of course, the water also moves as a result of currents and wind, but much more slowly than the swells. For example, if a chunk of wood were dropped into the sea, swell after swell would pass under it as the wood slowly moved in one direction or another with the surface water.

## Open-sea Swells

The rolling orb of energy beneath the surface of the ocean creates swells that begin far out at sea, eventually become waves, and finally break on shore. In Figure 11, you can see that the energy orb is more or less rounded and is inclined in the direction of its movement. Notice that the face of the swell is concave and that the circular movement of the orb as it rolls forward draws the water in front of it in and down to create a trough ahead of it. The water

## CHAPTER 2
# THE ANATOMY OF WAVES

**DIRECTION OF MOVEMENT**

LEADING EDGE

TROUGH

BASE OR SEA LEVEL

ENERGY ORBIT

**Figure 11.** *Swells are created by revolving orbs of energy that move shoreward under the surface "skin" of the sea.*

at the top of the swell would tumble forward if it were raised high enough to do so. You can also see that the sides of the swell rise smoothly from the surface of the ocean.

Unlike the sides of the swell, the leading edge appears irregular where the wind kicks up small ripples on its surface. At sea, the leading edge becomes lost in chops and other swells near the ocean's surface. The baseline of the swell is perfectly straight and level—like the surface of the ocean when it is not disturbed by swells or winds. It is important that you observe this fact closely; the ocean itself should always appear level, and a curved baseline would destroy that effect.

In storms or high winds, the top of a swell may be blown off and become foam. This type of foam is often called a whitecap (Figure 12) and is not the result of waves breaking on the shore. The foam rides the highest point of the swell for a while and is then left behind as the energy orb moves right out from under it. I'll have more to say about whitecaps and other types of foam in the following chapter.

## Painting Open-sea Swells

Remember that the face of the swell is a vertical wall of water that the light above can't reach. The face of the swell is therefore darker than the level water at the baseline and the flat surface of the ocean, which are both influenced by sunlight and atmosphere. The flat surfaces reflect the sky, while the swells are closer to the true color of the water. To achieve this effect, try painting the entire area of water the same color as the sky; then add the swells in the darker color of the water. To describe the con-

**Figure 12.** *At sea, the wind agitates the thin top edges of swells to create areas of foam, which are called whitecaps.*

cave face of the swell, gradually blend the dark area at the top into the light area at the base. Remember not to make the mistake of painting the surface of the water too dark to begin with, or the dark swells won't show up against it.

Whether you begin painting the swells at the horizon line or in the foreground, keep the overall perspective by making them smaller and more obscure as they recede into the background. Some swells should overlap others to establish depth and create the proper perspective. Remember also that only a few lines here and there aren't enough to suggest choppiness. The background is one area where quite a lot of work is necessary to achieve the effect of choppy water. If the distant area of your sea looks like a smooth lake with a few logs floating on it, you need more swells—many more.

From the shore, the distant water looks choppy because, in addition to many dark swells, it also contains glints of light reflected by the top surfaces of the swells. You should use a tiny brush to paint these highlights, using choppy strokes and concentrating on the area where the sunlight is strongest. The highlights inside the sunlit area should be the color of the sunlight; those outside should be a higher value of the color of the sky and should be added with the same choppy strokes.

## Ground Swells

For hundreds of miles, very little change takes place in open-sea swells other than those caused by natural forces. It is not until a swell reaches the shallows close to shore that the real changes take place. Here, it first begins to grow

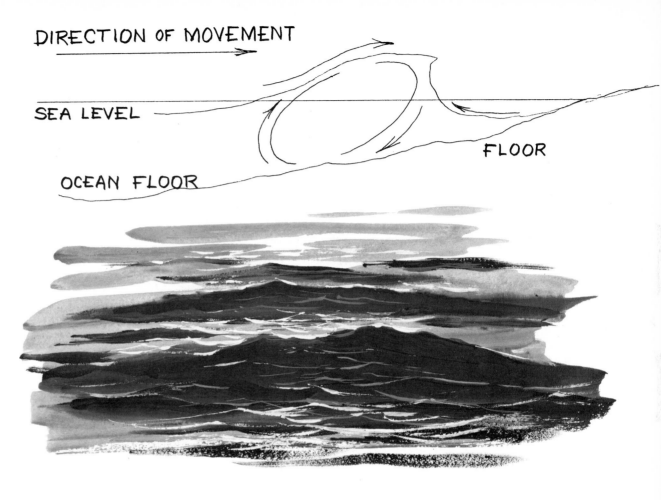

**Figure 13.** *Ground swells are created as moving orbs of energy touch the rising ocean floor, slow down, and push the swell upward.*

larger. Of course, it appears larger as it moves closer to the viewer, but it actually does increase in size as the energy orb is pushed upward by the rising ocean floor (Figure 13). The contact with the ocean floor also slows down the movement of the orb. The slope of its face becomes steeper and the trough ahead of it becomes deeper as the orb flattens and leans in the direction of the beach. The leading edge of water in front of the orb becomes shallow as the orb presses forward, and the first transparent effect appears.

Figure 14 is a front view of a ground swell close to shore. It has the same characteristics as its smaller predecessor, the open-sea swell, except that the ground swell is higher, more transparent, and is beginning to curl over at the leading edge. You can still see the gradual change from dark at the top to light at the base. The highest point of the leading edge will be the first to spill over when the wave breaks, and the highest chops along the edge will soon follow it.

## Painting Ground Swells

In Figure 15, I've taken the liberty of involving my ground swell with a rock to increase its forward tilt and make it a bit more transparent. As one side of the swell passes over the rock, the other side continues forward, then begins to curve around the rock. You might want to try painting a similar wave, adding a background of swells just for practice. You should avoid making a direct copy of my illustration, as it may cause you to concentrate more on achieving a likeness than on studying the anatomy of swells—so move the rock or add

**Figure 14.** *Close to shore, the ground swell looms upward, a mass of moving energy rising to become a wave and then a breaker.*

another tilt to the leading edge to vary the composition.

It is not necessary to use color in practice paintings like this. The ability to paint waves in black and white is also important, because you cannot rely on color alone to create a realistic picture. The correct values are also necessary. Besides, color may only compound the problems you encounter when you first try to paint a wave. (I'll have more to say about the use of color later on.)

Remember that there are no hard and fast rules regarding the sea. It is a moving and therefore a changing spectacle. An opaque ground swell is as common as a transparent one, and the contours of the ocean floor and submerged rocks may cause any number of variations. As you paint, just remember the "why" of these swells—the energy mass that creates them and influences their behavior. After you understand the normal or ideal swell, look into the variations that continually occur.

## Breakers

Finally, we come to the most spectacular aspect of waves—the true breaker. As the ground swell moves into even more shallow water, the ocean floor pushes the energy orb upward until it can no longer maintain its original shape and size. The orb breaks, the surface skin of the water separates, and in an effort to maintain itself the leading edge continues forward from the highest point and strikes the trough below. As you can see in Figure 16, a tunnel of air is created beneath the rounded curl. This tunnel —called a "pipeline" by surfers—does not appear in all waves but is occasionally created as

**Figure 15.** *When one side of a swell comes in contact with a rock, the motion of the swell is slowed at the point of contact and the other side begins to swing or pivot around that point as it continues forward.*

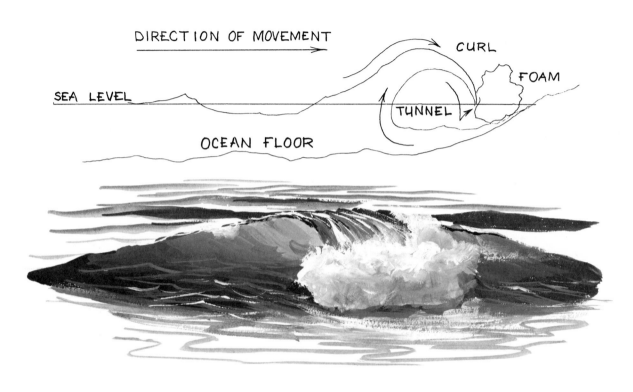

DIRECTION OF MOVEMENT

SEA LEVEL

OCEAN FLOOR

CURL

FOAM

TUNNEL

**Figure 16.** *When the ocean floor finally raises the energy orb too high, the leading edge of the swell breaks and falls forward to become a true breaker.*

the curl reaches far out over the face of the wave.

In Figure 17, take a closer look at what happens as the breaker develops. The face of the wave is curved away from the shoreline and actually moves upward as the swell rises. Meanwhile, the breaking edge begins to curl toward shore and is thrust forward by the remaining energy of the orb. The face of the wave is relatively smooth at this point, although it may be covered by patterns of foam left behind by the preceding wave. The irregular leading edge may break in several places at once as it continues to curl over.

As the breaking water strikes the trough ahead of it, it shoots upward, becomes boiling foam, and rides the forward face of the curl like a surfer. Much of the sound of surf is created by the crashing water striking the trough, but this is backed up by the deeper thunder created as the wave collapses and forces trapped air to burst out of the tunnel (Figure 18).

The water at the top of the curl appears darker than the breaking water below it, which becomes thinner and more transparent as it tumbles down. As the breaking water approaches the surface ahead of it, reflections of foam as well as of sky and atmosphere make it lighter still. At the same time, the face of the wave becomes thinner and more transparent, and the light shining through makes it lighter than the water at the base (Figure 19).

Unless the light is directly above it, a darker line appears along the top edge of the curl. This area is not transparent and the light does not shine through it. When you are in doubt as to what color you should paint this shadow line, look at the color of water at the base of

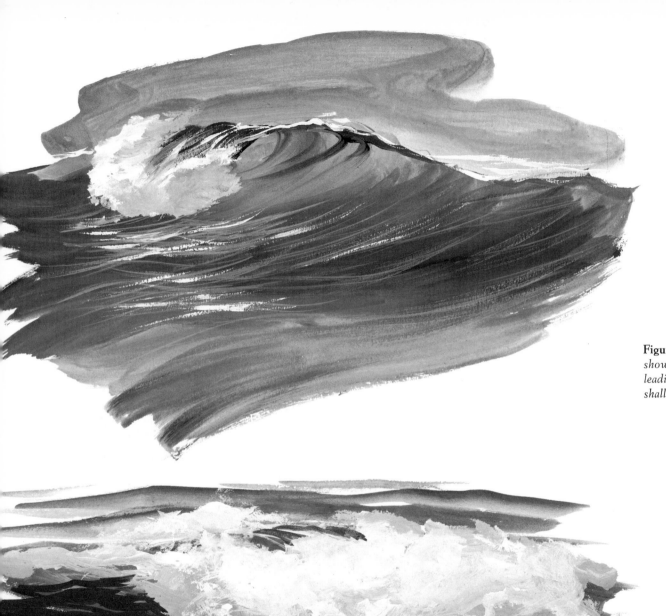

**Figure 17.** *When the face of a breaker is smooth, it best shows the gradual change from a dark base to a lighter leading edge. The water at the leading edge now becomes shallow and transparent.*

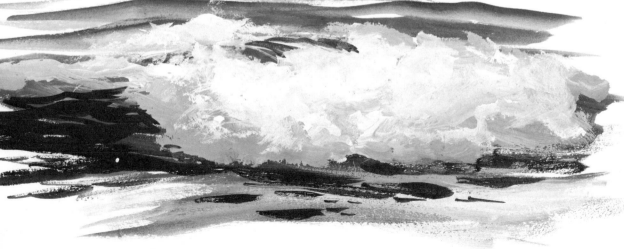

**Figure 18.** *As the wave collapses, it flattens out, becomes a caldron of boiling foam, and forces the air out of the tunnel beneath it. There is still enough forward momentum to move the wave further up on the beach.*

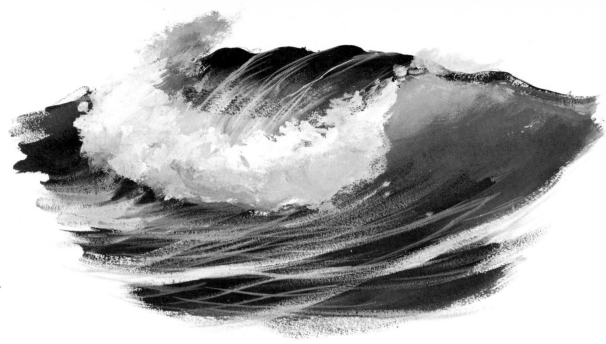

**Figure 19.** *The stream of breaking water is called the curl. It is thicker and therefore darker at the top, and thinner and lighter at the bottom where the breaking water becomes more transparent as it falls.*

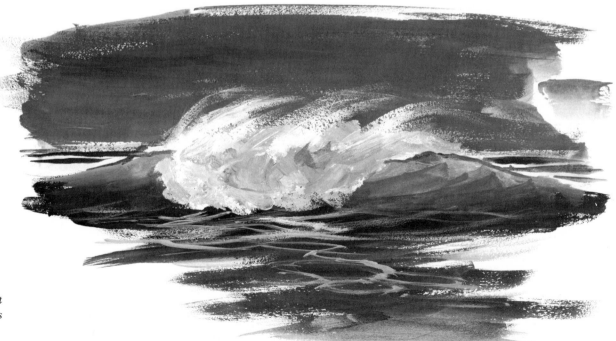

**Figure 20.** *When the wind is blowing from the shore, it may whip the foam back into the distance. These wisps of spray are called "horsetails."*

the wave between the transparent face and the flat surface of the ocean. If any area shows the true color of the ocean without the influences of light, foam, and atmosphere, that area does.

If there's any wind at all, it whips foam and spray off the top of the breaking wave and into the air above it (Figure 20). You should paint these "horsetails" with soft edges, starting at the base and moving your strokes outward. It is also best to keep all the horsetails whipping out in the same general direction, not only because the wind comes from one general direction, but also because the horsetails indicate the direction of the breaking water and add to the sense of movement in the painting.

## Painting Breakers

As I mentioned before, the only important rules of the sea are the ones it creates itself. When you paint breakers, think back to the origin of these waves, to the shape of the energy orb, and you won't break the foam in the wrong direction or give the breaker the shape of some prehistoric monster. The shape and direction of the energy cycle determine the characteristics of the breaker, and any variations of form are due to elements the wave meets on shore.

Try the color exercise on painting breakers, page 82, as many times as you wish. For the sake of practice, use an "ideal" wave for this exercise—a granddaddy wave of all waves, with the features described in this chapter (Figure 21). Of course, this wave is a little too perfect, but it's a good starting point for learning to paint all other waves. Once you've gained some mastery over the ideal wave, you can change it in many ways. By varying its size

and shape, the amount of breaking water, the foam and foam patterns, and the wave's position in relation to other waves and rocks, you can make it into whatever you wish.

Begin by sketching the outline of the wave, using a pencil or thinned oil paint on a scrap of canvas or textured paper. Leave out the details for now; we'll cover them later. Avoid creating a high, humpy wave that ends too abruptly at the baseline. Try to make it slope gradually down into the water ahead of it. Indicate the curl and the foam area, but keep them loose. Don't give the foam a recognizable geometric form.

For the second step, choose a green such as viridian and brush it undiluted into the face of the wave. Leave the foam and transparent areas unpainted. This is really an underpainting and it will change as you add other colors, so don't thin the paint or scrub it into the canvas so much that the white surface shows through. On the other hand, don't apply the paint so thickly that subsequent colors will become lost or muddied when you add them over the underpainting.

Now, choose a sunlight color such as cadmium yellow pale, and use it undiluted to fill in the transparent area on one side of the wave. Start at the top and blend the yellow gradually into the green area. Clean the brush and whip it back and forth across the edge between the two colors until there is no apparent line between yellow and green. By this time, there'll be little pure yellow, if any, left—and that's fine as long as the green in the transparent area is lighter than the original green areas. Repeat the same process on the other side of the wave and in the top of the curl. The

top area should start out dark and gradually lighten as it approaches the foam.

Darken and give a feeling of depth to the base of the wave with a mixture of ultramarine blue and a touch of burnt sienna. Again, blend the new color into the green but don't allow it to reach into the transparent area.

For the foam color, mix a small amount of pale yellow with white. This foam is in sunlight, so it must be very light. First, run a few curving streaks of the yellow and white mixture from the top of the curl down to the foam and blend them with the underpainting near the bottom to indicate that the water becomes thinner and more transparent as it plunges. Then load a brush with the same yellow-white mixture and scrub the paint into the foam. Use a circular motion, and leave a rather heavy amount of paint on the canvas, particularly at the top of the foam. Use a soft, dry brush to whip the thick paint back into horsetails. Do this very lightly or the paint will simply blend into the background.

Next, pick up some white paint and a touch of blue on a clean brush and brush it into the shadow area of foam. Blend it with the lower portion of the sunlight area, just enough so that there'll be no visible line between the two areas. Unless you've used too much yellow or blue in your mixtures, the foam should now look like white foam influenced by sunlight and shadow. If it looks like a flat wall, go back and add another fluff or two of the yellow-white mixture along the top of the shadow area. This will give it a more rounded effect.

Now choose a pale blue sky color and paint it into the trough in front of the wave, where it would naturally be reflected by the flat surface

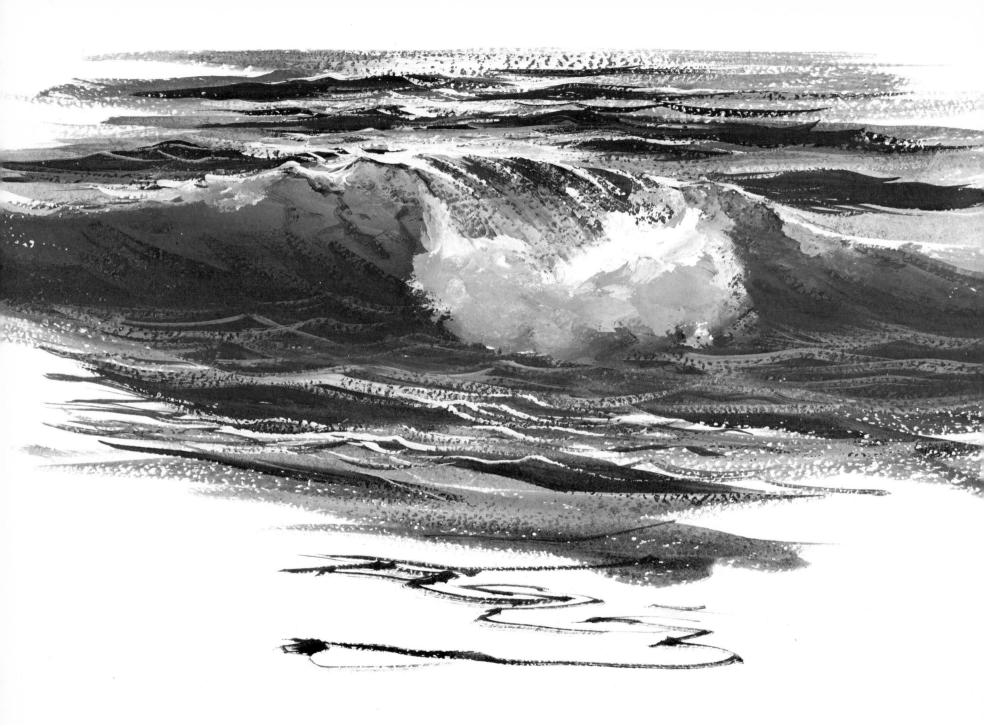

of the water. Gradually blend it upward into the dark water, but don't draw it up too far. If the blending is gradual, it will create the effect of a concave trough receding into the face of the wave.

Finally, use the yellow-white mixture and a very tiny brush to add a few highlights along the leading edge of the wave and on the surface of the water in front of the wave. These glints of light suggest some minor chops and add texture to an otherwise too smooth surface. You can also add chops in the foreground by painting them the same way you'd paint background swells. You can make these a bit darker than the surface, but highlight them with your sunlight mixture.

## A Pep Talk

Your first attempt at painting the ideal wave may not be what you expected, so try the exercise again and again until you can paint exactly what you want. Painting the sea isn't like painting a still life or landscape. This is a moving subject with remarkably peculiar habits, and mastery does not come with one or two simple exercises. Nor will it help if you go on to something else too soon. Stay with the ideal wave for a while—each try will bring an improvement.

Perhaps this is a good time for a short pep talk. You've undertaken to study and paint one of nature's most difficult subjects. Mastery will come with effort, not with anger, through hard work and repeated attempts rather than with a dash here and a daub there. Above all, mastery will not come if you have the attitude that you must make a beautiful painting each time you put your brush to canvas. No musician has ever mastered Beethoven without doing five-finger exercises. No ballet dancer ever arrived on the stage without years of grueling exercises. Why, then, should success in painting be any different?

When mastery of one element does come, the artist rarely notices it. By then, he has met another problem, another obstacle; he hardly remembers the trouble he had learning something that has now become second nature to him. And this is as it should be—satisfaction destroys initiative, whereas problems demand it. Progress is usually cloaked in frustration. Mastery is the eventual result of starting. When energy is transferred to a swell, the shore is still a long way off. But, like mastery, it is there.

**Figure 21.** *No breaker is exactly like another, but our "ideal" wave shows the major characteristics of all breakers—the choppy leading edge, the dark curl falling to become foam, the dark base, and the transparent face of the wave.*

# CHAPTER 3

# TYPES OF FOAM

So far, we've followed the original energy orb from its birth as a ripple through open-sea swells, ground swells, and finally to the breaker itself. But its life doesn't end with the breaker; when the breaker collapses upon itself and air mixes with the water to create foam, there's still enough energy left to carry the water and foam up onto the beach. There, the foam swirls about while millions of air bubbles crackle and burst, then washes back out to be met by the next wash of foam.

The most spectacular foam action occurs in the surf, the area between the closest breakers and the shore. Bursts, backwashes, rip currents, rocks, and secondary breakers all mix together in a symphony of light and motion. However, other types of foam are also created far out at sea under certain conditions, and these may appear almost anywhere on the ocean.

## Whitecaps

As I mentioned in the previous chapter, whitecaps are created as the wind whips off the thin edges of choppy sea swells (Figure 22). Don't confuse whitecaps with the foam of breakers close to shore. Whitecaps occur in the distance, when the sea is unusually rough and the swells are so agitated that they crash into one another. When you paint whitecaps, remember that the swells move right out from under them and leave them floating behind. Be sure to soften the edges of the foam to create the feeling of distance. It's best to add whitecaps after you paint the swells. When they're only in the background, they shouldn't command very much attention or they may detract from the center of interest.

## Combers

When the sea is unusually rough or when a large ground swell hits a hidden reef, foam cascades down the face of the swell. The foam often boils along with the swell for quite awhile before, like the whitecap, it is finally left behind. Although the entire swell resembles a breaker when it is covered with foam, it is actually a comber, or spiller (Figure 23). Like whitecaps, the foam here is not the result of breaking water, and the comber should not be confused with the true breaker.

## Foam Bursts

The foam burst has many of the same features found in breaker foam, but it is the result of a wave striking a rock or another wave. The impact sends the water skyward, where it mixes with air and begins to reflect the light and atmosphere (Figure 24). Remember that there is a connection between the wave and the burst. A burst of foam rising from a flat or otherwise placid sea is not very believable.

In most cases, the foam burst is light against a dark background, but the reverse may also be true (Figure 25). The direction of the sunlight is the determining factor, along with the value of the background. A foam burst usually appears darker in backlighting and may display a halo of light around its edges. In either case, it is best to feature one arrangement of values rather than making a conglomeration of light and dark. To make a light foam burst show up, paint the background somewhat darker than the foam. The amount of light on the burst will depend entirely upon the amount and direction of the sunlight.

## Painting Foam Bursts

You should paint foam bursts much as you'd paint breaker foam. They also have no definite shape, have both lost and found edges, and are most effective when divided into areas of light and shadow. Unlike breakers, however, the water in which foam bursts occur is dark at the base and gradually becomes lighter as it rises, mixes with air, and reflects light. If the water is thin in spots, it will also be transparent, though this is not necessarily the rule.

Take special note of the edges in Figure 25. The thinned-out effect is created by a strong wind and helps to show movement. You can create this effect by carefully whipping a large, soft brush over the wet paint along the edge. Try using a 2″ varnish brush, completely dry. Whip it softly back and forth until the edges blur; then leave them alone. As with so many painting aids, this technique can become a gimmick if it's overused and may destroy the freshness of the effect.

A burst caused by the wave striking a rock is worth mentioning here, even though there is a more detailed study of rocks in the following chapter. By the time the wave strikes the rock and sends the foam skyward, it is already directly over, or on top of, the rock. The rock is partially submerged and disappears in the water and foam around it (Figure 26). To create this effect, paint the foam and the base of the wave first, then blend the rock color into them. Use the rock color sparingly or you may lose the lightness of the foam altogether. Soften the edges of the rock, because they cannot be seen clearly through the foam. When you've added the rock, bring more foam over it.

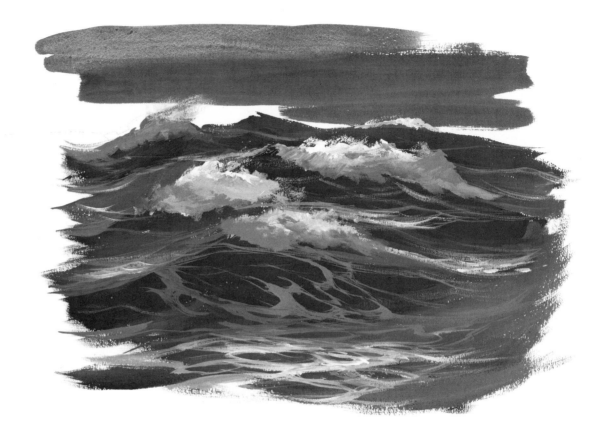

**Figure 22.** *This is a close-up view of whitecaps. These are created by the wind or by agitation in the swells and are usually seen far out at sea. The swells move right out from under the foam, which then breaks up into flat patterns on the ocean's surface.*

35

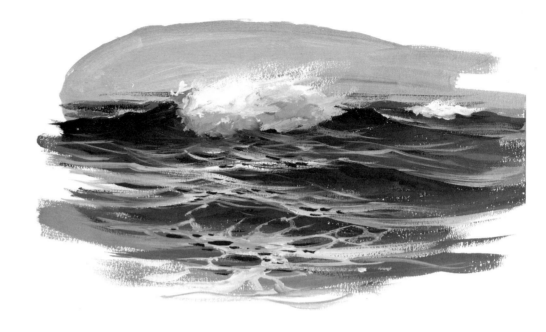

**Figure 23.** *A comber or spiller is a large ground swell with foam cascading down its sides. The swell often moves on, leaving the foam behind to form patterns on the ocean's surface.*

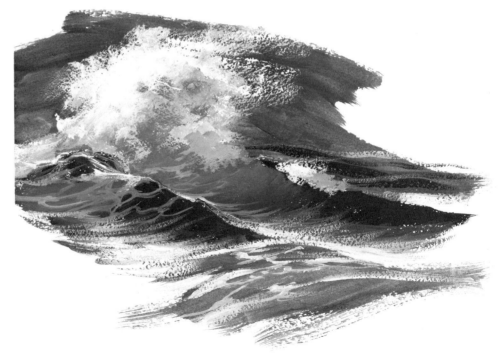

**Figure 24.** *The foam burst is usually the result of water striking an object such as a rock. Like breaker foam, it has no definite shape. However, the direction of its movement is upward rather than downward.*

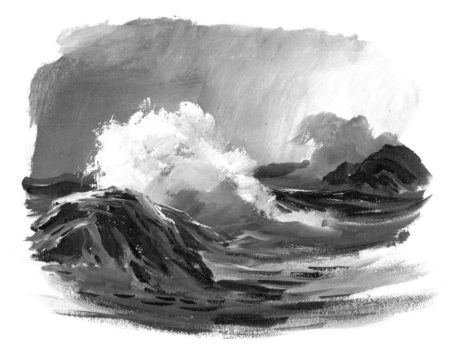

**Figure 25.** *Although foam is white, it may appear darker than the background in some lighting situations. In this illustration, the foam appears darker as the background becomes lighter in the right area of the sky.*

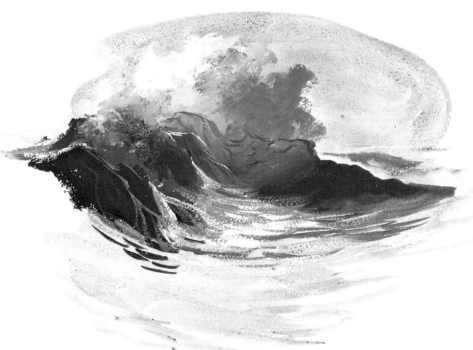

**Figure 26.** *At one point during the burst, a forward-moving spray or mist may appear and the rocks seem to fade into the foam. Always show the connection between the wave and the foam burst.*

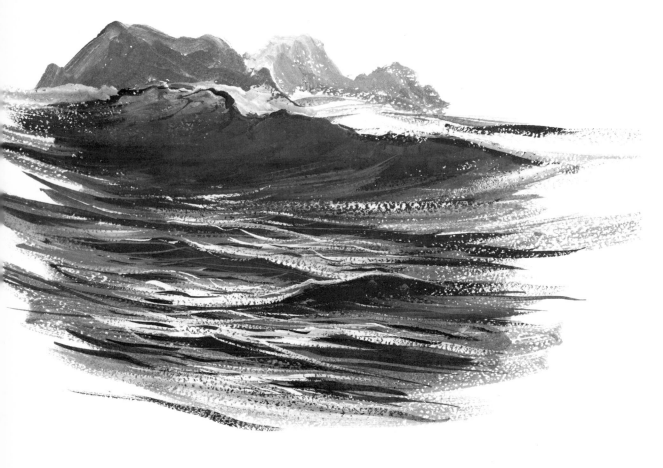

## Surface Foam

Surface foam is entirely different from foam bursts. It occurs in the area between the waves and the beach, which may be either clear or covered with foam, depending upon the amount of action taking place in the water. Even when the surface is clear (Figure 27), there are still minor ripples and swells. These should be painted much like those seen in the background. However, because these ripples are closer to the viewer, they display more contrast and sharper details than are visible in those in the background. There may also be reflections of the sky among the closer swells, especially if the viewer is looking down at the water rather than out to sea.

If the surface of the water is foamy, it may be either entirely frothy or covered with broken areas of foam. A frothy surface is the result of heavy activity and usually occurs when the waves are very close together or when there isn't enough beach area for foam to settle on. The surface is then too frothy and broken up to create the mirror effect of smooth water (Figure 28). In extremely choppy areas, minor swells and even transparent areas appear.

When you paint surface foam, use choppy strokes because the foam itself is choppy. To create this kind of agitation, the area below the surface must be quite rough; use cast shadows to help show the contours below the moving surf. Just as lost and found edges are effective, a variety of sharp and soft areas are descriptive of the overall froth. Try using a dry varnish brush to soften some of the edges while you leave others sharp and clear.

Surface foam contains the same colors as foam bursts. Use white brightened with a

**Figure 27.** *The surface of the water between the waves and the beach is sometimes smooth, sometimes covered with froth, or, as shown here, rippled by the wind or the action of long, thin, minor swells.*

touch of yellow, blue, or lavender to indicate sunlight and shadow. If the water has been churned up, some of the sand may have muddied the foam; a touch of brown-gray will indicate this.

## Scud

When waves break on a beach rather than against cliffs, the momentum of their energy carries the water, foam, and sand forward in the last rush that I call "scud" (Figure 29). It's easy to see scud when the light is coming from behind and the forward wall is in shadow. The forward wall seems to dance and run with a million tiny legs, and miniature "breakers" quite often appear at the edge. The height of the wall is determined by its distance from the beach; the closer this water is to the beach, the shallower it becomes.

A thick shadow line that also varies in thickness occurs below the edge of foam, much as it does beneath breaker foam, and tiny, irregular bubbles appear on the closest area of the scud. These bubbles create foam patterns and mark the end of the journey for the energy released long ago at sea.

When you paint scud, never make it look as if it's coming in like a straight wall. The breakers that cause scud collapse unevenly, and some parts of them slow down in back-washes while others rush to shore more quickly —so scud is never anything but irregular.

## Foam Patterns

Foam patterns may appear in rather calm surf. They, too, are created by breaking waves, and

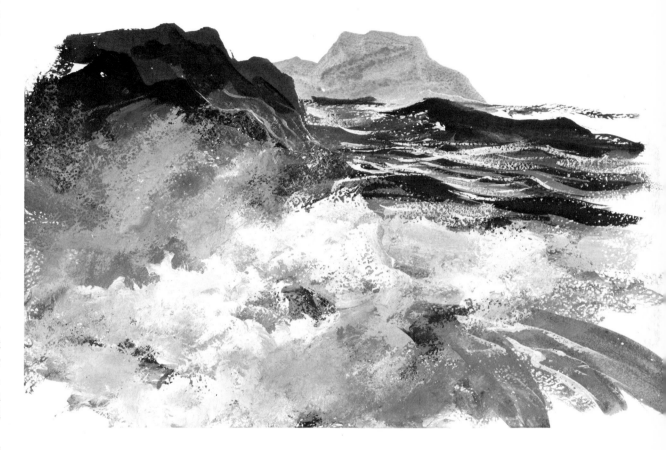

**Figure 28.** *A frothy surface is created when a wave collapses or when water pours over the rocks in all directions. In either case, the foam is without definite shape, and spots of water show through it here and there.*

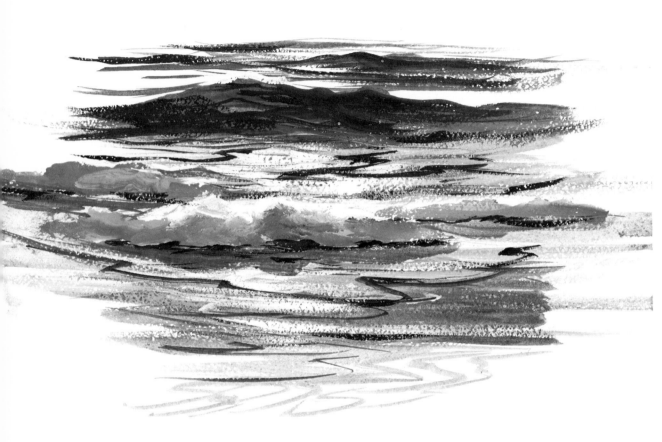

they are not only interesting but also very helpful in showing the contours of the water's surface. After the foam settles on the surface, backwashes and swells split it apart. At first, irregular areas of more or less rounded holes appear in the foam to create a mass foam pattern (Figure 30). As the foam separates even further, it tends to form lines over the surface of the water that result in a linear foam pattern (Figure 31). The mass patterns indicate a heavy but not frothy surf; the linear patterns, a quieter but still-moving surf.

Linear foam patterns are variations of lines and are easy to see. In Figure 31, notice the graceful path of the foam as it curves up the sides of the swells toward and finally onto the face of the wave. Because these lines can be used to show the irregularity of the surface, lead the eye to the wave, and then show the contour of the wave itself, they are an extremely valuable aid to the painter.

## Painting Mass Foam Patterns

You can create the proper perspective in the holes of mass foam patterns not only by making them smaller as they recede, but also by varying their shapes according to their positions. To see what I mean, hold a round disk such as a jar lid away from you at arm's length. Hold it upright as if it were floating on the vertical face of a wave, and you'll see the entire round surface. Then gradually tilt the top edge of the disk backward, and you'll see that the surface of the disk becomes an ellipse and finally a straight line as it lies flat. Holes in foam are never perfect circles like the jar lid, but similar changes take place in their shapes.

**Figure 29.** *The last bit of water and foam to reach the beach is called "scud." It is carried forward by what little is left of the once powerful energy that created the breaker.*

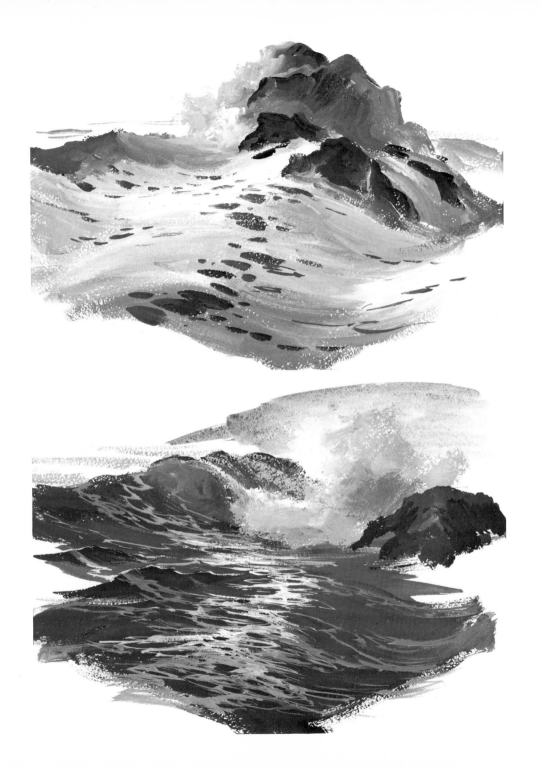

**Figure 30.** *Mass foam patterns cover most of the surface in the foreground water. The foam is separated by holes here and there, through which the water below can be seen. When painting mass foam patterns, you can arrange the holes to show the contours of the sea or to lead the eye to an important part of the painting.*

**Figure 31.** *Like mass foam patterns, these linear patterns are ideal for showing contours or leading the eye to the center of interest. Be sure not to scatter them or leave them disconnected from one another, or they may look like worms crawling over the water's surface!*

It takes a lot of practice to master mass and linear foam patterns, but once you do, you'll find them invaluable in painting the sea. On a scrap of canvas, try the two-step practice exercise on painting mass foam patterns, page 46. As you paint, remember that the holes you "punch" into the foam should be the color of the water below. Make sure the holes in the transparent part of the wave are also transparent and that the holes in shadow are as dark as the dark water. If some of the holes appear too large, run a few thin connecting lines of foam between them. You can also whip a brush back and forth across the edges of the holes to indicate motion.

## Painting Linear Foam Patterns

The exercise on page 47 will give you some practice in painting linear foam patterns. Remember to use both lost and found edges between the foam and water areas, and vary the sizes of the foam lines. Remember also that the areas of water among the foam lines are also useful in describing the rounded—but not circular—patterns of the foam.

The linear patterns will appear too busy unless you keep them in groups and use thin lines of foam to connect them. Plan one major foam path as a lead-in to the wave, and play secondary paths and lines off that. Although it's quite possible for foam lines to form an actual hodge-podge in the surf, it's better to organize them in your painting or they'll distract the viewer from more important elements. For the sake of perspective, keep the lines in the foreground larger than those in the distance.

After your first attempt, you may very well

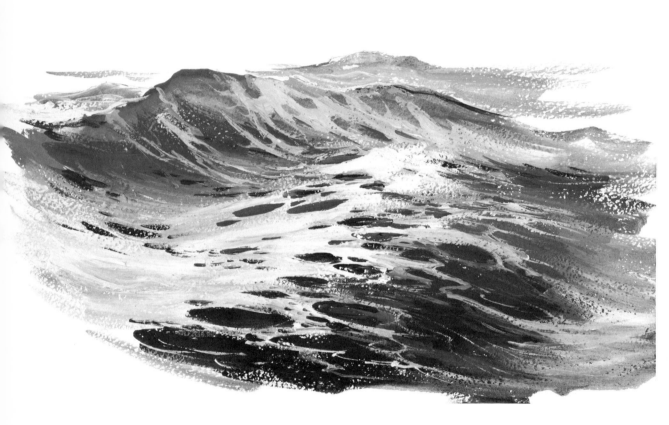

**Figure 32.** *A combination of mass and linear foam patterns is useful not only in describing contours and creating lead-in trails, but also in controlling the placement of lights and darks.*

be discouraged. But do try again! If the patterns look like worms crawling on the water's surface, you probably haven't connected enough of them. If they look too mechanical, they're probably all the same length and thickness and need more variation. If they're flat and uninteresting, there probably isn't enough contrast between the lights and darks. If the pattern looks like an "X" painted across the canvas, you've had it for the moment!

## Combining Mass and Linear Patterns

When you combine mass and linear foam patterns in one painting, allow one or the other to dominate in order to avoid a too-busy effect (Figure 32). Avoid using lines or groups that don't lead to your center of interest. These will be confusing and distracting unless you paint them in so subtly that they merely provide texture. Remember also that it takes time for the foam to break down from the mass pattern into the linear pattern, so the linear areas will be located farthest from the most recent bit of action. There may also be linear patterns at the tops of swells, where the force of upward-surging water may cause the holes to split.

## Silhouette Patterns

Foam patterns on the back surfaces of waves may appear as silhouette patterns when viewed from the front through transparent water. That is, when there is strong back lighting, the light shows through the transparent water in the areas around the foam, but is blocked by the foam itself. Those areas where the light is blocked appear as dark patterns.

The direction or angle of silhouette patterns is directly opposite the direction of the foam patterns on the front of the wave. To help you understand what happens, cut a strip of paper and draw a line or simple pattern on it. Fold the paper in half through the pattern and turn it so that the fold is at the top (Figure 33). Hold the paper so that you look directly at the front flap and cannot see the back side. Then slowly turn one end of the paper around toward you. As you turn the paper, notice that the pattern on the back flap seems to run in the opposite direction from the pattern in front. Like the pattern you just drew, foam patterns run up the front and down the back of a wave, and those on the back appear to be running in the opposite direction from those on the front.

You can use silhouette patterns to give waves depth and three-dimensional form to waves. When you paint them, use a darker version of the color of the water. Start the patterns at the leading edge and blend them into the wave as you move downward (Figure 34). Silhouette patterns should be painted before the front patterns are added, because the front patterns obscure the silhouettes wherever they pass in front of them.

## Pointers on Painting Foam

Several aspects of painting foam remain the same whether it's a foam burst, whitecap, or comber. You may find the following pointers helpful as you learn to paint the various types of foam:

The shape of a foam area is nebulous; it has no

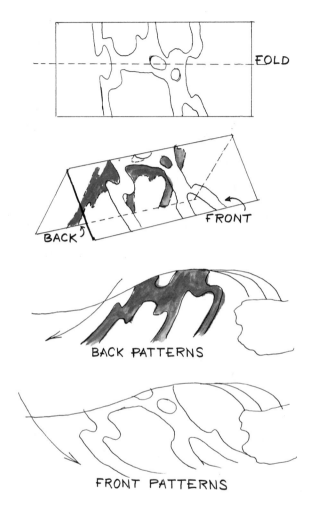

**Figure 33.** *This line diagram shows how silhouette patterns, which are actually foam patterns on the back of the wave, appear to run in the opposite direction from the patterns on the face of the wave.*

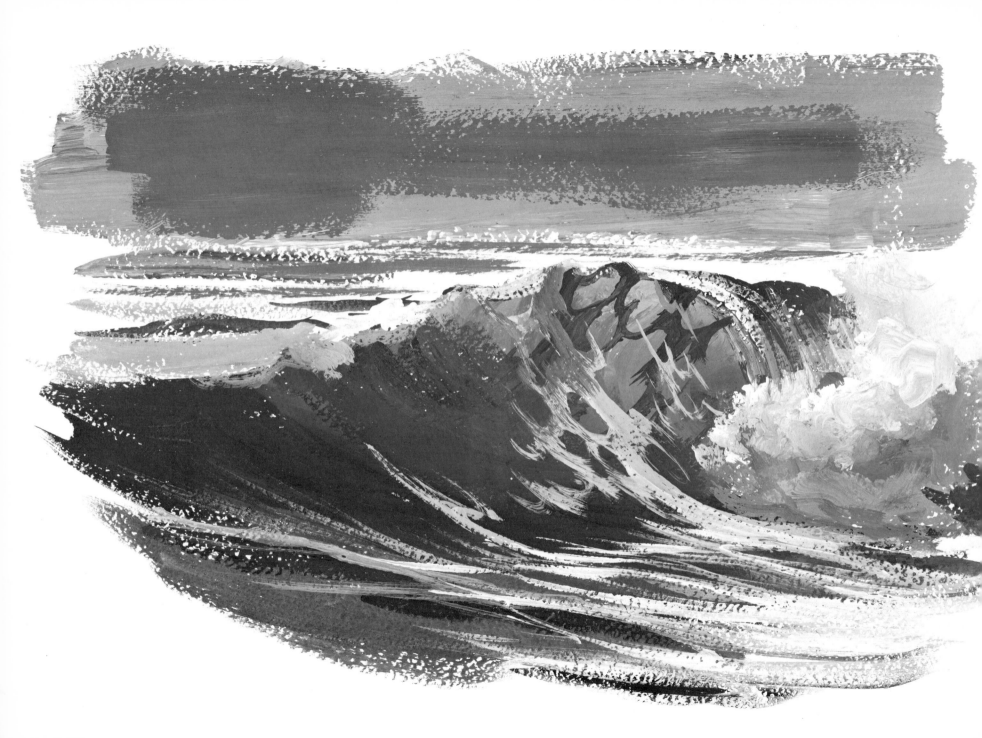

44

definite outline (Figure 35). Sometimes the upper edge is so soft that the elements behind it can be seen through it; at other times the foam has an almost harsh, solid edge. It's most effective to use a combination of both soft and hard edges to render foam.

Undiluted white paint, which so many beginners use, does not indicate much form. Even though foam itself is white, the light, shadow, and atmosphere also have their effects upon its color. Look for areas of light and shadow when you paint foam, and paint them as you did in the exercise on painting the ideal wave, page 82.

A thin shadow, darker than the foam itself, usually appears on the water below the foam. This line is thick in some areas, thin in others. Indicate it using both lost and found edges, in something close to the color of water.

Foam is a moving, frothy mass and nothing destroys that effect more quickly than painting it with a series of upward brushstrokes. A brush loaded with paint and scrubbed against the canvas in small, circular strokes leaves less directional marks that are more in keeping with the action of the foam. Secondary highlights applied the same way give the mass a more distinct form.

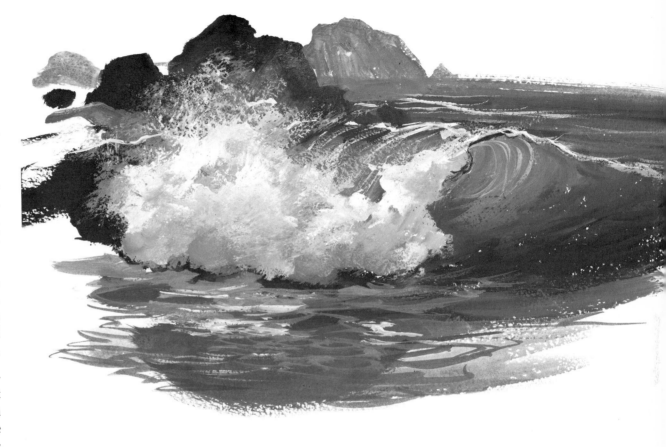

**Figure 34.** *(Left) This is an example of foam patterns occurring on both sides of a wave. The silhouette patterns are visible only in the transparent area, and then only when the light from behind them is quite strong.*

**Figure 35.** *Breaker foam is created when falling water strikes the trough below it. As the foam boils upward, it has no definite shape or form. Some portions may be thick while others are merely wisps of spray.*

## Exercise: Mass Foam Patterns

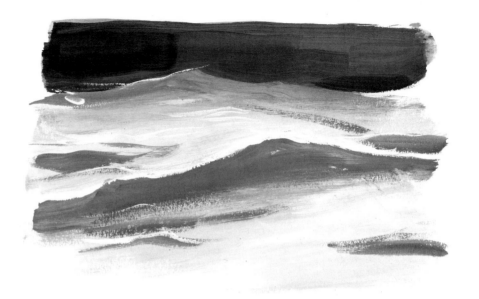

**Step 1.** *Paint the entire canvas or paper in two distinct values, one for shadow and the other for light. Use a value between these two to add some secondary shadows in the light area and a few reflected lights in the shadow area. Just a few of these accents and highlights will do: otherwise the area may become too frothy for mass patterns.*

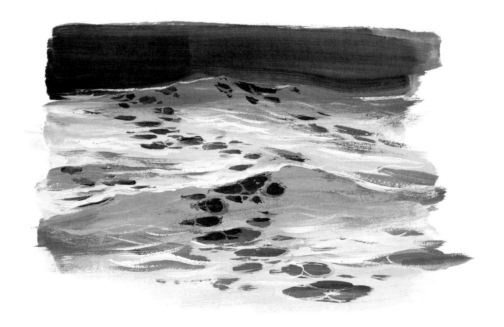

**Step 2.** *Load a small brush with a blue-green mixture, or whatever you've chosen for the color of water. Lay the brush flat against the surface and move it around to "cut" elliptical holes in the foam. Don't scatter the holes; place them along one major path and add a few secondary areas where swells may have split the foam apart. Use a variety of sizes and shapes, but give the holes a more or less rounded form. If handled properly, the holes will show movement, define contours, and create lead-ins to the center of interest just as lines do. In fact, a series of holes create a line. You may also add a final touch to this study by running a few connecting lines of foam through the holes.*

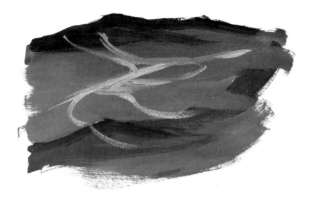

**Step 1.** *Scrub in an underpainting in the color you want to use for the water. Don't build up the paint too thickly or it will be difficult to paint foam lines over it. You won't need thinner if you brush paint well into the surface. Paint in a darker color where the water lies in shadow, and add some lighter areas of sunlight. A touch of blue for the dark and yellow for the light will do it. Then use a few strokes of white to indicate the direction of the foam.*

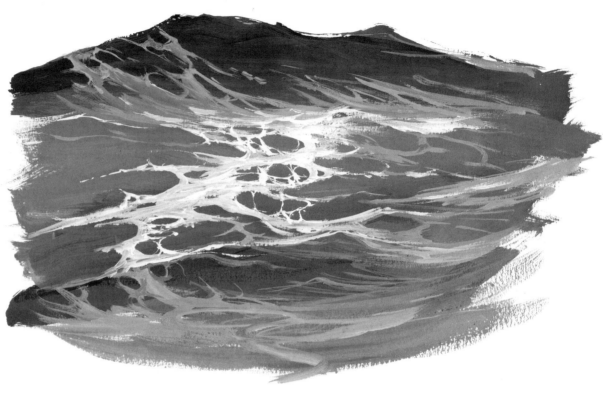

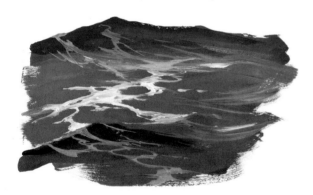

**Step 2.** *Load a #1 or #2 flat brush with a mixture of "sunlight white." Hold the brush flat against the canvas and move it back and forth with a tight zigzag motion. You'll need a very light touch and plenty of paint on the brush to do this. You should paint the major path of foam first and connect the lines. Follow this up with secondary lines that trail off on each side, and then add more thin interconnecting lines. As you paint patterns in the shadow area, switch to the blue-white shadow mixture.*

**Step 3.** *Finally, use a dry varnish brush to soften the edges of the foam. Use a light touch, and brush in the direction of the moving water. This will blur the patterns and show movement. Add a few more connecting lines between the foam lines and a bit of glitter to the sunlit areas, using a tiny brush to apply few strokes of white mixed with a touch of yellow.*

# CHAPTER 4
# ROCKS AND SPILLS

The shapes and colors of rocks vary with their geographic locations. Regardless of the variations, however, rocks are an integral part of marine painting and are indispensable in describing the struggle between land and sea. The most common way to misuse rocks is to overplay them, so that what is meant to be a portrait of water becomes a rockscape. In some cases, rocks may be the focal point of your seascape, but unless you're careful, they may dominate a composition when they're meant to be only subordinate or secondary.

When you use rocks as a secondary element, it's important that you observe the following points. First, avoid painting them in such unusual shapes that they distract the viewer. Remember that rocks appear hard in contrast to the soft water and foam. Also, if you create too great a contrast of colors or values between the rocks and the water, the rocks will show up more than you may want them to. You can de-emphasize rocks by covering them with reflected lights and water spills, which I'll discuss later in this chapter.

## Rock Forms

Rocks have dimension; they have tops and sides, cracks and crevices. Unless you show these features, the rock you're painting may look like a piece of cardboard or a one-dimensional blob of color. In Figures 36 and 37, I've done simple line drawings of two types of rocks —rounded and block-shaped boulders respectively. Notice that top, side, and interior planes are visible on both types of rocks, and observe how the form of both the block-shaped

rock and the boulder can be described by gradations of light to dark values.

## Submerged Rocks

The way you paint areas of rock under water is no less important than the way you render rocks above the surface. Incorrectly painted, a submerged rock—or any rock—may look as if it's floating on the water.

When you paint submerged rocks, or submerged areas of rocks, remember that the water swirls up against them so that the color of the rock can be seen through it here and there. You should blend some of the water color with the rock color in areas where the rock is visible (Figure 38.) You can do this by applying the rock color to the water and then moving your brush back and forth over the area, in the direction of the lapping water. (In fact, you should always apply your brushstrokes in the direction of the water's movement. The texture of the strokes should flow with, not against, the water.)

If a rock is submerged in shallow water—for example, when a swell passes over it—most of its form and color will be visible through the water. However, the surface movement will blur out any distinct edges. In this situation, you can paint either the rock or the water first; just remember that you're looking *through* the water at the rock and be sure to blend the two colors together. For example, you may apply a blue-green mixture for the water, then scrub a brown mixture into it to indicate the rock. You should then soften the edges and run a couple of linear foam trails over the area to make the rock "sink" into the water (Figure

39). Begin the trails beyond one side of the rock and continue them across and then beyond the other side. Otherwise, they may simply look like texture, and the rock will still sit high and dry above the water.

When a rock is only partially submerged, simply treat the submerged area as you would any submerged rock. Blend the rock color with the water color and add the foam trails. Then add sunlight, shadow, and texture to the area above the water (Figure 40).

## Distant Rocks

In the lesson on foam bursts, you saw that when a rock is the cause of the burst, the resulting spray and mist envelop it and make the rock almost disappear. Distant rocks seem to fade and become lost in the atmosphere in much the same way (Figure 41).

When you paint distant rocks, start with the farthest one, which should be barely visible, and add a bit more detail as you work forward to closer and closer rocks. Each rock should appear darker and more distinct than the one behind it; the nearest rock should be the one with the greatest contrast of light and dark and should have the sharpest edges and most detail. When in doubt as to what color you should use to lighten a rock, remember the color combinations you mixed for atmosphere in the exercise on page 83, and simply mix one of them with the color of the rock.

## Painting Rocks

For some practice in painting rocks, try the step-by-step exercise at the end of this chapter.

**Figure 36.** *The boulder at the left resembles an assortment of odd-sized blocks, with very distinct top and side planes; the rock at the right has a more rounded form.*

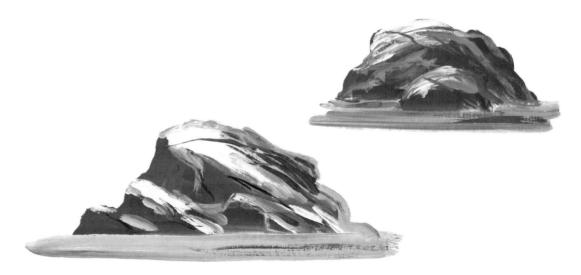

**Figure 37.** *Light and shadow can be used to describe the block-shaped boulder on the left, as well as the rounded form of the rock on the right.*

49

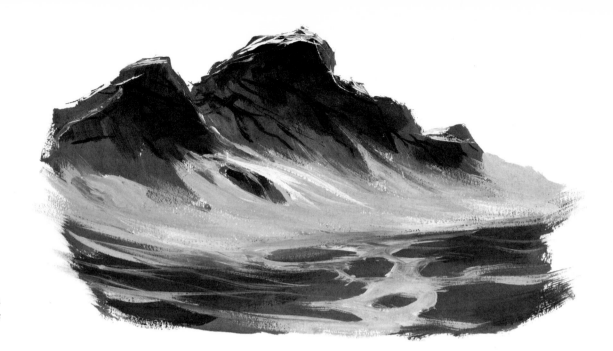

**Figure 38.** *To prevent the rock from appearing to float on the surface, blend the water and rock colors in the areas where the rock is visible beneath the water.*

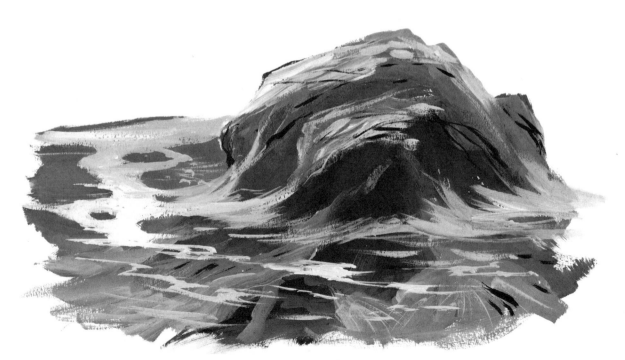

**Figure 39.** *In shallow water, most of a submerged rock may be visible below the surface. You can paint it right into the water, or vice versa, and blend the two colors together. Then run foam trails over the surface to make the rock "sink" into the water.*

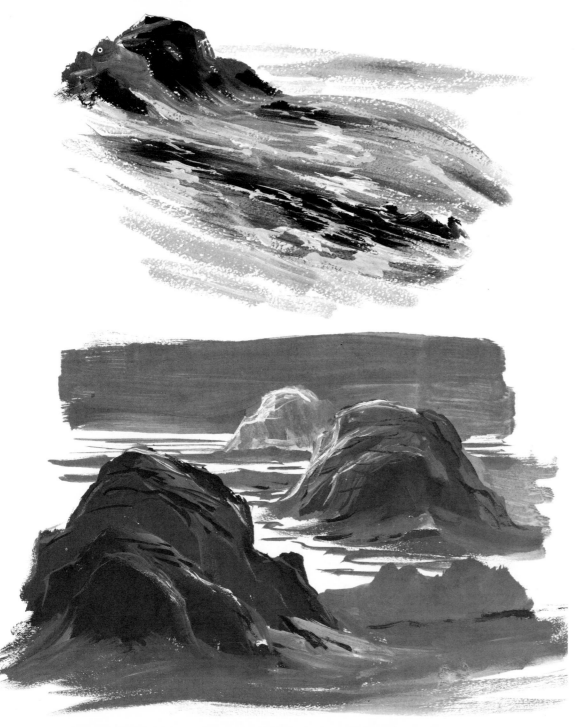

**Figure 40.** *When a rock is partially submerged, paint it in just as you would a submerged rock. Blend the submerged area with the water color, and leave the areas above the water as an overpainting.*

**Figure 41.** *The colors and values of rocks appear to fade as the rocks recede into the distance. This effect is caused by intervening atmosphere.*

For study purposes, I suggest that you use as your model a small rock that has all the basic features you want to learn to paint—texture, cracks, a variety of planes, and an interesting shape. Set it up on a table, study it with a light shining on it from a variety of directions, and pay careful attention to the top and side planes (Figure 42). As you paint it, avoid using only browns and blacks, and remember to suggest reflections of the sky and sunlight on the upper surfaces (Figure 43). Also, try to create some texture, and use both hard and soft edges.

## Overflow

When a wave collapses over a rock, it leaves a cascade of water that can be divided into three distinct types: overflow, spill-offs, and trickles. The overflow occurs immediately after the water collapses over the rock. Very little rock shows through the cascading water; its outline is described only by the contours of the water itself.

To paint a rock in this state, it's best to draw the outline of the entire rock, even though most of it will later be covered with water. This outline will guide you in painting the contours of the water around the rock. Then paint in the water, establish the direction from which the sunlight is coming, and apply areas of light and shadow. Where the water is quite deep, allow more of the blue-green to show; where it's shallow, allow the rock color to "show through." Where the water rushes over the sides of the rock, make it foamy. In Figure 44, for example, I painted in the water in front of the rock, then added foam where the falling water meets the surf ahead of it.

## Spill-offs

Moments after the overflow occurs, the activity in the water subsides and the more distinct spill-offs become visible. As the foam dissipates, the water becomes clear enough to display more of the rock color beneath it. The large spill-offs, or spills, follow the path of least resistance as they tumble down between the major sections of the rock, and the water at the top of the rock becomes much more shallow than the water at the base (Figure 45).

## Painting Spill-offs

Before you try the exercise on painting spill-offs at the end of this chapter, try the following experiment so that you'll understand what actually happens to the water during the spill-off stage. Find a small rock with a few deep cracks and crevices, mix up a thin wash of white oil paint and turpentine, and pour the wash over the rock. Like water, the wash will seek out and follow the major cracks and crevices as it runs down the rock.

As you paint spill-offs, try to make the water appear to flow down the rock in much the same way as the white wash does. Although spill-offs occur when water flows over large bluffs, as well as when it passes over rocks, you should not start them so high above the ocean's surface that their origins are beyond imagination. Be sure the size, height, and amount of detail visible in spill-offs is correct in proportion to the size and distance of the wave from which they originate, as well as in proportion to the size of the rocks or bluffs upon which they occur (Figure 46).

**Figure 42.** *For study purposes, use a small rock that best represents the characteristics of the rocks in your area. Observe its features with the light shining on it from a variety of directions.*

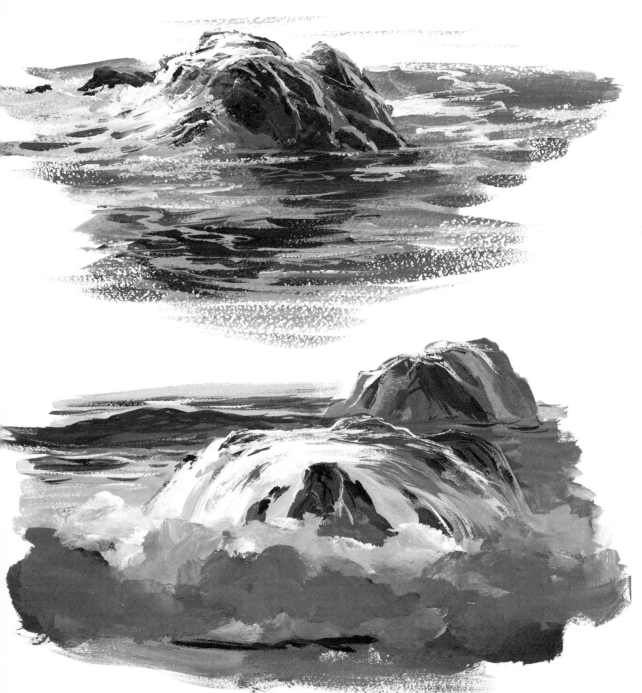

**Figure 43.** *Light, shadow, and reflected light determine the values found on a rock. Here, I used light to relieve the overall dark values of the rock.*

**Figure 44.** *Immediately after a wave passes over a rock, the overflow covers so much of it that only a few areas remain visible. The shape of the rock can be indicated by areas of light and shadow, as well as by the contours of the water around it.*

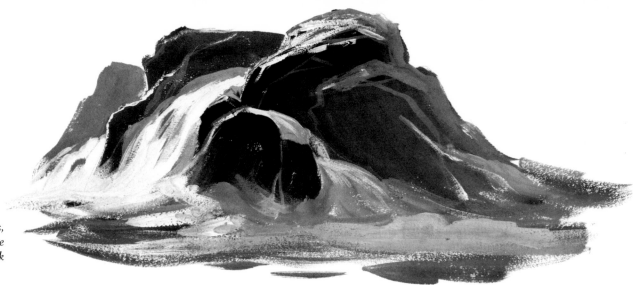

**Figure 45.** *When the turmoil of the overflow subsides, the spill-off stage occurs. The water gushes through the major cracks and valleys in the rock, and more of the rock color is visible through it.*

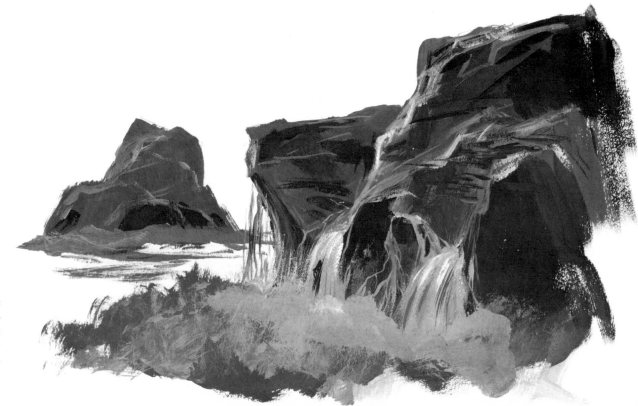

**Figure 46.** *Spills and trickles, even when they fall from a bluff, should never start so high that they become unbelievable. Keep in mind the size of the waves from which they originate, and remember to show the action of the spill-offs by adding foam to the water where they meet the surface.*

## Trickles

When most of the wave has passed over the rock, only tiny trickles of water are left to meander through the crevices on their way down the sides of the rock (Figure 47). Trickles move more slowly than the spill-offs and flow through even the smallest cracks.

When you paint trickles, first paint in the entire rock, making sure that the underpainting isn't so thick that subsequent colors will blend in and become muddy. Use areas of light and shadow to describe the shape of the rock, and paint the darkest colors into the deepest cracks. Then use a very tiny brush to paint the trickles. Start at or near the top of the rock and move downward, just as the water does. Some trickles should be in shadow, some in light. There are more trickles near the base than there are near the top of the rock, because the cracks divide and create more indentations for the water to flow into.

Allow the trickles to flow into foam at the base, rather than ending abruptly on clear, smooth water. Avoid spacing the trickles evenly, don't use straight lines to indicate their direction, and make them both wide and narrow, with both lost and found edges.

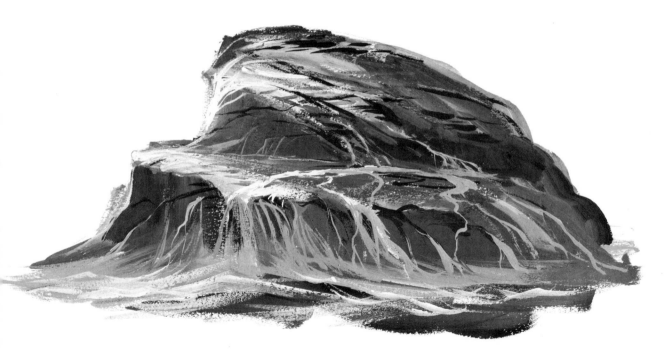

**Figure 47.** *Trickles represent the last stage of a wave passing over a rock. Like spill-offs, they follow the cracks and crevices in the rock, but these seem to meander along on their way downward.*

55

## Exercise: Rocks

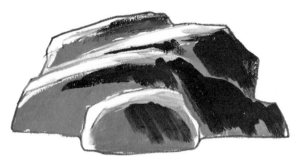

**Step 1.** *Draw the rock, indicating the top and side planes as well as the overall mass. Avoid using unusual shapes that might distract the viewer. You might want to have someone else look at it to make sure that you haven't drawn a rock that looks like an automobile or a duck or some other unrock-like object. Being so closely involved, the artist is apt to miss what is obvious to others.*

**Step 2.** *Paint the vertical planes that don't face the sun in a middle-toned color. If you start with too dark a color, the shadows you add later won't show up. Use a painting knife to create sharp edges. Remember—don't apply so much paint that subsequent overpainting won't show up.*

**Step 3.** *Use a yellow to represent sunlight, and blend it into the dark underpainting where the top and sides of the rock face the light source. Next, use blue or purple to darken the portions of the rock in shadow.*

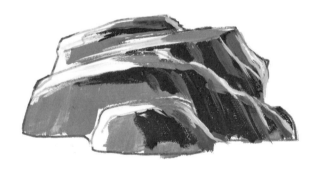

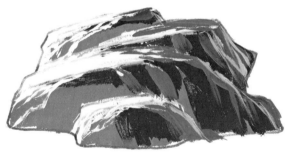

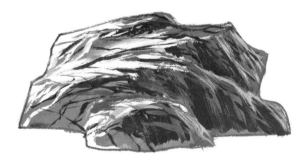

**Step 4.** *If the rock is wet, the upper surfaces will reflect the color of the sky. So decide what color your sky should be, and apply that mixture to the top planes of the rock. If it blends with the rock color, so much the better; it will create the effect of viewing the rock through the reflected light. Reflected or bounced light also appears on dark areas of the rock, so blend a bit of the sunlight color into the shadows here and there. This reflected light is not as intense as the actual sunlight, and it may contain some of the sky color as well as sunlight.*

**Step 5.** *Add just a few glints, or highlights, to the edges of the rock nearest the sun. These should be the same yellow as the sunlight and should be applied with a tiny brush or knife.*

**Step 6.** *Finally, work in a few cracks and add some texture. You can create the cracks by loading a painting knife with a slightly different or darker color than that of the rock itself and drawing it across the surface to create a mottled effect. To "cut in" the smallest cracks, use the edge of the knife, rather than the flat surface. Apply the texture using either a brush or knife loaded with darker or a lighter color.*

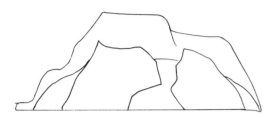

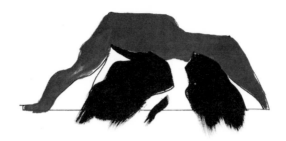

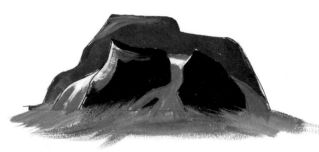

**Step 1.** *Draw a rock, outlining a number of separate and distinct cracks and crevices where the major spill-offs will occur.*

**Step 2.** *Follow the same steps you used to paint the basic rock in the preceding exercise, but this time leave the canvas untouched where the major spill-offs will be. The rock color should not be visible through the water in those areas unless the water is very shallow and transparent.*

**Step 3.** *Now mix the color you want to use for the water. Paint in the base of the spill-off first, being careful not to blend in too much of the rock color. As you proceed upward to the top of the rock where the water is more shallow, you may allow more rock color to show through. Remember to use areas of light and shadow to indicate form.*

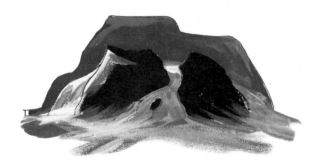

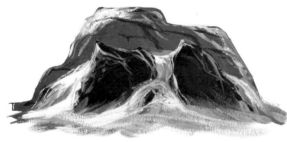

**Step 4.** *Add some texture to the surface of the spilling water to show its movement. Use small amounts of white mixed with blue or yellow, holding your brush at the top of the spills and wiggling it back and forth on the canvas as you move it downward. Repeat this procedure several times, following the contours of the rock beneath the water as you apply the paint.*

**Step 5.** *Finally, use a tiny brush to add glints of light on both the rock and the spill-offs.*

# CHAPTER 5

# SKIES, CLOUDS, AND BEACHES

In a true seascape painting, water is the most important element. Skies and beaches are important only so far as they influence the contours and colors of the sea. (They are nevertheless important enough to warrant a chapter in this book!)

The sky is more important than the beach, because it has a greater effect upon the water. The sea has almost mirror-like qualities and therefore depends primarily on the sky for its color and value. Even if the sky is not shown at all in a painting, its effect is still visible in the light reflected by the water.

The most important thing to keep in mind when painting sky is that it's a vast area of moisture and particles of matter. Its color is created as light waves pass through the atmosphere and are broken up into various colors. Sometimes the atmosphere is quite dry and clear, and visibility extends to the horizon line. At other times, there is a great deal of moisture in the air and it's difficult to see anything clearly beyond a mile or so. On a foggy day, the moisture is so thick that almost nothing is visible.

You can control the degree of depth in your painting by controlling the characteristics of the atmosphere. Just remember that the more moisture there is in the air, the less light and color will be visible through the atmosphere. Such information may seem trivial, but there are times when too much depth in a picture destroys the effect of the action in the foreground. To limit the distance the viewer can see into the picture, it is necessary to increase the amount of atmosphere and consequently decrease the intensity of the light and color.

## Background Skies

Too often, I've seen students re-work a sky area again and again before they painted in anything else. Such skies never look right, and the reason is that they've been treated as the main subject of the painting. It's better to first wash in large background areas such as the sky rather loosely, then refine them after other elements and details have been added. It's amazing how quickly a sky loses importance and recedes into the background once something is painted in front of it!

The characteristics of a background sky should match those in the rest of the painting. It's much too easy to allow the sky to become so interesting that it detracts from the rest of the picture. A busy composition sometimes needs an area of calm, and an uncluttered sky is just the thing (Figure 48). At other times, a bland, uninteresting sky may appear unfinished if placed in an otherwise active scene. In that case, an overall feeling of movement can be achieved by continuing the activity into the sky (Figure 49).

Clouds can also be used to give the sky added interest. If the clouds are far in the background, keep their edges soft to indicate distance. To avoid making the clouds too busy, use large masses and only a minimum of contrast in color and value. I'll discuss specific types of clouds and how to paint them later on in this chapter.

## Clear Skies

When the sky is totally clear, with very little moisture in the atmosphere, it's usually blue.

Such a sky is related to the sea only in color and the least interesting of all the types of sky found over the sea. There's nothing to give it motion or mood, and a large area of bland sky seems to be divided from, rather than subordinate to, the sea. I suggest that you avoid using a totally blue sky unless it occupies only a narrow strip of the painting. Then you can break it up by allowing rocks, waves, or foam bursts to jut across the horizon line. Another way to make a blue sky less monotonous is to gradually lighten it around the sun (Figure 50).

Never use blue paint straight from the tube to paint a sky. You should always mix white or yellow and white with the blue to indicate the effects of sunlight and atmosphere. Generally, a blue sky is lighter toward the horizon line, and gradually becomes darker toward the top of the painting.

## Cirrus Clouds

There are many types and combinations of clouds, but rather than becoming too deeply involved in meteorology, we'll study just a few—those that will occur most often in your paintings. The first, cirrus clouds, are those wispy, feather-edged clouds you see high in the sky (Figure 51). Although they seem to be scattered throughout the sky in a helter-skelter pattern, it's best to give them all a definite direction in order to tie them into the composition as a whole. That is, you should indicate them with horizontal, vertical, or diagonal lines that blend and merge with those of the sea and rocks.

Cirrus clouds are composed of ice crystals and are basically white, but they are also in-

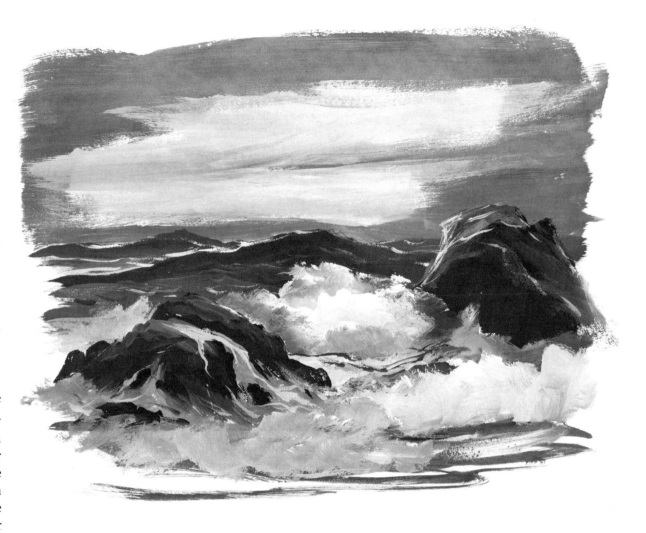

**Figure 48.** *Sometimes it's necessary to include an area of calm in a very "active" composition, and the sky can provide such relief. In this illustration, for example, soft-edged clouds offset the harder edges in the rest of the composition.*

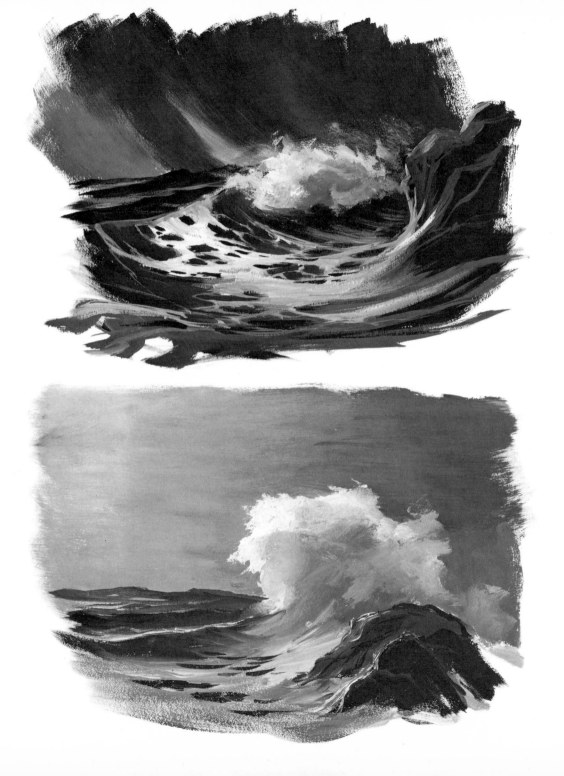

**Figure 49.** *The sky should always be in harmony with the sea; it need not always include the same degree of activity, but it should continue the same feeling of movement. Here, the bold brushstrokes used in the sky imply action.*

**Figure 50.** *You can add interest to a sky with no clouds whatsoever by making it lighter near the area of the sun, darker as you move away from the sun.*

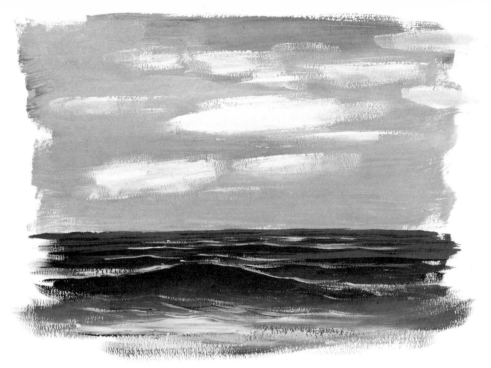

**Figure 51.** *Cirrus clouds are feathery, soft-edged clouds that form interesting patterns in the sky. They can be softened so as not to detract from the sea, or arranged to balance the rest of the composition.*

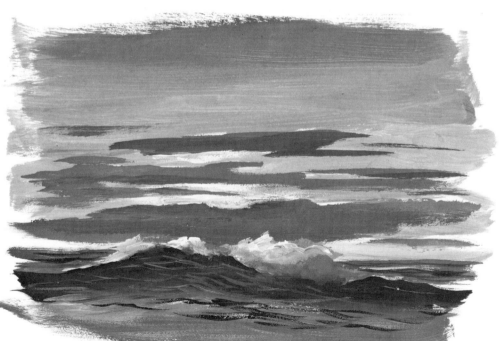

**Figure 52.** *Stratus clouds are usually seen near the horizon line in the morning or evening. Here, they're back lighted and in harmony with the horizontal lines in the rest of the composition.*

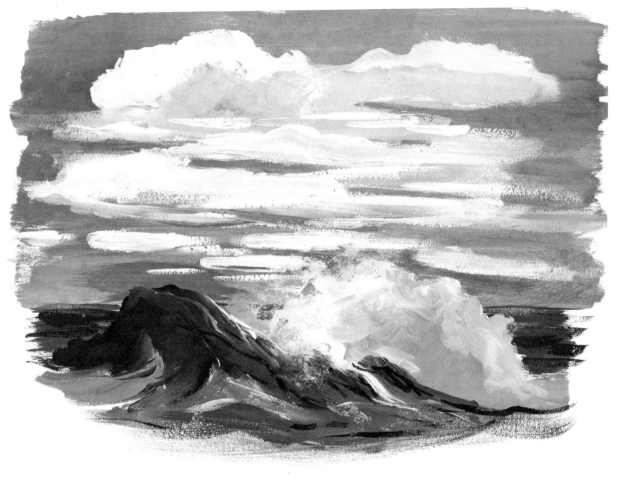

fluenced by the colors of the sunlight and atmosphere. Use a large, soft brush to paint them, and use a hazing brush to whip their edges into indistinct lines. Remember that cirrus clouds are rather thin, usually not dense enough to display areas of dark shadow. They're usually completely light when in front lighting, totally dark when the sun is behind.

## Stratus Clouds

The clouds seen most often over the sea in the morning and evening are stratus clouds. These thin, fog-like clouds are usually arranged close to the horizon in horizontal clusters or bands (Figure 52). Stratus clouds are usually too thin to display strong shadow effects and are most often either totally light or totally dark.

Back lighted stratus clouds may be quite dark, with highlighted edges or the often-mentioned "silver lining." Actually, the highlights are the color of the sun and are most intense in the areas nearest the sun and weakest in the areas farthest away from the sun. Because these clouds are usually seen in the distance, their basic white color is often influenced by the colors of the atmosphere and sun.

Masses of stratus clouds sometimes group together and form what is called strato-cumulus clouds. You should paint these as you would stratus clouds, but add more clouds and allow less light to show through them, because they're more closely clustered together and therefore rather dense (Figure 53).

## Cumulus Clouds

When masses of moisture rise from the surface of the sea and seem to be boiling upward, they

**Figure 53.** *Sometimes stratus clouds group together in large masses. Here, they fill the sky and add depth to the picture as they recede to the horizon line.*

may be classified as cumulus clouds (Figure 54). Cumulus clouds have bulk as well as height and are dense enough to show distinct areas of light and shadow. These clouds are usually higher than any others in the sky, so there may be sky visible between them and the horizon line. Stratus clouds often develop from cumulus clouds and appear below or in front of the rising cumulus.

If there are strong winds, they may whip off the tops of cumulus clouds, and the stratus clouds below them may form what fishermen and sailors call a "squall line." This is an accumulation of moisture near the base of the clouds that becomes rain as the clouds are pushed rapidly forward by the wind (Figure 55). Often, the rain falling from the squall line slants toward the sea as the clouds move toward the land and leave a trail of rain behind them.

The position of the sun is extremely important in painting cumulus clouds. Be sure to show both light and shadow, dark under sides, and the influence of the colors of the atmosphere. Remember that cumulus clouds are quite dense, so the setting sun doesn't usually show through them.

## Nimbus Clouds

These are the rain clouds that appear so dark and "drippy." Rather than rising like the cumulus, nimbus clouds fill the sky and appear to be falling (Figure 56). The under sides are very dark from the accumulation of moisture, and some of these clouds do release rain, often in squalls. While they have enough mass to display areas of light and shadow, they often

**Figure 54.** *Cumulus clouds look and behave much like foam. They boil upward and display distinct areas of light, shadow, and reflected light.*

obscure the sunlight completely and appear primarily dark.

In back lighting, the effects of the sun on nimbus clouds are similar to those seen in fog —there are diffuse areas of glow, rather than distinct patches of sunlight. Paint nimbus clouds by showing their darker under sides. Don't try to show the tops as you would with the cumulus clouds; nimbus clouds fill the sky and only their under sides are visible. However, you can give them a bit more interest by adding a few wispy highlights here and there.

It's quite easy to show depth by using nimbus clouds. Simply paint the closest clouds higher, larger, and darker than the ones that recede into the distance. Be sure they overlap one another, and if you show areas of rain, make them smaller as they recede into the picture (Figure 57).

## Cloud Combinations

Almost any of the cloud types just described can be combined with others in one picture (Figure 58). However, be careful not to add too many of them; it's easy to end up with a skyscape if you let the sky outshine the sea. Whenever possible, study the skies over the ocean to see which cloud formations and combinations occur most often. Some forms don't occur at all in certain locations. For example, the huge thunderheads found over the desert, or the peculiar feather clouds that curve over a mountain peak, rarely develop over the sea.

## Light Shafts and Shadow Lines

Shafts of light and lines of shadow often extend from cloud formations to the sea below.

**Figure 55.** *Moving cumulus clouds may grow heavy with moisture and release rain. In this case, they have grouped together to form a squall line.*

**Figure 56.** *While cumulus clouds boil upward, nimbus clouds seem to drip downward. These are the real rain clouds, and they may also form squall lines.*

**Figure 57.** *You can use nimbus clouds to show depth by making them overlap one another and varying their values as they recede.*

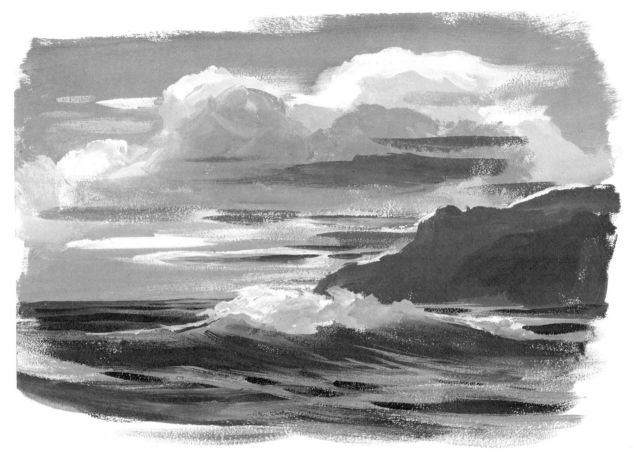

The light shafts are created as sunlight breaks through holes in the cloud in much the same way as light shines through a knothole in a piece of wood. The shadow lines are cast by clouds as they obscure the sunlight.

It's best to paint both light shafts and shadow lines as straight lines and use additional clouds to obscure their origins (Figure 59). The angles at which the lines extend from the clouds to the surface of the water depend upon the position of the clouds in relation to the sun. When a cloud is directly beneath the sun, the light shining through it or the shadow extending from it is perpendicular to the sea below. Light shafts and shadow lines that occur in any other area of the sky slant at the same angle as the light from the sun. To indicate this angle accurately, follow an imaginary straight line that extends from the sun to the spot where the light shaft or shadow ends.

Use your own judgment when you add light shafts and shadow lines. Like clouds, they can be so interesting that they become the center of attention. They can easily draw the viewer's eye away from the sea, and their straight lines and contrasts of light and dark values aren't always in keeping with the rest of the composition. As I mentioned at the beginning of this chapter, it's best to make the sky and the elements within it subordinate to the sea.

## Fog Banks

A fog bank is an area of moisture that creates a transition between light and dark values and is most often visible at the horizon line (Figure 60). It can be used effectively to break up the monotony of a clear blue sky.

**Figure 58.** *Almost any combination of clouds can be found in the sky. Here's a combination of cumulus clouds underscored with stratus clouds. Use the combination best suited to your composition.*

The base of the fog bank may be placed between the foreground and the horizon line at any height, but if it's located above the horizon line, the entire fog bank should be treated like a cloud. The top edge of a fog bank should never be indicated by a straight line across the canvas; it should seem to move in a series of soft, jagged, or slightly curving lines. When you add a fog bank, be careful not to divide the sky into two equal areas.

Although fog banks are basically gray, remember that they may be either warm or cool. Also, the farther a fog bank is from the viewer, the more it will be influenced by sunlight and atmosphere; a fog bank on the distant horizon line may not be gray at all, but quite yellow with sunlight or blue with atmosphere.

## Total Fog

While fog is atmosphere that fills the sky (Figure 61), it too may be uninteresting if the entire area is uniform in color and value. You can make fog more interesting by gradually intensifying the color and value as you proceed from foreground to background. Sometimes, it will also be possible to suggest the influence of sunlight behind the fog by lightening and warming the color as you approach the area around the sun. As in painting a clear blue sky, avoid showing too large an area of fog, and try to vary the colors and values within it.

Like fog banks, fog is basically gray but may be either warm or cool. Rather than mixing black and white for the gray, try mixing two complementary colors—such as red and green or purple and yellow—with white. When combined, complementary colors tend to can-

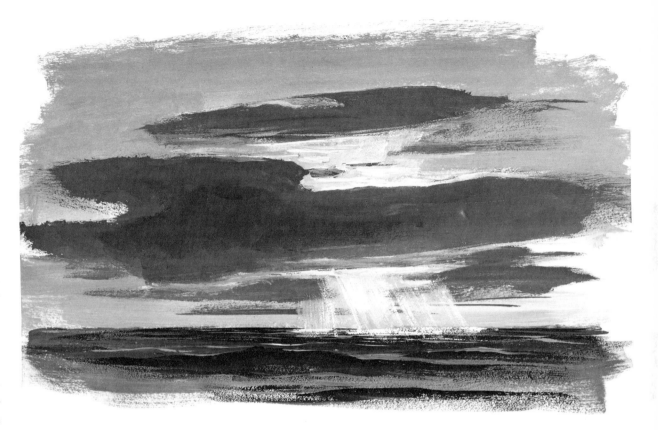

**Figure 59.** *Light shafts are fascinating but may be too distracting when they're not meant to be the center of interest. If used carefully, they can balance a composition that has too many horizontal lines.*

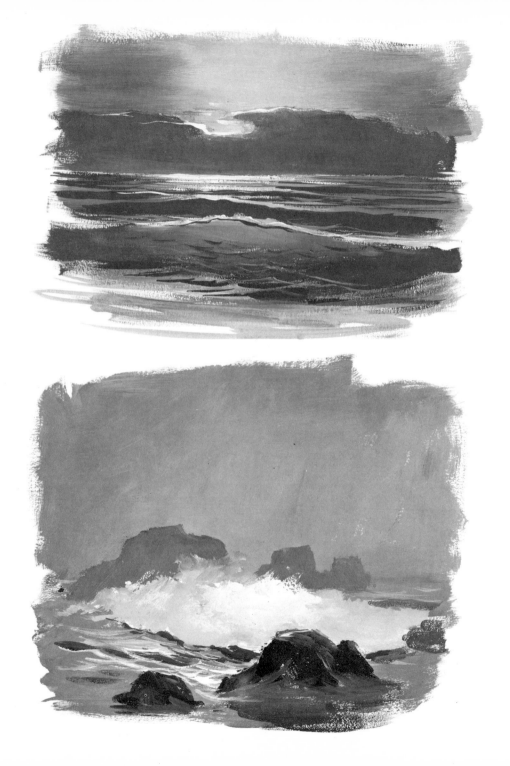

**Figure 60.** *The fog bank provides an excellent transitional area between the values of the sky and the sea. It also softens the otherwise straight harsh line of the horizon.*

**Figure 61.** *When fog is very thick, little outside of the foreground can be seen. Here, the fog fills most of the picture.*

cel each other out to produce a neutral gray. A little more of one color or the other will determine how warm or cool the mixture is.

## Beaches

When beaches are used in a painting, they should accentuate rather than detract from the water. As in skies, too much attention to detail and too many points of interest in a beach area may stop the viewer from looking any further.

The contours of a beach are rarely straight or flat, and the surface usually rises as it moves inward and away from the surf. There may also be dips and humps in the sand, which determine where the washes of scud will move over the surface (Figure 62).

## Sand

The colors of the sand differ from one location to another, so it's difficult to advise you about what colors to use. Generally, sand tends to be a gray-tan or brown, it's also influenced by the colors of the sunlight and sky.

The wind sometimes cuts ripples in the sand that look a great deal like the ripples in the surf (Figure 63). It may also blow the sand into humps or mounds of various sizes. If the sand appears too flat or too smooth for the rest of your composition, simply cut in a few shadows to break it up. In Figure 64, notice that the wind has piled the sand up on one side of the rock to create a shadow. The drifts on the rest of the rock make it seem to be buried in the sand, rather than simply sitting on the surface.

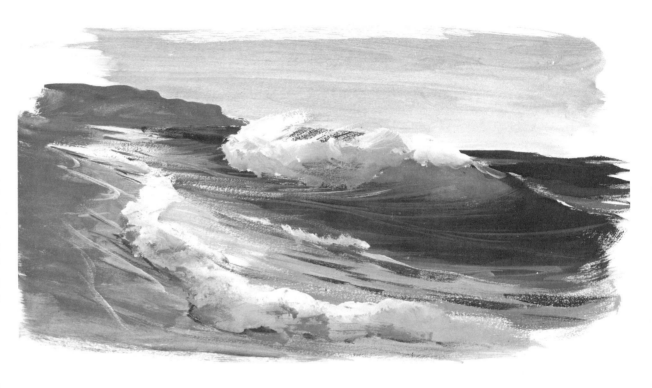

**Figure 62.** *The contours of a beach may be quite irregular, with many high and low spots. You can indicate this easily by making the leading edge of the scud line curved.*

Footprints also leave marks in the sand, but these may be distracting if painted too realistically. Footprints suggest the presence of people; much as an airplane changes the character of the sky, footprints inject a new psychological element into a painting meant to be a portrait of the sea.

## Foam Lines

As scud washes back into the surf, it leaves wet sand and a thin foam line to mark the closest point reached by the tide (Figure 65). The foam line is usually irregular, often a series of sweeps or cusps that overlap one another, and is underscored by a thin, dark edge of varying thickness. If the wash has been recent and little of the foam has dissipated, some foam trails will also extend backward from the line to the surf. There's less foam left in older foam lines, and bits of debris such as pebbles, bits of wood, and seaweed become visible.

## Slicks

The area of wet sand left behind by an outgoing wave is called the slick. Unless it's broken up by ripples, foam, or moving water, its surface is even more mirror-like than that of the sea itself. The slick reflects the sky, the incoming waves, and any rocks located in it. To paint the slick, you can almost ignore the color of the sand and simply use the colors of the sky and whatever else is close enough to be reflected in it. Humps of sand that rise above the slick are, of course, the color of sand.

Backwashes of foam, whether light or dark, obscure the reflections in the slick. Notice in Figure 66 that the reflection of the rock is broken up here and there by the foam patterns. Notice also that the edges in the reflection aren't quite as distinct or sharp as those on the rock itself. I'll describe reflections, their characteristics, and how to paint them later on in this chapter.

## Outlets

An outlet from a creek may sometimes cut through the sand on a beach. Like the slick, the water in such an outlet also reflects surrounding objects. Outlets make fine lead-ins to the center of interest (Figure 67). They should never be indicated as straight lines, but as graceful curves or zigzags. It's best to use one major lead-in and a few secondary paths. No matter where they start, outlets should eventually connect with a slick or the surf.

## Tidepools

Tidepools form when water is trapped among rocks or in indentations in the sand. Because the water in tidepools is still, it reflects even more clearly than the slick (Figure 68). When you paint a rock reflected in a tidepool, try running a thin, light ripple or two across the reflection. This will not only break up the space but will also add depth to the reflection.

## Reflections in Water

As you can see in Figure 69, reflections in water are mirror images of the objects above the surface. When you look at an object and then look at its reflection in water from a point of view at or near the water level, the image you see in the water will include exactly what you see when you look at the object itself. If you could walk all the way around the object as you looked at it from any point of view, you'd always see only the side facing you reflected in the water.

The length of reflections also depends upon your point of view. When seen from a point of view at or near the water level, reflections are as long as the objects they reflect are high; when seen from some distance above or below the water level, reflections appear foreshortened (Figure 70).

The clarity of a reflection depends upon the condition of the water's surface. In Figure 71, notice that the calm water in the tidepool reflects an almost perfect image of the rock. Such an image can occur only when there are no ripples to disturb the surface of the water. Figure 72, on the other hand, illustrates a more realistic reflection, broken by both a hump of sand and a thin foam trail. In Figure 73, there's no noticeable reflection at all. The surface of the water is completely broken up by chops and foam. In such a situation, it's possible to suggest a reflection by daubing a few strokes of the color of the object onto the horizontal surfaces of the water in areas where there is no foam.

## Painting Reflections

When objects are reflected in shallow water, the sand at the bottom shows through and influences the colors of the reflections. As you can see in Figure 74, the reflection of the dark rock is lighter than the rock itself, that of the

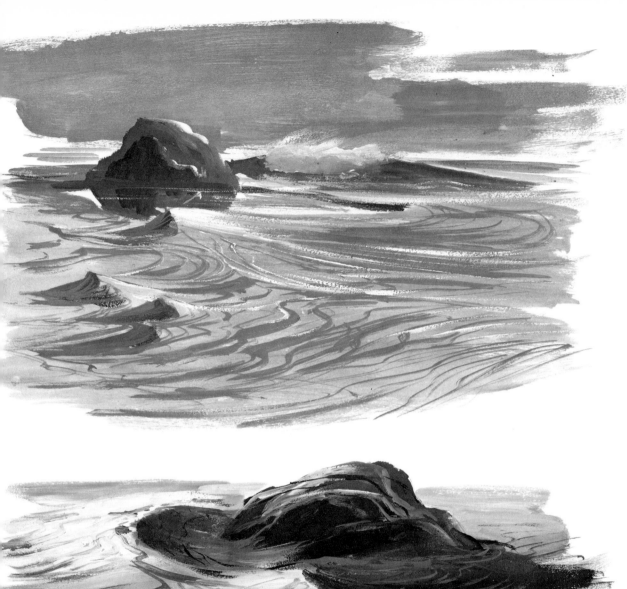

**Figure 63.** *Tides and wind carve the sand on the beach into humps and textured lines. These make excellent lead-ins and can be used to break up an otherwise flat, uninteresting area.*

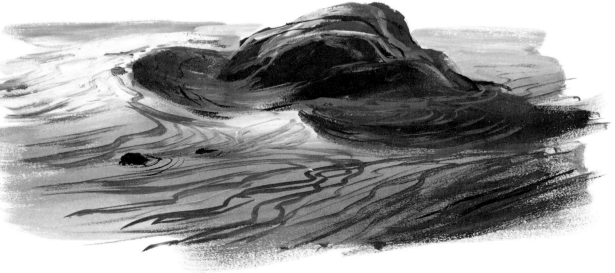

**Figure 64.** *The wind may cause sand to pile up on one side or another around a rock. These drifts can be used to show an interesting contour, as well as to add to the flow or motion of the composition.*

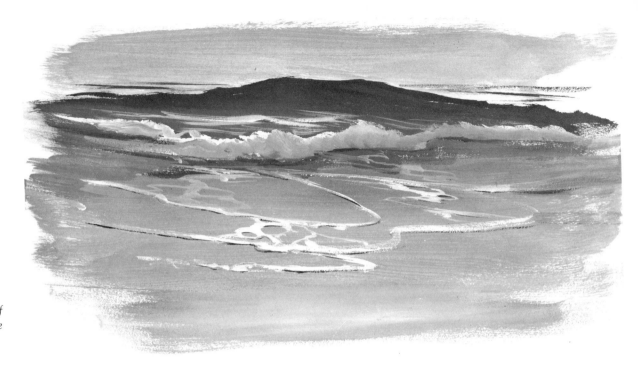

**Figure 65.** *Receding scud lines leave moving trails of foam on the wet sand that follow the contours of the beach.*

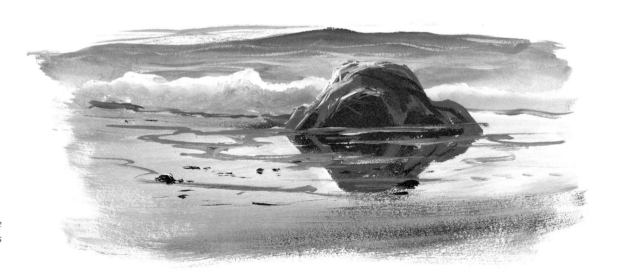

**Figure 66.** *When sand is very wet, the water reflects the surrounding objects, as well as the sky. This area is called a slick.*

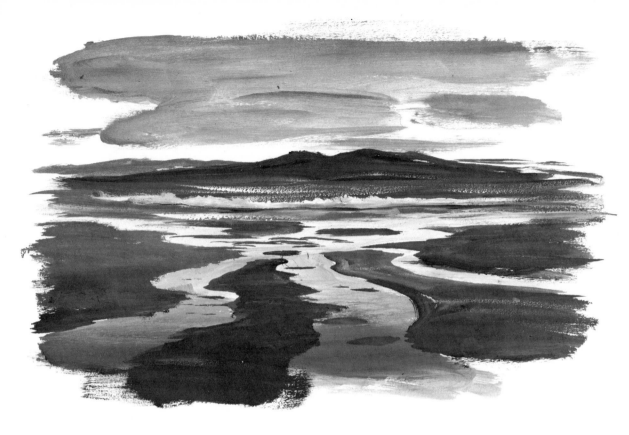

**Figure 67.** *Outlets from creeks and tidepools make excellent lead-ins to the center of interest. As with foam trails, connect them and keep them moving in one general direction.*

**Figure 68.** *You can make excellent use of tidepools to break up a flat foreground. Here, the smooth water reflects the rock and the sky.*

light rock is darker, and the reflection of the middle-toned rock remains about the same.

To paint reflections in shallow water, you should first paint in the object and the sand below it, then blend the two colors together in areas where the sand color is visible. Add any foam trails or ripples as your final touch.

In addition to rocks and debris, water also reflects the sky, or atmosphere. To paint a shallow tidepool that reflects only the sky, simply mix a touch of sand color with the color of the sky and apply it to the area. To paint the reflection of the sky in water that's too deep to display the color of the sand below, simply add the color of the sky to the color of the water.

If the sun is directly over the water, it too can be reflected by the surface. It isn't necessary to include the sun itself in your painting in order to show its reflection in the water. Simply paint the color of the sun into the water in a straight line that begins directly below the sun and extends to the viewer (Figure 75). Remember to add such reflections only on smooth horizontal surfaces that face the light.

## Objects on the Beach

Many interesting objects—including driftwood, wrecked ships, and even people—can be found on beaches. But the more of these you add, the more your painting will become a beachscape, with water as the secondary or background subject. Of course, such paintings aren't taboo; many artists have created beautiful paintings using the beach or the sky as the prominent feature. But beachscapes simply aren't the subject of this book!

**Figure 69.** *Reflections in water are mirror images of the objects above the surface. Seen from a point of view at or near the water level, reflections include exactly what you see when you look at the object itself.*

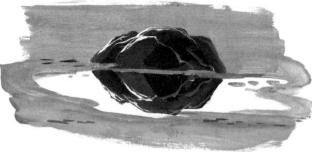

**Figure 70.** *From a point of view above the water level, you see a foreshortened reflection.*

**Figure 71.** *A true "mirror" reflection such as this is rarely found in seascape painting. Here, the undisturbed water in the tidepool reflects the rock accurately.*

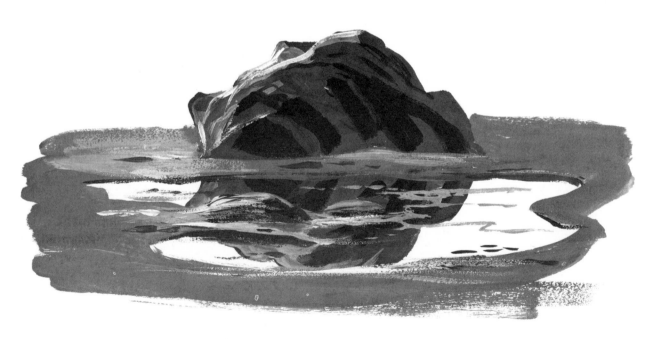

**Figure 72.** *This is more realistic reflection than that in Figure 71. Ripples and humps of sand in the water break up the reflection.*

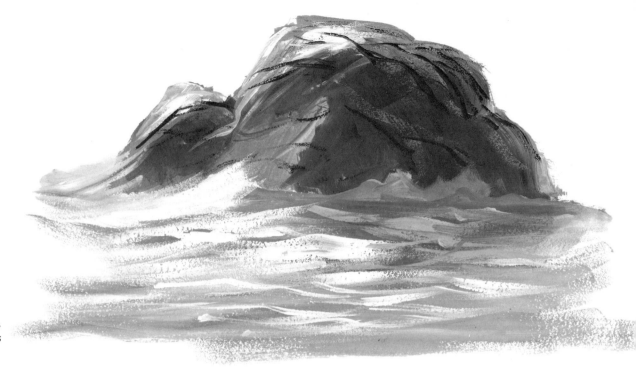

**Figure 73.** *When the surface of the water is agitated, there are no reflections to speak of, only cast shadows and reflected light.*

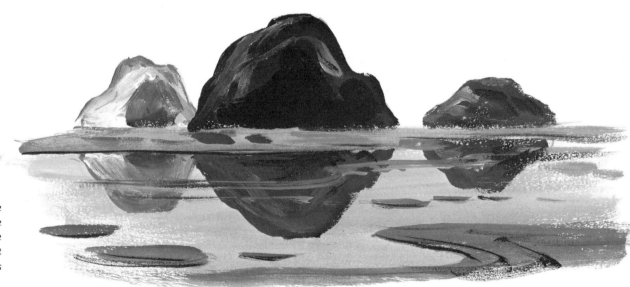

**Figure 74.** *In shallow water, the color and value of the sand below the surface influences the color and value of the reflection. Notice here that the relection of the dark rock is lighter than the rock itself, that of the light rock is darker, and that of the middle-toned rock remains the same.*

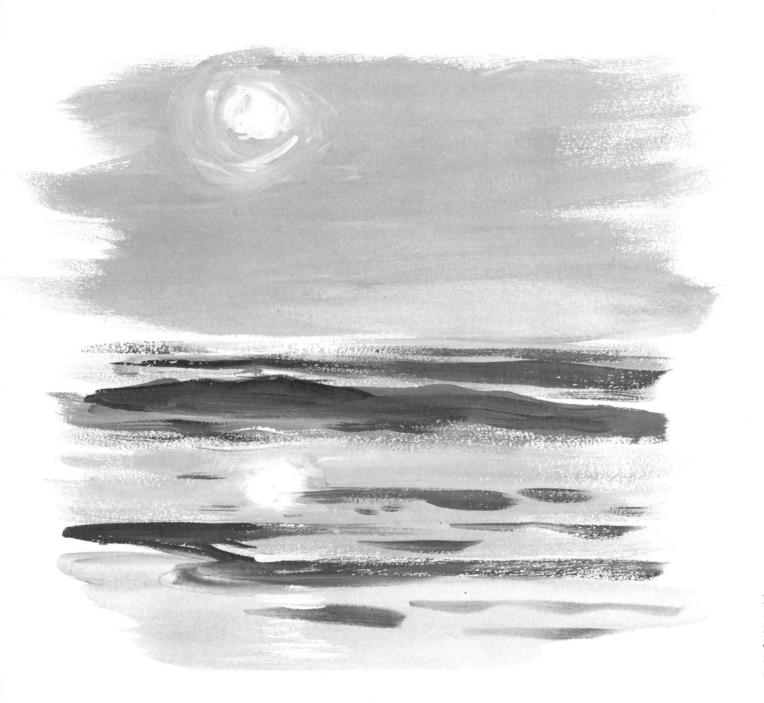

**Figure 75.** *When you paint the sun reflected in water, be sure that the reflection describes a straight line from the area of water directly below the sun to the viewer.*

## CHAPTER 6
# COLOR

The colors found in seascapes vary from one location to another, as well as according to what each artist has found to be his favorites. However, when students are confronted with the complexities of nature, they may be at a loss as to what colors to use without some knowledge of oil colors and how they behave.

This knowledge cannot be acquired only by reading this book. You must experiment and learn through trial and error. In spite of the vast array of tube colors found in display cases, you'll seldom find one that exactly matches any color you see in nature. Your palette of colors is only a starting point, a base upon which you may build by mixing new colors from it. Besides, if you could have a tube of paint to match every color you see in nature, you'd need a very large truck to haul them all around!

*Color Terminology*

Let's take a very quick look at basic color terminology—as illustrated by the color wheel in Figure 76—before we study how to select and use colors to paint the sea.

The *primary* colors are red, yellow, and blue; these cannot be duplicated by mixtures of any other colors.

The *secondary* colors, orange, green, and purple, are derived by mixing together two of the primaries: orange is a combination of red and yellow; green is a mixture of yellow and blue; purple is a combination of red and blue.

The *complementary* colors are those that appear opposite each other on the color wheel:

red and green are complementary, as are yellow and purple, and blue and orange. When mixed together, complementary colors produce a neutral tone.

The *adjacent* colors are simply those that occur next to each other on the color wheel.

You should also know that white *tints* a color, while black *shades* it.

You're probably also aware that certain colors appear warm and others seem cool. For example, red and orange are usually warm, while blue and green are usually cool. Yellow can be either warm or cool, depending on whether it contains a bit of red or blue. Notice also that each combination of complementary colors contains one warm and one cool color. Any color can therefore be made warmer or cooler by the addition of its complement.

*Choosing Colors*

Consider the simplicity of the musical scale and the complex arrangements that can be made from the notes. Like musical notes, colors can be raised, augmented, diminished, and combined in thousands of ways. After years of experimenting, I've become comfortable with the following five colors, plus white. From these, I can mix all the other colors I need.

Permalba white

Alizarin crimson

Viridian green

Ultramarine blue

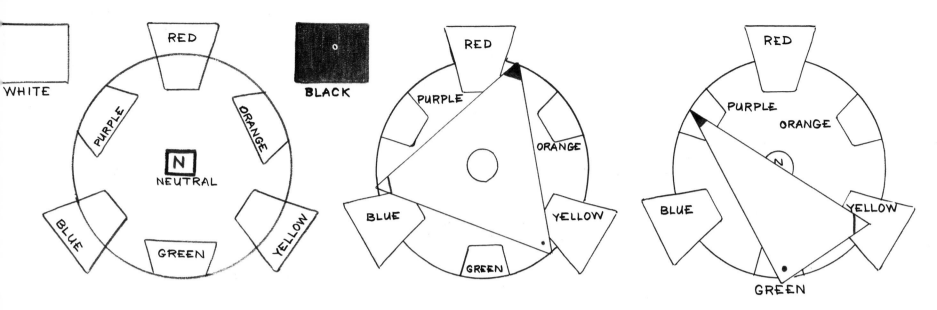

**Figure 76.** *This simple color wheel shows the primary and secondary colors, as well as the neutral color that results when two complementary colors are mixed together. The addition of black to any color shades the color, while the addition of white tints it.*

**Figure 77.** *The three primary colors and the three secondary colors each form an equal-sided triangle. When rotated on the color wheel, an equal-sided triangle cut from paper will indicate all the possible combinations of primaries, secondaries, and the mixture in between.*

**Figure 78.** *This triangle describes a line from the dominant color to its complement and indicates one adjacent color. The complementary and adjacent colors can be used as minor colors in your color scheme.*

Burnt sienna

Cadmium yellow (pale, medium, or deep)

The following colors may be substituted quite satisfactorily for the palette just described:

Titanium white

Cadmium red deep

Cadmium green

Manganese or cerulean blue

Brown madder

Any yellow

I don't mean that you shouldn't try other colors. However, I've found that either palette contains all the colors necessary in seascape painting.

## Color Moods

Some people have peculiar reasons for liking or disliking a particular color, but most people do have similar reactions to most colors. The warm colors tend to create a sensation of warmth or excitement, while the cool colors are more restful. Gray or neutral colors can be either warm or cool but are less intense and therefore have less impact than the primaries and secondaries.

The colors you use should be your own decision, but remember not to combine too many colors in one painting or you may create a disturbing hodge-podge of moods or emotions. The best way to prevent this effect is to use one color predominantly, with accents or highlights provided by one or two minor

colors. Even though you may combine and use a number of colors in one painting, try to create one overall color effect. Think of your painting as a display in the window of an expensive emporium as compared to one in a dime-store window—simplicity makes the difference!

## Color Scheme

The colors you choose for your color scheme need not be pure colors; they may also be mixtures of two colors, with one predominant.

The simple device illustrated in Figure 77 will help you decide upon a harmonious color scheme. To make it, cut an equal-sided triangle out of paper and darken the tip of one corner with either paint or ink. Then place the triangle over the color wheel on page 79, with the marked corner pointing to what will be your dominant color. For example, if you select a deep orange (red mixed with a touch of yellow) as your dominant color, place the marked corner at that point on the color wheel. The second corner will then point to yellow mixed with a touch of green, the third to blue mixed with a touch of red. These will be your two minor colors, of which you should use one more than the other. Placing a dot in the second corner and a line in the third may help you keep track of which color of the two minor colors you want to use more often.

Each time you turn the triangle so that it points to another dominant color, it will indicate a different color scheme. You'll always have either one warm color and two cool or two warm colors and one cool—a well-balanced color scheme in either case.

You can expand your selection of color schemes by cutting a new triangle that does not have equal sides. Cut this one so that one side describes a straight line from one color to its complement and the other two sides meet at a corner that touches a color adjacent to one of the first two (Figure 78).

Using this triangle, you can select a dominant color and then find its complement and another harmonizing color to use as minor colors. For example, if you choose purple as the dominant color, the triangle will then indicate yellow as the complement and either orange or green as the adjacent color, depending on which way you hold it. Then it's up to you to choose the adjacent color—orange or green—that best harmonizes with the purple and yellow. The choice is yours, of course, but remember to play down both the complementary and adjacent colors in relation to the dominant color.

I often make my sunlight color dominant; I wash sunlight over every other element and can therefore use my dominant color as the final color I apply to a painting. As I said, it's not necessary to select a pure color such as yellow for the sunlight, and the minor colors can also be mixtures of colors. For example, I may select a mixture of yellow and orange for the sunlight, then use a combination of blue and purple for the shadows and blue and green for the water. If my colors seem too raw or stark, I tone them down by mixing them with touches of their complements.

*Tillamook Shoreline. Oil on canvas, 24" x 36". Collection of Julian C. Motley, San Jose, California.*

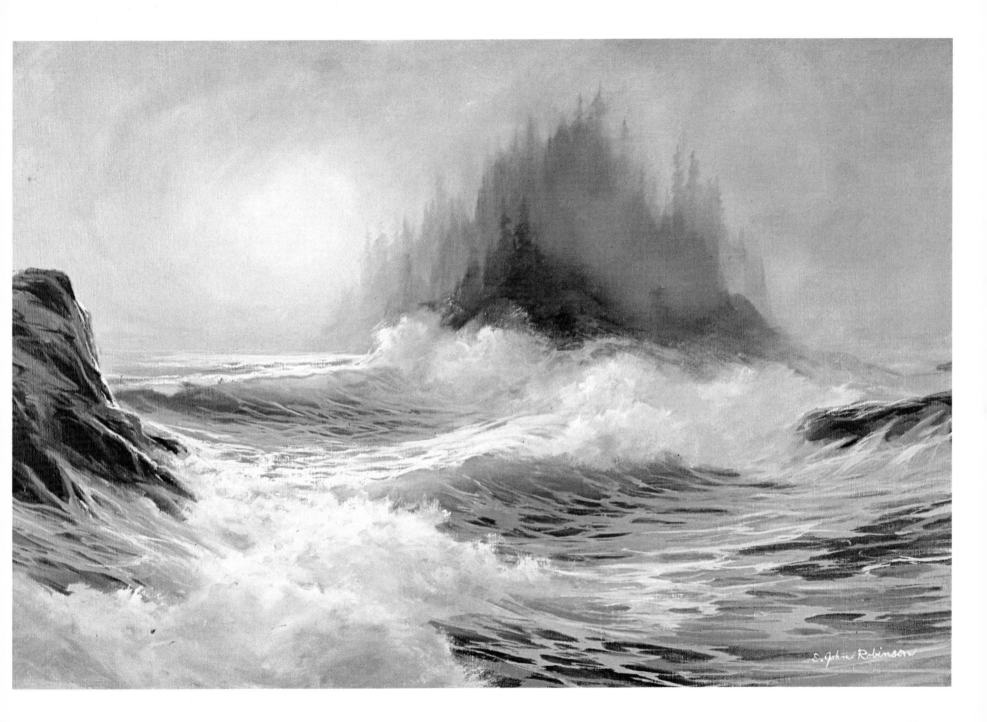

*Color Exercise: Breakers*

**Step 1.** *Use a thin wash of ultramarine blue to make a simple outline of a wave. Show the form of the breaker and indicate the area of foam.*

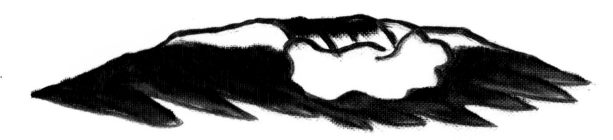

**Step 2.** *Scrub in the wave, using undiluted viridian green. Leave the areas of foam and transparency untouched.*

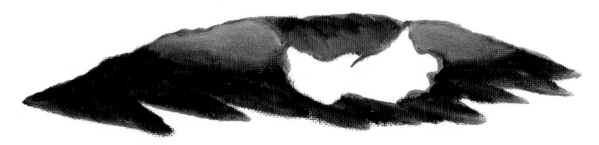

**Step 3.** *Blend undiluted cadmium yellow pale into the transparent area and add a small amount of it to the green areas, blending the two colors gradually where they meet. There should be no visible line of separation between the yellow and green.*

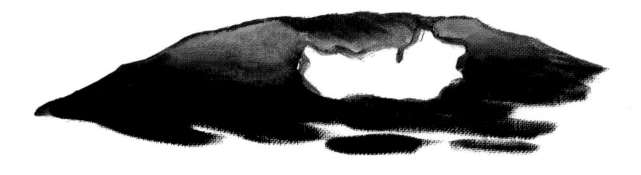

**Step 4.** *Create the feeling of depth at the base of the wave by adding ultramarine blue mixed with a touch of burnt sienna. Don't paint into the transparent area.*

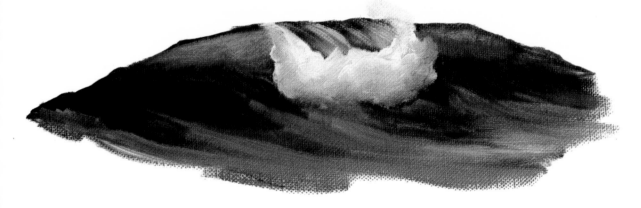

**Step 5.** *Add a bit of pale yellow to white and scrub the mixture into the top portion of the foam. Use the same mixture to add a few streaks of foam along the curl. Use a mixture of blue and white for the shadow area of the foam. You can also use the same blue mixture in front of the wave, where the smooth surface of the water reflects the blue atmosphere.*

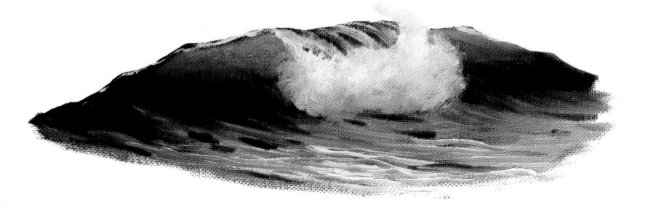

**Step 6.** *Finally, add touches of highlights and texture, using the yellow-white mixture for the highlights and the blue mixture you used in Step 4 for the dark areas.*

*Color Exercise:*
*Local Color, Atmosphere,*
*and Sunlight*

**Step 1: Local Color.** *Use a pale blue mixture for the sky, white for the foam, viridian green for the water, and a mixture of one part burnt sienna and one part ultramarine blue for the rock. Don't worry about the details at this stage—we'll apply them later.*

**Step 2: Atmosphere.** *For the atmosphere colors, mix a very pale blue from ultramarine blue and white. Scrub the mixture lightly over the entire underpainting, applying it most heavily in the areas facing the sky—the flat surface of the water and the top of the rock.*

**Step 3: Sunlight.** *Mix pale yellow and white for the sunlight and apply the mixture heavily over the areas where the sun shines directly. These occur mainly in the foam, but the sun also strikes areas of the rock and foam trails.*

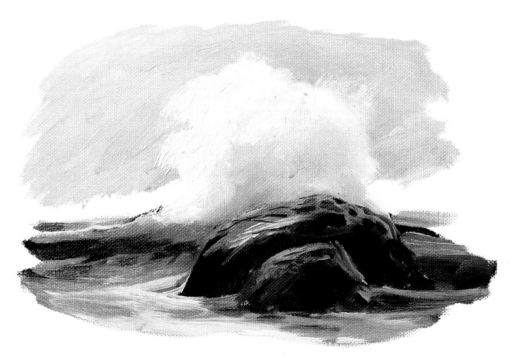

**Step 4: Shadow.** *For the shadows in the foam, mix a purple from alizarin crimson and ultramarine blue, and add plenty of white. For the shadows below the rock and in the water, use the same purple mixture but add less white to make it deeper.*

## Color Exercise:
## Variations in Sunlight

**Variation 1.** *Follow the same procedure here that you used in the preceding exercise. Begin as you did in Step 1, using the same combination of local colors. Now, try using lavender (alizarin crimson, ultramarine blue, and white) for the sky and atmosphere, cadmium yellow medium for the sunlight, and a deeper purple for the shadows.*

**Variation 2.** *Again, the local colors here are the same as those used in the preceding exercise. For the atmosphere in this exercise, however, try a deep gold mixed from cadmium yellow deep, burnt sienna, and a touch of ultramarine blue. For the sunlight, use a mixture of orange and white; for the shadows, undiluted ultramarine blue. Notice that the effect of the sunlight varies, depending upon its color, the color of the shadows it creates, and the atmospheric conditions.*

**Sun's Up.** *Oil on canvas, 24" x 36". Collection of Mr. and Mrs. Richard Szumski, San Jose, California. A shadowed foreground and warm light suggest morning on the California coast. This is mainly a horizontal composition, with a suggestion of diagonal movement in the foreground. The center of interest is the beaking wave, which is the apex of the flattened triangle formed by the wave and the two rocks.*

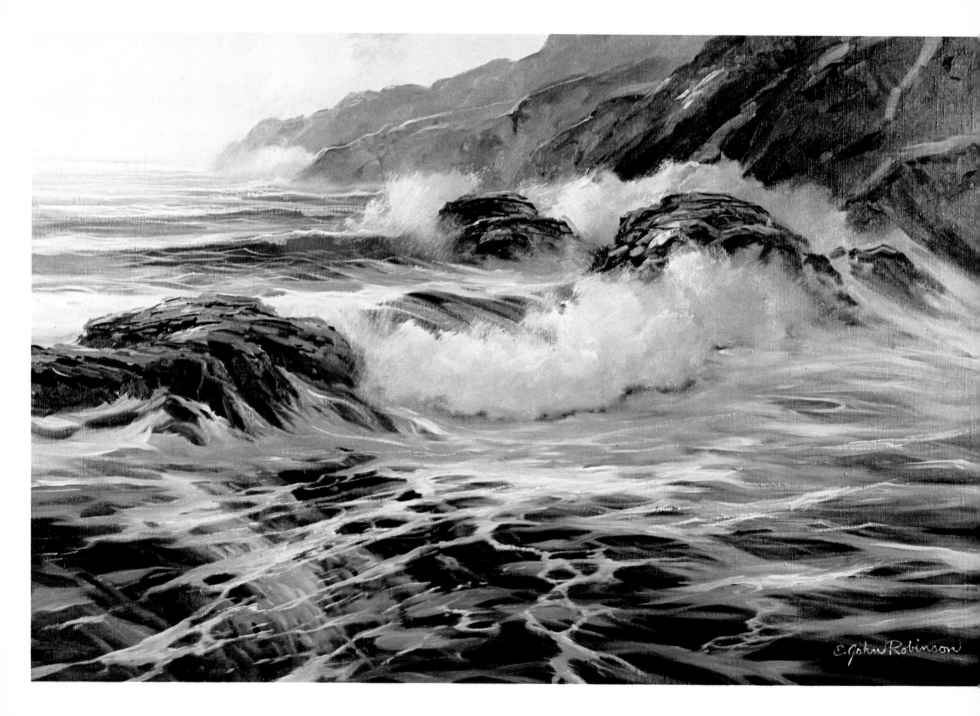

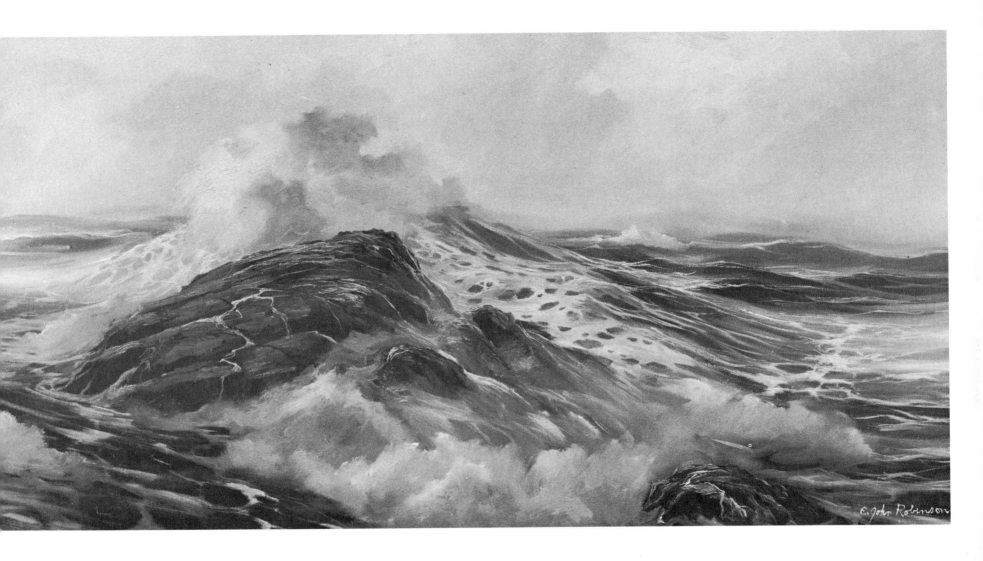

**The Shoals.** (Left) Oil on canvas, 24" x 36". The linear composition for this painting is a backward "S" that begins at the tip of the farthest headland at the left, continues through the foam hitting the bluff and the breaking wave in the center, and ends in the foam patterns in the foreground. Here, you can see movement below the surface of the water, as well as the fading effect the atmosphere has on the colors and values in the background.

**The Power.** (Above) Oil on canvas, 24" x 48". This composition is based upon a pyramid; the implied triangle occurs between the rocks and the foam burst, with the center of interest at the peak of the triangle. Notice that I purposely left the sky quiet as a relief from the action elsewhere in the painting.

# SUNLIGHT AND ATMOSPHERE

Now that you've learned a bit about colors and their characteristics, let's see how color is influenced by sunlight and atmosphere and take a look at some of the many color combinations that can be used to describe these effects.

## Local Color

To understand local color, think of water and all other objects as having their own intrinsic colors. For example, we can say that foam and clouds are basically white, that the color of rocks varies from one area to another but is basically gray or brown, and that water is basically clear. These are local colors, with little external influence upon them.

Local color, sometimes called "true" color, is most obvious on an overcast day, when the colors of the sunlight and shadow are not intense enough to obscure it (Figure 79). Even on an overcast day, however, local color may be influenced to some degree by sunlight and atmosphere (Figure 80). For example, although water is basically clear, its color is influenced by the sun and atmosphere—as well as by the sand, rocks, and plants on the ocean floor—and it's safe to say that shallow water is generally green and becomes bluer as it deepens. For the most part, the artist must decide just which color mixtures best describe the local color.

## Atmosphere

One important influence upon local color is the atmosphere, which includes the sky and all the moisture in the air. The colors of the atmosphere are reflected by water, rocks, and foam, and the amount of moisture in the air determines the intensity of the light, as well as how far we can see into the distance.

A common way to make objects appear to recede into the distance is to whiten or tint them to suggest the intervening atmosphere. However, this method is not entirely accurate, because it is based on a white atmosphere; the atmosphere actually varies from near white through every possible color, depending on local weather conditions and, most important, on the position and color of the sun.

## Sunlight

The sun brings about the most important and noticeable changes in local color, and its position determines where the areas of light and shadow will occur, as well as the colors of the sunlight itself.

When the sun is behind you as you look out to sea, it creates what is called front lighting (Figure 81). In this lighting situation, shadows occur behind objects and are usually not visible, and colors in the foreground are as light, or washed out, as those in the background.

When the sun is directly overhead, it creates what I call "down lighting." Shadows are evident but very short in this lighting situation, and colors in the foreground are more intense than those in the background (Figure 82).

When the sun is far out over the ocean and low in the sky, it creates a back lighting situation; shadows occur in front of objects, and the background is quite a bit lighter than the foreground (Figure 83). Transparent water is at its best when sunlight streams through it from behind.

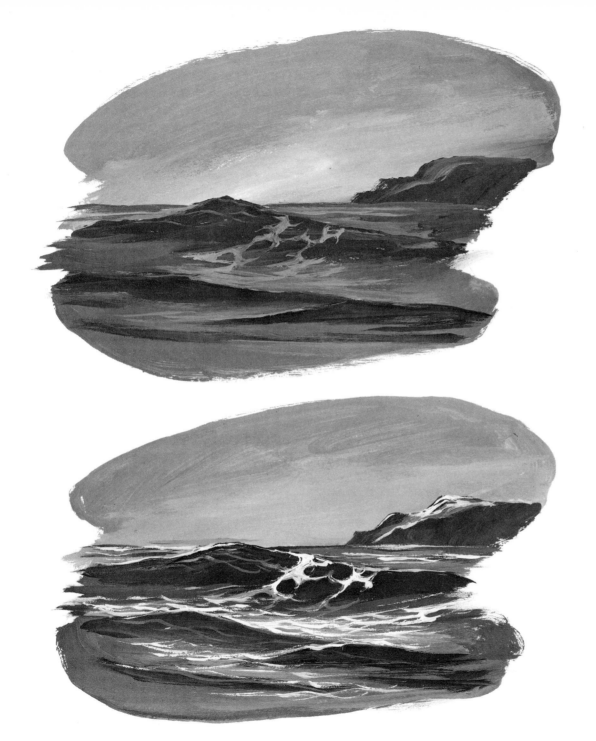

**Figure 79.** *While some light and dark areas are visible on an overcast day, the effects of sunlight and shadow upon local color are minimal. What you see is essentially the true color of objects influenced only by atmosphere.*

**Figure 80.** *This is the same subject as that shown in Figure 79. The local color here is influenced by sunlight and shadow, as well as by atmosphere.*

**Figure 81.** *Front lighting has a tendency to make colors in both foreground and background appear washed out. In front lighting, there is no distinct line between light and shadow; shadows occur behind objects and are therefore rarely visible.*

**Figure 82.** *Down lighting creates interesting patterns of light and dark areas but very few shadows. This is the type of lighting seen at high noon.*

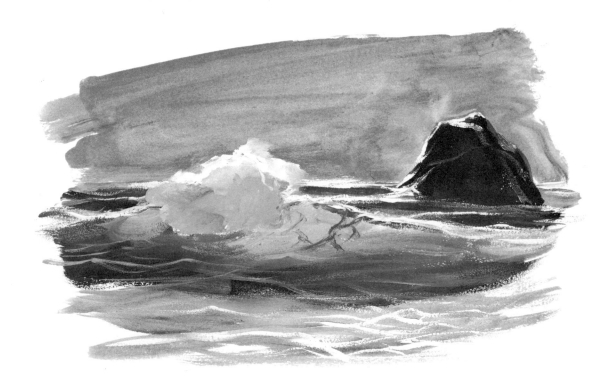

**Figure 83.** *Back lighting often produces a halo effect around objects and creates noticeable contrasts between light and shadow. In back lighting, transparent areas of waves are most obvious and most beautiful.*

**Figure 84.** *Side lighting is my favorite lighting situation. It produces strong contrasts between light and shadow, and the light and dark areas can be used to describe the form of objects.*

If you turn to look north or south when the sun is either in front of or behind you, you'll see what is meant by a side lighting situation (Figure 84). The objects you see will be partly in sunlight, partly in shadow, and the resulting differences in color and value can be quite useful in describing the form of the objects.

Although, as I mentioned earlier, intervening atmosphere influences the intensity of sunlight, the position of the sun itself is responsible for its color and the degree of warmth or coolness of the light. The warmest tones are visible in early morning or late evening, when the sun is low in the sky. On the West Coast, the light is warmest just as the sun sets over the ocean. As the sun moves higher in the sky, its light tends to become cooler and less intense.

The position of the sun influences the colors of the atmosphere as well as the local colors of the water. The atmosphere displays the greatest amount of sunlight color in the area right around the sun, and the sunlight becomes weaker and less noticeable in areas farther away from the sun.

## Painting Sunlight

By now, you're probably aware that everything you see has its own local color, which in turn is influenced by atmosphere and sunlight. One way to show the influence of sunlight upon local color is to first match the local color of the object as closely as possible to a color on the color wheel. As the sunlight is then added, all the colors on the color wheel that lie between the original or local color and yellow are applied in succession, until the areas facing the sun are painted pure yellow. The same procedure can also be used to add shadows, substituting the colors from the original color through blue.

For example, if you began with red as your local color, you'd gradually add yellow to make the object a lighter and lighter orange as you worked toward the area that received the most sunlight. You'd then paint the lightest lights pure yellow. For the shadows on the same object, you'd begin again with the original red and move toward blue on the color wheel, adding blue to make the shadows darker and darker purple. The darkest darks would be pure blue.

Although this method works well to indicate sunlight and shadow, I have several objections to using it. First, I dislike using mechanical aids such as the color wheel to describe anything in nature. Even more important, the assumption behind this method is that sunlight is always yellow—and it isn't. Also, this method doesn't account for the colors of the atmosphere, which also influence the local color of objects, especially those in the distance.

As you experiment, remember also that even though white paint can be used to lighten colors, it is not useful in adding the effects of atmosphere and sunlight. White itself is not a color and therefore contributes no color to your painting. Also, if you use white paint in the light areas and highlights, you might be tempted to use black paint for the shadows. Black can certainly be used to darken areas, but like white, it adds no color.

As in mixing local colors, the colors you use for atmosphere and sunlight depend primarily upon your own judgment. Rather than mechanically following any particular procedure or theory, I suggest that you observe the colors in nature carefully, experiment with color combinations, and try to use your colors to achieve a pleasing color harmony.

## Painting Local Color, Atmosphere, and Sunlight

Try the color exercise on page 84 for some practice in painting local color, atmosphere, and sunlight. Beginning with the local color (Step 1), paint the foam white, the sky pale blue, the water viridian green straight from the tube, and the rock a half-and-half mixture of ultramarine blue and burnt sienna. Fill in each element completely, but don't allow the local colors to blend together where they touch one another. It isn't necessary to thin the paint, but apply it just heavily enough to cover the canvas.

Assuming there's some distance between viewer and the scene, there will also be a certain amount of atmosphere between them. To suggest the intervening atmosphere (Step 2), paint a pale blue mixture over the local color, applying it lightly so that you don't cover the local colors completely. The white foam displays the strongest atmospheric influence because it's the lightest and therefore the most reflective color. The top of the rock faces the sky and also reflects a great deal of atmosphere. Use only a bit of the pale blue mixture to lighten the rest of the rock and the wave. Remember to clean your brush carefully and frequently, especially after you paint in the darker colors.

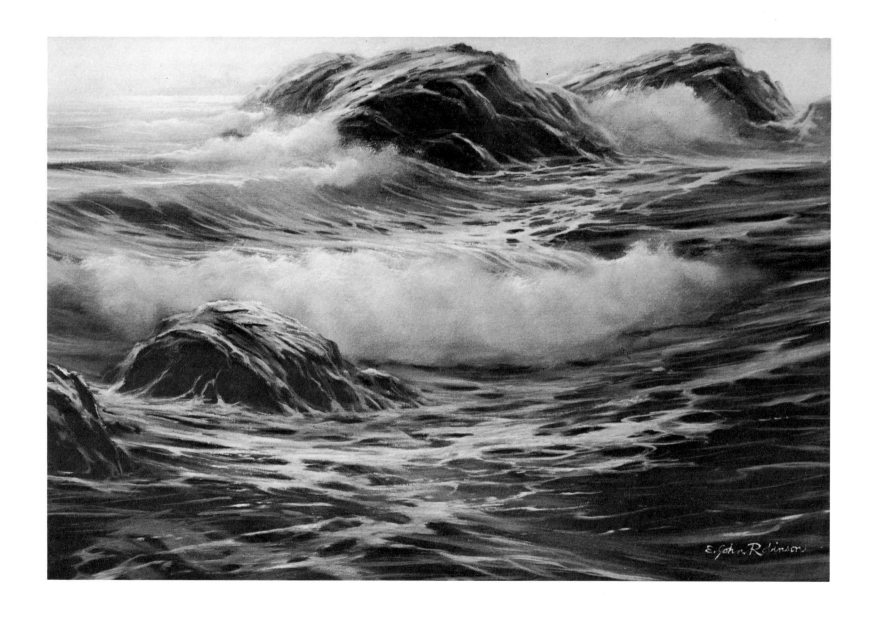

**The Shallows.** *Oil on canvas, 24" x 36". Notice that the rocks seem to sit in the water here. The water rushes up against them in some areas while it forms trickles in other areas. There is also a suggestion of rocks beneath the surface of the water in the foreground.*

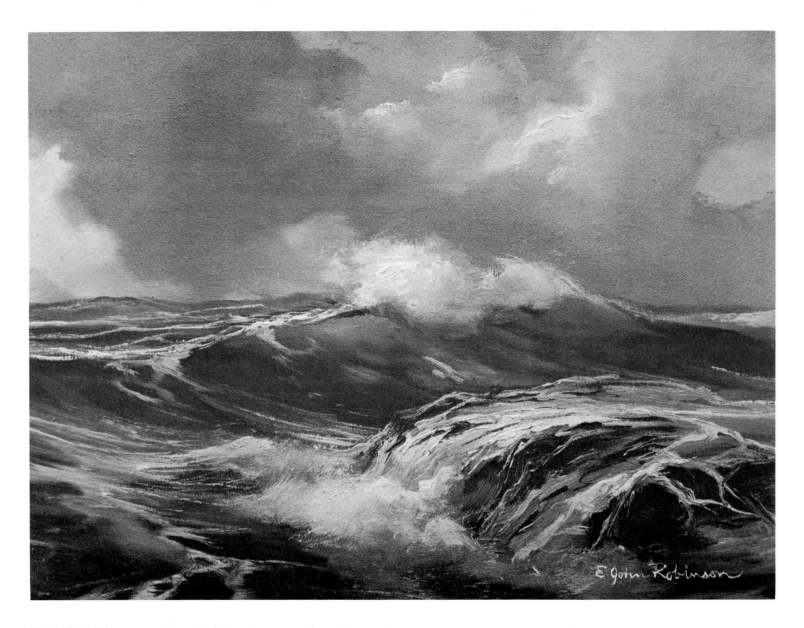

**Windy Day.** *Oil on canvas, 12" x 16". When the sea is made up of moving lines as it is here, it is best to carry the movement into the sky. The viewer's eye automatically follows the movement in a composition, and the overall feeling may be lost if the motion ends at the horizon line. Every element in a composition should be planned to suggest the overall theme.*

What you have on your canvas now should be quite close to the color effects you see on an overcast day. Now, let the sun shine! For the sunlight (Step 3), mix a small amount of cadmium yellow pale into a pile of white paint. Use just enough yellow to tint the white *slightly*. Clean your brush thoroughly, load it with the sunlight mixture, and apply it heavily to the edge of the foam facing the sun. You should also add secondary highlights in the lower area of the foam.

Next, dip a small clean brush into undiluted cadmium yellow pale, scrub it into the upper portion of the green wave, and blend it in thoroughly between the green area and the white of the foam. Apply a few highlights of the same yellow to the portion of the rock nearest the sun, blending it in thoroughly.

For the shadows (Step 4), mix equal parts of red and blue. Don't add white at this time, but dip your brush into the red-blue mixture and blend it into the side of the rock turned away from the sun. Again, don't apply the paint so heavily that the rock becomes purple; use it simply to darken the rock. Use the same mixture to darken the green base of the water, but don't allow it to touch the yellow highlights. Although I've treated the shadows as a separate step here, they are actually dependent upon the sunlight and could be applied in the same step. I'll discuss shadows and how to paint them in detail later in this chapter.

Finally, mix a brushful of the purple mixture into some white paint and apply a lighter shadow to the side of the foam opposite the sun. Be careful not to make this shadow too dark or allow it to reach into the highlight area.

Except for some details and textures, the painting is now complete.

## Variations in Sunlight

The rising and the setting of the sun create colors that vary from pale yellow through warm yellow, orange, red, and deep red. Atmosphere and sunlight influence each other, and the colors created can be subdued or brilliantly clear, depending upon the amount of atmosphere present and the position of the sun.

The two variations in sunlight color on page 86 illustrate the wide range of colors that can be used to paint sunlight. When you try each of the two variations, begin with the same local colors you used for the exercise on page 84—white for the foam, viridian green for the water, and ultramarine blue and burnt sienna brown for the rock.

In the first variation, the sunlight is a warm medium yellow, the shadows are purple, and the atmosphere is lavender. Although you painted a yellow sunlight and purple shadows in the preceeding exercise, the colors you used were very pale, much like those seen at high noon or on a hazy afternoon. This new combination suggests a warmer day, probably mid-morning or mid-afternoon. Because the sun is not at its zenith, its red rays are long and mingle with the blue sky to create the lavender effect in the moisture-laden atmosphere.

When the sun rises or sets, the rays tend to become even warmer in color. Try using orange for the sunlight in the second variation, and allow it to turn the atmosphere a deep yellow. The shadows should be a deep blue.

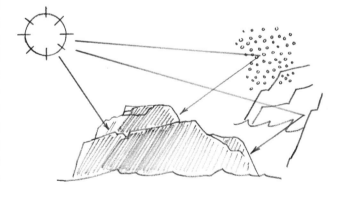

**Figure 85.** *This line diagram shows that light can either strike an object directly or first bounce off another object or the atmosphere and come back to lighten the side turned away from the sun.*

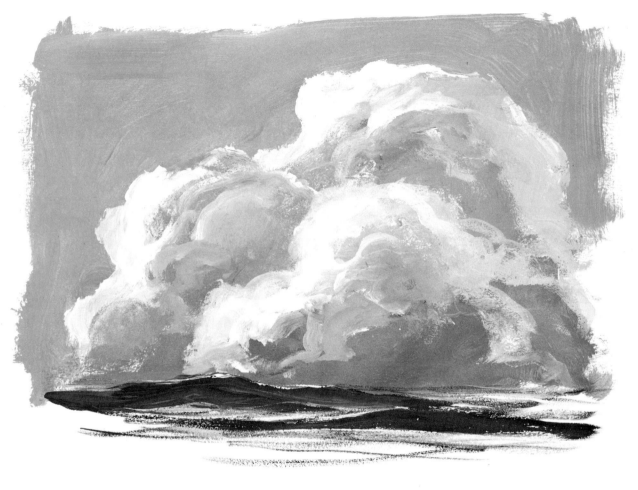

In both variations, notice that the foam still looks like white foam, and that the local colors are still visible even though they've been effected by the atmosphere and sunlight.

## Reflected Light

The side of an object facing directly away from the sun is often lighter than other sides of the object in shadow. The reason for this is that sunlight bounces off other objects, as well as off dust particles and drops of moisture in the air, and hits the far side of the object to make it appear lighter (Figure 85). Obviously, objects receive more reflected or bounced light on days when the atmosphere is filled with moisture than they do on clear days (Figure 86). However, the activity of the sea also sends a great deal of moisture into the air, especially in the areas around foam bursts. Even on clear days, the light not only strikes the burst itself but is also reflected back by the moisture or spray in the air around it (Figure 87).

Reflected light doesn't bring out the brilliance of colors like direct light, and its effects should be painted differently from those of direct light. One way to paint reflected light is to mix together the colors of the atmosphere and sunlight to create a more subdued combination; another way is to blend the atmosphere color into the local color of the object.

## Glitter

The sun creates a variety of interesting effects as it shines on and is reflected by the water. The first is glitter, which looks like broken areas of sparkle scattered over the ocean's sur-

**Figure 86.** *As sunlight bounces off the atmosphere, the back sides of the clouds become almost as light as the front, which is facing the sun.*

98

face (Figure 88). Glitter occurs primarily in the background sea, when the sun is either directly over it or is moving toward the horizon line. It may also be visible in the foreground water in a front lighting situation. In either case, glitter is created as ripples catch the light and reflect it toward the viewer like a million tiny mirrors.

Glitter is often the lightest light in a painting and should therefore be applied with discretion; a small amount will accentuate the darkest value, but too much may make the darker values seem washed out and weak.

## Glare

Like glitter, glare is created as sunlight is reflected from the water toward the viewer. However, glare occurs on smooth water and is usually visible in larger patches (Figure 89). It can be created in a front lighting situation as light hits and is reflected by the smooth face of a wave or in down lighting as light is reflected by a trough in front of a wave. It rarely occurs in back lighting, because the light is usually reflected back away from the viewer, although it may occasionally be visible in a back lighted slick on the beach. Glare occurs primarily in the foreground, but may be seen in the background when clouds block out all but a patch of light near the horizon.

## Glow

The third effect of sunlight, which occurs both on the sea and in the sky, is glow. Glow is created in the sky as the sunlight spreads through and is reflected by the moisture in the

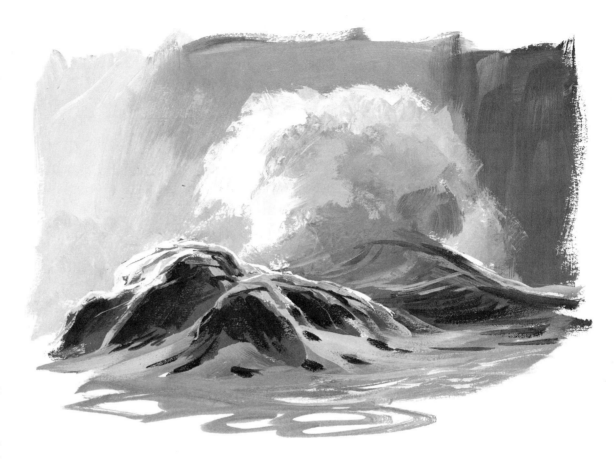

**Figure 87.** *This is an example of how strong light is sometimes bounced back by heavy moisture in the air above an active sea. Here, the bounced light makes the sides of the foam burst and rocks farthest away from the sun appear lighter than the other sides in shadow.*

**Figure 88.** *Glitter is the reflection of sunlight on the water, broken up into small patches by the irregular ocean surface. Glitter can occur at any time of day.*

**Figure 89.** *Glare occurs most often in the foreground as the sunlight reflects from the water directly into the viewer's eyes. Glare is most intense when the light strikes the surfaces of dark, smooth water facing the viewer.*

atmosphere; in the water, it is simply a reflection of sunlight radiating out from the sun (Figure 90).

To paint glow, mix your sunlight color into the color of the sky, applying it most heavily in the area nearest the sun and using smaller amounts as you move outward. Then simply repeat the procedure on the surface of the water, using the sunlight color mixed with a bit of the sky color and making the glow less intense as you move outward. The area of glow on the sea may also contain darker swells and lighter glitter, which can be painted over the glow.

If the sun is to one side of the picture, use the same procedure again, adding the most intense glow to both sea and sky in the areas nearest the sun and gradually blending it into the other colors as you move away from the sun.

## Spotlighting

Spotlighting occurs when most of the sky is overcast or full of clouds and the light breaks through in only one small area (Figure 91). Artists have been using spotlighting for centuries, because it enables them to do just that—spotlight one area of a painting while rendering the rest of the painting in shadow or at least in weaker colors.

If not handled properly, spotlighting may become too obvious and may also result in a rather poor painting. For example, if you spotlight only one small area of a painting and do not allow the viewer to look any further into the composition, you're wasting your time and his on the rest of the painting. One way

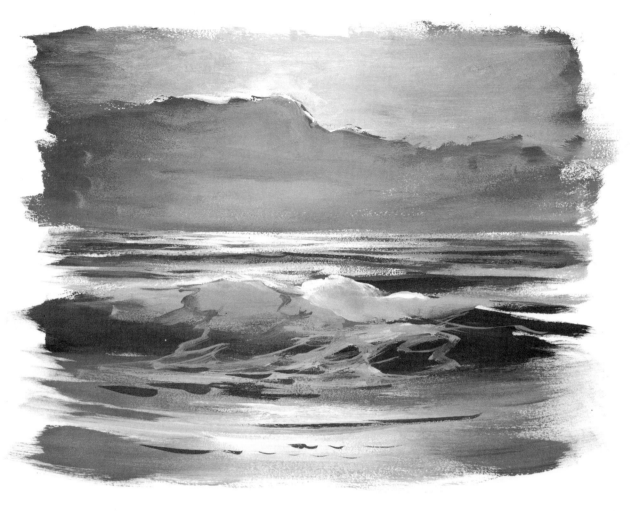

**Figure 90.** *Glow is created in the sky as sunlight diffuses, or spreads, through the moisture in the atmosphere; in the water, it is a reflection of sunlight. Glow is most intense in the area around the sun and gradually weakens in the areas farther away from the sun.*

**Figure 91.** *Spotlighting occurs when the sun shines through an opening in the clouds or heavy atmosphere onto one isolated area. It can be used quite effectively to accentuate the center of interest.*

**Figure 92.** *Spotlighting may become too obvious a device or may be so stark that the rest of the picture becomes lost. To avoid this situation, use a secondary echo of light elsewhere in the painting.*

to avoid this situation is to use an "echo" or secondary spotlight elsewhere in the painting (Figure 92). Of course, such echos should not be as intense or interesting as the main area of spotlighting or they may detract from the center of interest.

## Light and Perspective

Sometimes objects such as rocks, breaker foam, and some clouds extend quite far into the background. To show the object in perspective, you'd naturally make it smaller as it recedes. However, light, shadow, atmosphere, and bounced light are also extremely useful in describing objects in the correct perspective.

Take a look at Figure 93 for an example of how light behaves in perspective. In this case, there is side lighting on a rock that recedes into the distance. Notice that the lightest light and darkest dark meet at the point of the rock nearest the viewer. As the rock extends back, the atmosphere equalizes the contrast, causing the light side to appear gradually darker and the dark side to appear lighter at the same time. Bounced light contributes even more light to the dark side of the rock. The top of the rock reflects both sunlight and atmosphere. However, it receives no direct light and the colors are therefore more subdued on the top of the rock than they are on the side facing the light; they seem to fade even more as they recede into the distance.

## Shadows

The presence of sunlight automatically means the presence of shadows. Shadows naturally

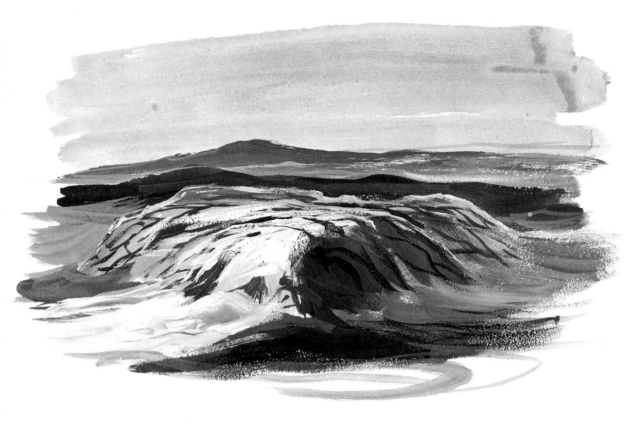

**Figure 93.** *In perspective, the lightest portion of the light side and the darkest portion of the shadow side of this rock meet at the point nearest the viewer. As the rock recedes, the light side becomes slightly darker while the shadow side becomes slightly lighter.*

occur on surfaces that face away from the sun; unless they contain reflected light, the surfaces that face directly away from the sun have the darkest shadows. The contrasts between areas of light and shadow are greatest on clear days, when the atmosphere has little effect on the colors of each.

## Painting Shadows

Again, you should decide for yourself what combinations of colors to use for shadows. You may have noticed in the color exercises on pages 84–85 that the shadow colors I suggested were complements of the sunlight colors you used. I doubt that shadow colors are actually the complements of sunlight colors, but the French impressionists had a delightful time with this theory (which has been all but forgotten since their time). Their primary subject matter was light and all its effects—houses, trees, and haystacks were little more to them than objects upon which the light could fall.

In any case, you should bear in mind that although this theory of complementary color is not a hard and fast rule, it certainly is useful. For one thing, any color appears more brilliant when placed next to its complement. If a complementary color is used for the light areas, it can be automatically accentuated by a complementary shadow.

This theory may also be the basis of teachers' suggestions that cool shadows be used with warm light and warm shadows with cool light. As you can see, each combination of complementary colors contains one warm and one cool color. However, a heavy atmosphere may contribute so much reflected light and color

to the shadows that this approach would not describe the shadows accurately.

I suggest that you try using combinations of complementary colors and then experiment with other shadow colors. If your combinations go beyond the realm of what is actually possible in nature, you'll notice it right away—and at least you won't be using black or brown to darken objects, or pure white to lighten them!

## Cast Shadows

Cast shadows occur on a surface when an object located between the light source and the surface itself blocks the light and keeps it from striking the surface (Figure 94). Cast shadows sometimes have characteristics much like those found in the natural shadows on the sides of an object turned away from the light. However, because cast shadows occur on surfaces that would otherwise be filled with light, they receive a great deal of color and reflected light from the atmosphere and other objects and may therefore display entirely different colors and effects.

## Painting Cast Shadows

To describe a natural shadow on a rock, you'd probably paint the shadow color over the local color and then add small touches of bounced light and the colors of the atmosphere. The color of cast shadows, however, should simply be a darker version of the local color of the surface upon which they are cast. For example, if you were painting the rock, the water, and the cast shadow in Figure 95, you'd first paint

**Figure 94.** *A cast shadow must be aligned with the object casting it and the sun behind it.*

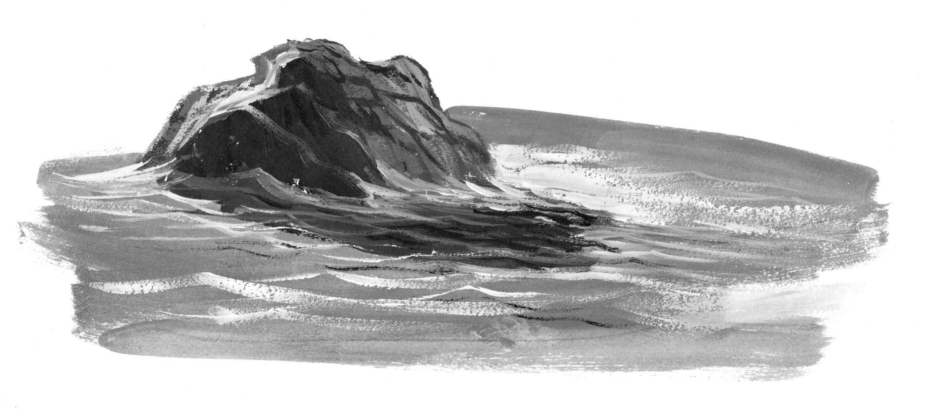

**Figure 95.** *The shadow cast by a rock on water is a darker version of the color of the water, not of the rock. The degree of darkness in the shadow depends upon the strength and closeness of the light source—the stronger the light, the darker the shadow.*

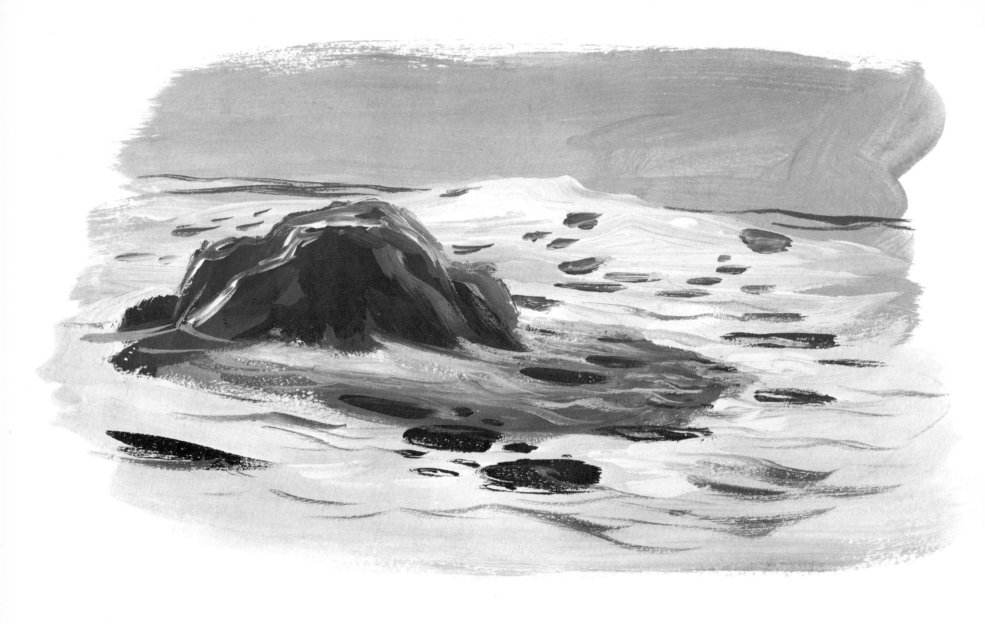

**Figure 96.** *The shadow cast by the rock upon the foam is lightest in the area nearest the rock, where it receives reflected light from the rock.*

the local colors. Then, because the surface of the water faces upward, you'd add atmosphere colors to lighten it. Finally, you'd add the cast shadow color—a darker mixture of the colors you used for the water—and blend it into the area shielded from the sun.

To paint a shadow cast on a light surface such as white foam, you should first add the influence of the atmosphere to the local color, then use the complement of your sunlight color to darken the shadow area. Since the local color of the foam is white, it's not possible to use a darker version for the cast shadow; instead the cast shadow must be treated like a natural shadow. Also, because the foam is so light, the color and value of the cast shadow will be even more noticeable than they would be on a dark surface. As you can see in Figure 96, the cast shadow on the foam is noticeably lighter in the area nearest the rock, where it receives reflected light from the rock.

Although it may seem unnatural to paint shadow colors *over* atmosphere colors, this procedure insures that the darkened area will not be so dark that the textures and reflected lights within it cannot be distinguished.

## Color Interchange

In addition to reflected light and atmosphere colors, cast shadows on light surfaces may also display what can be called a "color interchange." This means that the surface in shadow receives a small amount of color from the object that is casting the shadow upon it. The object itself also receives some color from the surface upon which it casts the shadow. For example, a rock may receive some color from the foam upon which it casts a shadow, and the foam may likewise receive a small amount of color from the rock. This color interchange usually occurs in the area where the two objects meet (in this case, where the rock emerges from the foam) and is usually so slight that you can simply ignore it unless you plan to make that area your center of interest. In that case, just whip your brush back and forth where the two surfaces meet until their colors are blended together.

## Shadow Edges

The leading edge of a shadow cast upon a light surface is the darkest part of the shadow and may also be more pure in color than other parts of the shadow. Some artists "punch up" the brilliance of their sunlight colors by using pure or almost pure complementary colors in areas where the leading edge of a cast shadow meets an area of sunlight (Figure 97). For example, if you used orange for sunlight and blue for the cast shadow, both colors would be influenced in many areas by atmosphere and reflected light, and neither one would really be a pure color. However, you could make the colors of both the light and shadow appear more brilliant by painting the leading edge of the shadow pure blue (or at least more pure than the rest of it) and the adjacent area of sunlight pure or almost pure orange.

Obviously, these pure colors should be applied gradually and carefully so that the result won't look like a blue stripe next to an orange stripe. In fact, neither should be applied as a line of color, and both should be blended gradually with the colors around them.

**Figure 97.** *Notice here that the light area is lightest near the shadow edge and that the shadow is darkest in the same area. While this is a slight exaggeration, you can use pure complementary colors in this area to make both the sunlight and shadow colors appear more brilliant.*

## CHAPTER 8

# COMPOSITION

Composition means different things to different people and, fortunately, it encompasses a variety of approaches that can be used to make a particular painting express the feeling or idea the artist wants to convey. There is more to composition than just the pleasing arrangement of colors, values, and shapes, and it is not simply a matter of forcing a statement upon the viewer. Like subject, color, and technique, composition is the artist's vehicle of self-expression, of communication, and an understanding of some of the basic approaches and principles of composition is essential in creating effective and interesting paintings.

## Center of Interest

The center of interest of a painting is the area to which the viewer's eye is primarily attracted. In order to attract attention, the center of interest must include either a strong contrast of values or colors, more texture and detail than the rest of the painting, or some unusual element that will automatically catch the eye. Of course, a combination of these elements can also be used effectively. The main consideration in creating a center of interest is to feature one area without making the other areas of the canvas so interesting that they become distracting. However, to isolate the center of interest entirely would make it too strong, and it should be balanced by an echo or secondary area of interest elsewhere.

Wherever you place your center of interest, remember that it should include only a small area of the painting, or it won't attract the viewer's attention. In fact, the center of interest will merely blend with and become lost in the foreground or background if it covers more than a third of the canvas. Remember also that you shouldn't place the center of interest too close to the edge of the canvas, or it will lead the viewer's eye out of the picture before he has a chance to appreciate the entire painting. If you must place your center of interest close to the edge, be sure to make the supporting areas interesting enough to keep the viewer's eye moving within the picture.

## Lead-ins

Using objects or lines in the composition to create a path, or lead-in, to the center of interest is a popular way to draw the viewer's attention to a particular area (Figure 98). There may be more than one lead-in in the composition and each may enter from any part of the canvas. If you use lead-ins, remember not to create an interesting path that leads to nothing. The viewer must be rewarded at the end of the trail.

Lead-ins are essentially lines. They may be implied, like those that run along the edge of a rock to a shadow and finally to the focal point, those that follow a headland or bluff, or the lines created by sweeping clouds. They may also be actual lines in the form of linear foam patterns that curve and sweep into the center of interest (Figure 99). There are numerous ways to create lead-ins, but remember that none of them should be too obvious. Let them become lost and found as they weave in and out along the contours of objects; use one major path supported by minor paths.

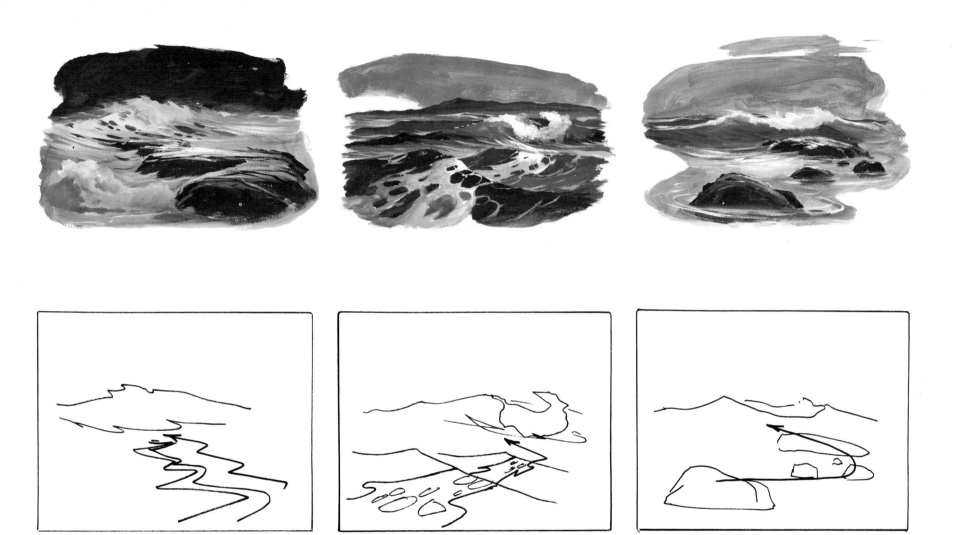

**Figure 98.** *Beginning in the foreground, the rocks lead the eye to the wave, which is the center of interest. In the line diagram, you can see that although the lead-in is jagged it follows the basic contours of the rocks.*

**Figure 99.** *Foam patterns make effective lead-ins to the center of interest. Here, they lead the eye over the contours of swells from the left foreground to the center of interest. The direction is indicated by the arrow in the line diagram.*

**Figure 100.** *A series of small rocks can be used like stepping stones to create a path to the center of interest. In the line diagram, notice that the rocks describe a slow curve, which makes a sizable sweep before it reaches the center of interest.*

Another form of implied lead-in is a "stepping stone" path (Figure 100). Rather than being one continuous line, it jumps from object to object and finally ends at the focal point. The most obvious example of this is a series of rocks leading to the center of interest; others include a series of shadows or dark swells, a series of highlights on the swells, or reflections in the trough ahead of a wave.

As I said before, don't make your lead-ins too obvious, but feature one major path and add a few minor ones. Allow the path to lead to the center of interest at the speed best suited to the mood. In other words, make a jagged, fast-moving path in an active sea (Figure 101), a slow, lazy path in a gentle sea (Figure 102).

## Perspective

It's somewhat more difficult to define perspective in seascape painting than it is in landscape painting. Of course, perspective involves decreasing the size of receding objects, weakening values and colors in distance, and placing objects one behind another. But there's also the matter of point of view. When you look straight out to sea with your eye level at the horizon line, you need pay little more attention to perspective than to follow the guidelines I just mentioned. However, when your point of view is below the horizon line and you're looking up at the water, you'll have to deal with perspective in the objects above your eye level (Figure 103). As well as decreasing in size and color intensity as they recede, objects also appear smaller and less distinct when located above eye level.

When he sees the scene from this point of view, the viewer is forced to disregard the background sea as well as the horizon line and to concentrate on the foreground. The leading edges of swells and rocks stand out sharply, and the tops of objects are not visible. Viewed from such an angle, the sea can be an awesome spectacle; it can look as if it's about to inundate you at any moment.

When you stand at a point above the sea and look down at it, your eye level is well above the horizon line, which may not even be included in the composition (Figure 104). In this case, the tops of rocks and other objects are visible, while the sides are not. Rather than seeing the leading edge of a swells, you see the trough ahead of it.

When you look up or down the coast from any point of view, objects seem to decrease in size much as they do when you look out to sea, and you must again pay attention to perspective (Figure 105). Keep in mind also that such a view may include the meeting point of sea and sky, which can be used effectively as the center of interest.

## Outlining

The most common way to approach composition is to outline each object to indicate its position in relation to the other objects in the picture (Figure 106). My objection to outlining is that there are no such clearly stated lines to be found in nature. Also, outlining doesn't capture the real feeling or movement of a painting. Such a superficial arrangement of objects isn't enough; the composition should also imply a rhythm upon which the painting can be built.

## Linear Symbols

As I said earlier, lines can be implied by the juxtaposition of different values and colors, as well as by the placement of objects in the picture. These lines may be straight or curved, calm or jagged, vertical, horizontal, or diagonal, and their positions and relationships to other lines in the composition can be used as symbols to convey a wide variety of moods and meanings.

For example, if a rough sea is battering the land, you can best describe the feeling by using hard, jagged lines for the sea and softer, curved lines for the rocks or beach (Figure 107). You can make the sea look even more powerful by making it darker and letting it occupy a larger area than the rocks. On the other hand, you can imply strong resistance on the part of the rocks by giving them hard-edged lines as you soften the lines in the attacking sea (Figure 108). To give the rocks a bit of pride as well, you can allow them to rise up from the sea to occupy a higher position.

Lines, or linear symbols, can also be used to create the feeling of depth in a painting (Figure 109). As they recede, you can make a series of lines gradually smaller, less jagged, thinner, and higher in value. You can also make their angles less sharp than those in the foreground or make the lines converge or overlap one another.

## Horizontal Lines

The horizontal line is the most commonly used symbol in seascape painting, although many artists may not even be aware that they're

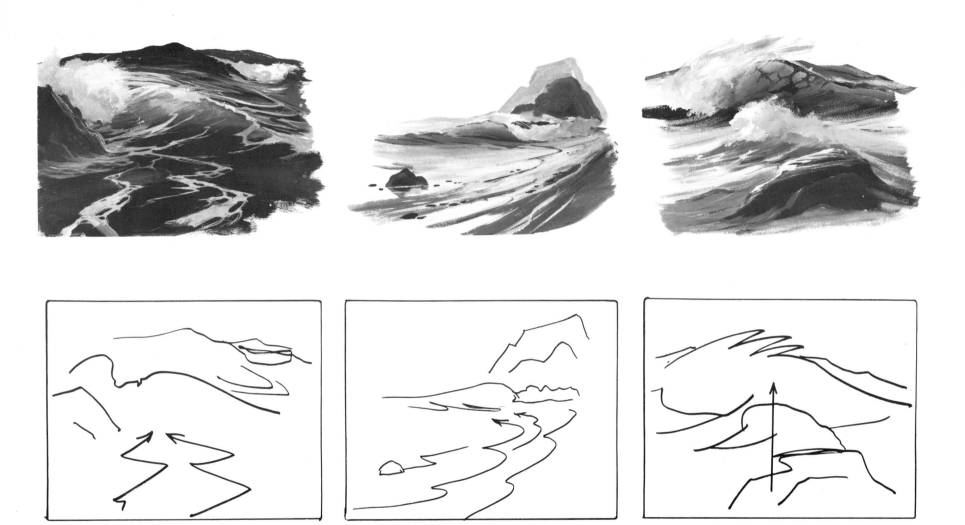

**Figure 101.** *The foam patterns here lead swiftly and sharply to the center of interest, setting the mood for a fast-moving composition. The secondary leads behind the major wave are less abrupt but are also moving toward the major spot of interest. In the line diagram, notice that the jagged lead-ins move quickly into the composition.*

**Figure 102.** *A slow, lazy path to the center of interest is in keeping with this composition. The sea is moving slowly and is made up of gentle waves that create an uncluttered feeling. The line diagram illustrates that the lines of foam on the beach are natural lead-ins; they're long, lazy, and slow-moving.*

**Figure 103.** *Here, the point of view is below the horizon line. The face of the wave and the front side of the rock are prominent, while very little background is visible. Notice that the center of interest, the wave, is located above the horizon line. The arrow in the diagram indicates the line of vision.*

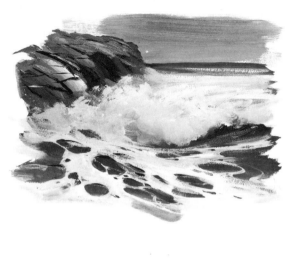

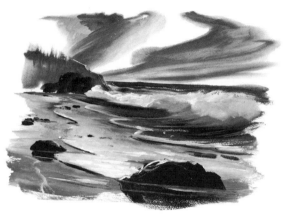

using a symbol. In fact, although I'll discuss them here, I think horizontal lines have been overused and should be shelved for a while.

Horizontal lines blend nicely with horizon lines, beaches, and long, gentle waves (Figure 110). A straight horizontal line is calm and rather unmoving. If it's slightly curved, it gains some feeling of movement, although this movement is slow and lazy. Sharpening the corners of the curves will add some speed to the movement, but not enough to indicate real activity. Oddly enough, you can make a calm horizontal line—and any other straight line—convey a feeling of extreme nervousness by changing it into a series of jagged points (Figure 111).

*Vertical Lines*

Vertical lines indicate strength (Figure 112). A straight vertical line appears static or unmoving. Curving it slightly will make it show some movement but will also decrease its strength. Making it jagged will increase both its movement and its strength. It's difficult to use vertical lines in seascape paintings, which are usually based on horizontal lines, but they can be very effective when handled correctly. A series of curved and jagged verticals can be used to create a powerful composition.

*Diagonal Lines*

The line that best implies movement is the diagonal. Although one straight diagonal line has little to say, a series of diagonals creates the effect of unrest, if not of violent activity (Figure 113). They also suggest harshness and

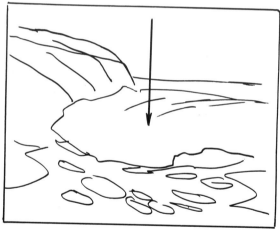

**Figure 104.** *While this is not exactly a bird's eye view, you can see a great deal of the tops of objects and little of the sides. In the line diagram, the arrow indicates the line of vision—from a point of view slightly above the composition. Notice that the holes in the mass foam patterns are more rounded rather than eliptical when viewed from this angle.*

**Figure 105.** *When you look up or down the coast, objects seem to diminish in size much as they do when they recede into the background. In the line diagram, notice that the lines of sea, beach, and sky all converge at a point at eye level. This is a natural place to put the center of interest.*

even anger. However, like all symbols, they should be used sparingly; too many diagonals may become repetitious and uninteresting.

Placing one diagonal line against another suggests opposition, or opposing forces. This effect is quite useful in depicting storms or battles between land and sea. It's most effective when some of the diagonals are hard and others are soft; even if you use only one or two, nervous lines certainly contribute to the feeling of a storm painting. Figure 114 illustrates the basic composition used in such a painting—*Storm Fury*—which is reproduced in color on page 153.

## Curved Lines

Curved lines, particularly horizontal ones, also have symbolic meanings. Lines that curve upward—like those in the rising sun—convey the feeling of birth, newness, or buoyancy, and are most effective when used in a series (Figure 115). You may find downward curves (Figure 116) less desirable when you understand the meaning they've traditionally been used to convey. For centuries, artists have based compositions involving death on the downward curve. In paintings of Christ on the cross, for example, downward curves have been used in the clouds, in Christ's arms, and in the kneeling and standing figures in the foreground. Downward curves droop; they're weak and sad. (Perhaps they could be used in a seascape to suggest the depressing effects of pollution!)

It's difficult to use curved lines, whether horizontal, vertical, or diagonal, in seascape paintings. If they appear in only one area—

**Figure 106.** *There are no real lines in nature; the outline you see here would simply be implied in nature by the meeting of different values and colors.*

113

**Figure 107.** *The strong, harsh lines of the sea seem to overwhelm the soft, rounded lines of the rock. In the line diagram, you can see the jagged lines in the sea and the curved lines in the huddle of small rocks at the lower left. This composition symbolizes the sea overcoming earth.*

**Figure 108.** *Here the rocks seem to be resisting the sea; even the small rock in the foreground seems stolid and unmoving. The line diagram shows the jagged lines in the rock opposing the weaker, smooth lines in the sea to symbolize earth resisting the sea.*

**Figure 109.** *Lines can be used to indicate depth in the sky as well as in the sea. Simply lighten and shorten them as they recede. The line diagram shows how to shorten lines to create the illusion of depth.*

in clouds, for example—they may look out of place in the composition. When used in the sea, curved lines may destroy the feeling of space that horizontal lines create. However, curved lines can be used quite effectively when they're distributed throughout the composition—for example, when rocks are the main feature of the painting and clouds are also present in the sky.

## Circles

Placing curved lines together to form a complete circle or oval is a very popular approach to composition. The circle contains the scene within the confines of the canvas and unifies all the elements at the same time.

The main problem with using circles is that they may be too confining. A circular composition may enclose the center of the canvas and separate the main scene from the edges of the painting, thus forcing rather than enticing the viewer to seek the center of interest. It's a good idea to break the circle at some point, to suggest that the space continues beyond the canvas (Figure 117). However, the break should not be so noticeable that the eye is drawn to it and by-passes the center of interest. Whenever the viewer's eye is allowed to leave the center of interest, interesting elements should be used to lead it back into the composition. Also, when a circular composition separates the corners of the canvas from the main scene, it should not cut off equal areas at each corner. Some corners should include only the very edge of the canvas, while others contain a larger area.

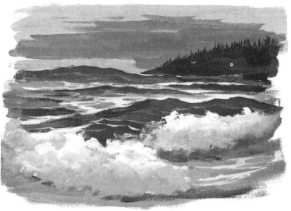

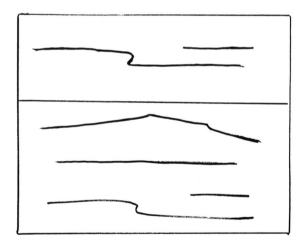

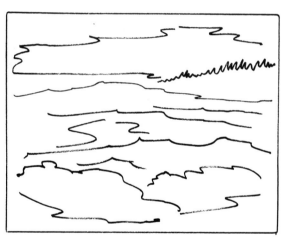

**Figure 110.** *This is truly a horizontal composition, from the clouds down through the horizon line, the wave, and the beach. Even the rock, which is rounded, is wider than it is high. In the line diagram, I simplified the composition to a few lines. Although these deviate slightly, they're still primarily horizontal.*

**Figure 111.** *Horizontal lines can be made to look quite nervous. As the line diagram illustrates, all the lines here are horizontal; however, they're jagged, choppy, and broken, rather than straight, smooth, and quiet.*

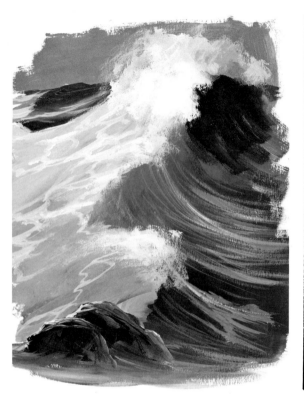

### The Arabesque

The ancient arabesque is a variation of the circle (Figure 118). It has been used for centuries as a symbol of both unity and opposition, and has also had religious and political overtones. It's difficult but not impossible to use the arabesque in a seascape. You should take the same precautions with the arabesque as you would with the circle, being careful not to allow it to become too confining and leaving it open in one area. Experiment with the various ways to turn the arabesque. (If the curves are lined up just so, it may look like the symbol of a well-known chain of food stores!)

### Combining Linear Symbols

I've described a few of the lines that can be used as symbols as well as to create effective compositions. There are many more lines and many more ways to use them, and almost any of them may be used in combination with others to suggest a combination of moods. Just remember to feature one particular line and use the others to support it. It's also important not to use the wrong lines in a particular composition. For example, a calm seascape may be destroyed by a headland covered with the nervous, jagged lines of a forest; a slowly moving sea may lose its effect if filled with sharp diagonal waves.

### Values in Composition

Values can be used to imply lines, but they have other important uses as well. Besides

*Figure 112. The lines in this vertical composition are implied by the juxtaposition of different values. In the line diagram, you can see that one continuous line serves as the skeleton of the composition. Though it meanders a bit, it's still basically vertical.*

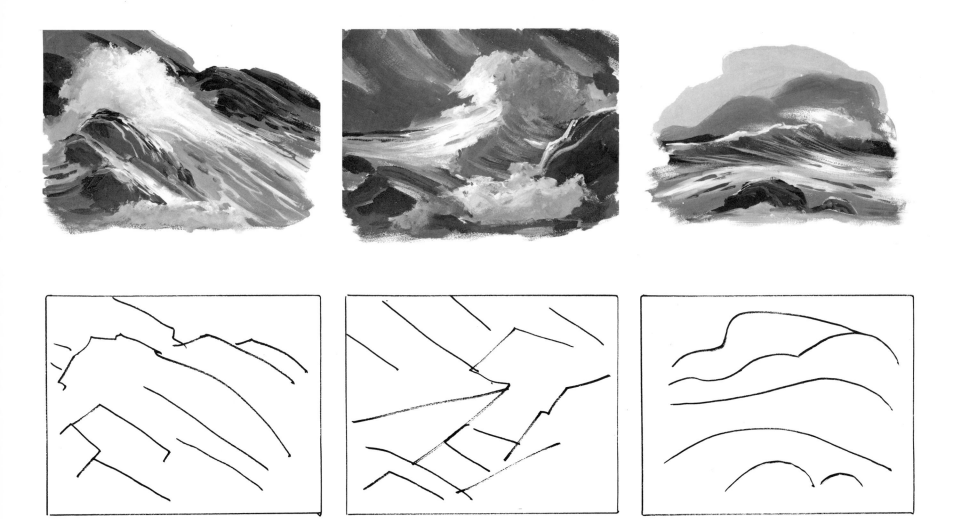

**Figure 113.** *A diagonal composition strongly suggests movement. In the line diagram, you can see that the lines seem to be moving toward the lower right corner. It's only the center of interest—the foam burst in the upper left corner—that prevents the lines from leading the eye out of the picture.*

**Figure 114.** *A combination of diagonal lines leading in a variety of directions creates the effect of opposing forces. Here, the lines in the sky and wave are directly opposed to those in the rocks. The line diagram shows that the diagonals seem to be forced against one another.*

**Figure 115.** *From the rocks in the foreground through the swell and the clouds, the upward curves make everything appear to be on the rise. In the line diagram, you can see rising lines more clearly.*

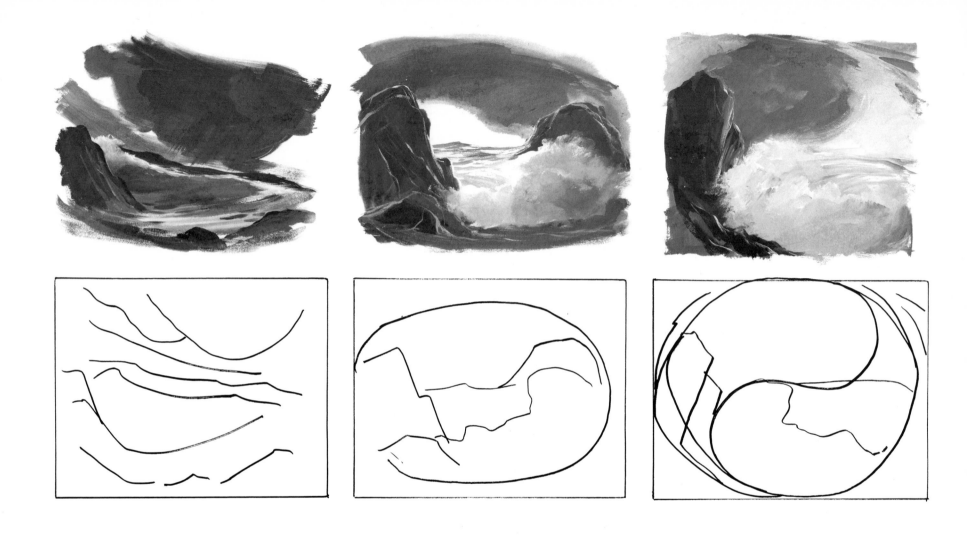

**Figure 116.** *If rising lines create the feeling of birth, downward curves convey the opposite mood. Here, the lines swinging downward in the sky and sea are heavy and depressing. In the line diagram, you can see that all the lines curve downward. These lines can be used effectively to describe storms.*

**Figure 117.** *Unfortunately, circular compositions may contain the scene to too great a degree and should therefore include an outlet or opening at some point. The line diagram shows that the circle in this figure is not quite complete and that it contains a variety of lines within it.*

**Figure 118.** *The arabesque, or "yin and yang", is a variation of a circle divided into two sections. In the line diagram, you can see that I divided the upper area of the arabesque between the rock and sky, the lower area between the sky and water.*

being commonly used to achieve neat balances, they're also important in creating contrasts, the feeling of depth, a pleasing division of space, and even in suggesting moods.

The values of any color range from the lightest light visible to the darkest dark visible. Some teachers suggest that their students divide this range into ten parts, or ten intervals, between the lightest light and darkest dark, but three divisions are enough for the purposes of composition. The intervening values will fall into place between these three as you paint. So for now, think of values in terms of light, middle, and dark, with one full step between the light and dark and a half-step between the middle tone and either the light or dark (Figure 119).

## Placing Values

It may be easier for you to learn how to use values effectively in your compositions if you think of your picture space as divided into three areas: foreground, middle ground, or center of interest, and background (Figure 120). Of course, the center of interest need not always be placed in the middle ground, but let's assume it is for the sake of this discussion.

There are six possible ways to apply your three values to the three areas of the painting and each combination produces a different mood or effect. (For example, you can use a light value in the background, a dark in the middle ground, and a middle value in the foreground, and so on.) However you arrange your values, your center of interest should be the smallest of the three areas, and the foreground and background should also differ from each other in size. Dividing foreground and background into equal areas would not only make them both uninteresting, it would also weaken the effect of each value. You'll avoid confusing the viewer if you place your values so that one is dominant, the second provides a bit of contrast, and the third takes up an even smaller area of the canvas and serves as the focal point.

The positions of the values in a painting can be used to enhance its mood or feeling. For example, dark tones make the sky seem foreboding, if not depressing. Don't rule this out as poor composition, however—the artist is free to present every mood and emotion and shouldn't limit his paintings to "pretty" or "pleasing" representations. And, in fact, dark background in a storm painting, with a shaft of light spotlighting the center of interest, can make a very dramatic composition (Figure 121).

On the other hand, light backgrounds create an open, airy feeling, a light mood. Backgrounds can be lightened by the addition of light clouds or sunlight dancing in a moisture-filled sky (Figure 122). Middle-tone backgrounds are neither depressing nor airy and play a less important part in the picture than either dark or light backgrounds.

When you arrange values for a well-balanced composition, keep in mind the power of darks. If you use a dark value in one area, try to balance it by placing secondary darks in one or more other areas. A group of three darks arranged roughly in the shape of a pyramid makes a pleasing balance, but remember that one of the dark shapes should be larger than the others (Figure 124). If you use this configuration, you should place the center of interest somewhere within the pyramid to insure that it will attract attention. Remember also that rocks don't necessarily have to be dark—in fact, rocks in full sunlight can be quite light.

The thing to avoid in any arrangement of values is the repetition of one size or shape,

**Figure 119.** *Although there are a number of values between the lightest light and the darkest dark, think only of three— light, middle, and dark—for the purposes of composition. The others will fall into place between these three as you paint.*

or a symmetrical placement of similar values, such as two areas of the same value on each side of the canvas. It's far more interesting to use one, three, or five areas of similar values than to arrange them in even numbers (Figure 125). In a horizontal composition, you can use one large dark area to balance two smaller ones.

*Contrasting Values*

Contrasts of values, as well as of colors, shapes, and sizes, command attention. When correctly placed, these contrasts can be used quite effectively to emphasize the center of interest. For example, you can create the strongest contrast in your center of interest by making the center of interest light, foreground dark and the background middle-tone, or vice versa (Figure 126). Assuming that the background is dark, there'll be one full step between the dark background and the light center of interest, while there'll be only a half-step between the background and the middle-tone foreground; the greatest contrast will occur at the center of interest. If you make the middle ground dark and either the foreground or background light, the strongest contrast will still occur at the center of interest (Figure 127).

However, when the center of interest is middle-tone, the contrast between it and either the foreground or background will be only a half-step, while the contrast between the background and foreground will be the strongest in the picture (Figure 128). The viewer's attention will be drawn to the strong contrast, rather than being attracted to the center of interest.

BACKGROUND

MIDDLE GROUND

FOREGROUND

**Figure 120.** *In this line drawing of a composition, notice the division between background, middle ground, and foreground. How much you include of each area depends upon your point of view, as well as upon what you wish to show.*

In order to overcome this distraction, you should treat a middle-tone center of interest in such a way as to draw attention away from the light-dark contrast. While a man-made object will automatically draw attention when placed in a natural setting such as a seascape, it may also look inappropriate in a painting of the sea. The most effective way to add new interest is to introduce an entirely new color in the center of interest, preferably a color that contrasts with those used elsewhere in the painting. For example, you can introduce a warm tone in an otherwise cool painting or—better yet—add the complement of the overall color scheme. You can also draw the viewer's eye to the center of interest by paying more attention to detail, texture, and action in the center of interest while playing it down in other areas.

## Combining Approaches

You can begin a composition using either an outline, linear symbols, or value arrangements. However, with the exception of quick outdoor sketches, your compositions will be more complete if you follow your beginning approach with the use of the other two approaches.

In Figure 123, notice that I used each approach, one after the other. I prefer to begin with the linear symbol because it best describes the direction of the movement in a painting. This may be followed by either outlining or the arrangement of values. Here, I used the outline second and then applied the values.

If you begin your composition with an outline, it will be quite easy to sketch in the values over it, but it will be rather difficult to follow

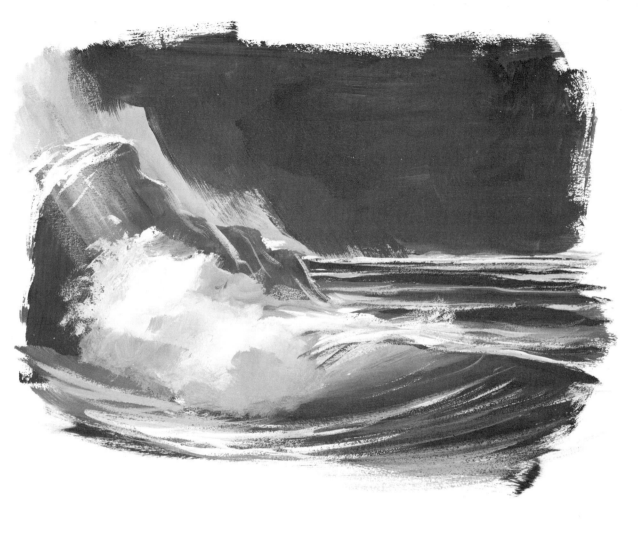

**Figure 121.** *Dark backgrounds are ideal for creating the mood of a storm. Here, we have a dark background, a light center of interest, and a middle value in nearly every other area. This combination can be very dramatic.*

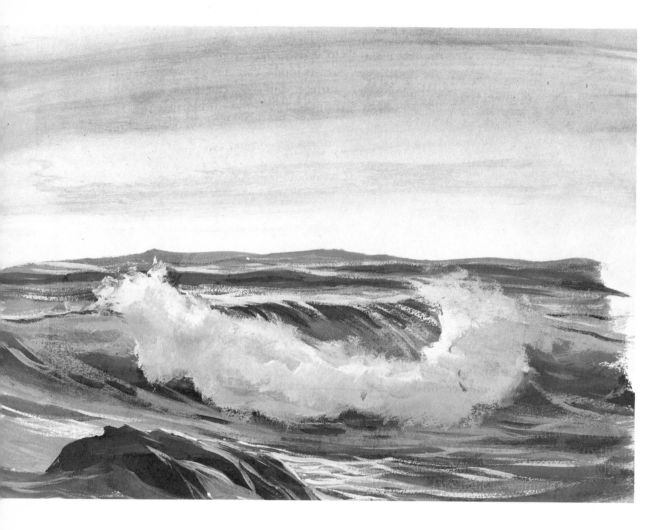

the outline with linear symbols because the lines may become confused. When you start with the values, it will also be difficult to work in the symbols, but you can use the values themselves to suggest the mood or meaning. Once you've placed your values so that they convey a particular mood, you can then make the outline continue the mood by following the value scheme as you place the objects. However, you'll need a well-developed feeling for the natural lights and darks found in seascapes before you can incorporate them successfully into a predetermined arrangement of values.

## Creating Moods

Putting together the right elements is the key to successful composition. The combinations you use should include not only what you've studied so far in this book but also many others, the most important of which is the mood of the sea and of the individual artist. Your moods must match those of the sea in order for you to express the sea convincingly; it is your moods and emotions that are transferred to the canvas as you paint.

Remember that a wide variety of times of day, atmospheric conditions, and aspects of the sea can be used to express mood. The following is a list of fifteen such elements that can be combined in various ways, according to your mood and that of the sea.

There are other elements, but this list alone will give you 125 combinations. If you multiply that by only three color schemes—warm, neutral, and cool—you'll have 375

**Figure 122.** *Light backgrounds are airy and open. When the background is light, it can be quite effective to make either the center of interest light contrasted with middle and dark values, or dark contrasted with middle and light values.*

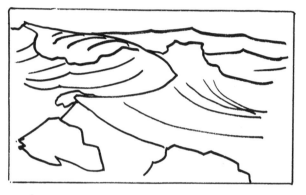

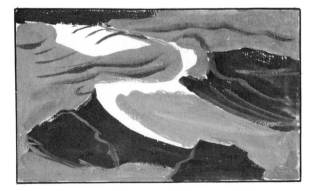

**Figure 123.** *This is one of many ways to approach composition. First, I used a simple line to show movement; my next step was to build the outline around the line; finally I added the values.*

combinations. Multiply that by only fifty different scenes, and you couldn't paint all the combinations if you completed a painting every day for the next fifty years!

Of course, such numbers are meaningless, except in answer to the person who says, "If you've seen one seascape you've seen them all." But you can see that the number of combinations available make it unnecessary for you to repeat any composition unless you're trying to improve upon it.

| Time of Day | Atmosphere | Mood of the Sea |
|---|---|---|
| Sunrise | Clear | Calm |
| High Noon | Hazy | Nervous |
| Mid-Afternoon | Fog | Active |
| Sunset | Clouds | Stormy |
| Evening | Overcast | Mysterious |

## To Sum Up

Here's a brief summary of the points you should keep in mind as you create your compositions:

Simplicity should be your by-word; the painting will grow more complex as it develops.

Feature one primary mood, atmospheric effect, overall value and color scheme, and source of light; make every other element subordinate to these.

Combine those elements and approaches that best represent your mood, as well as the mood of the sea.

Regard any studies as just that—studies. Although masterpieces do occur, they're rarely the result of a conscious decision to "make this painting a masterpiece."

Most of all, try to enjoy the excitement of learning and remember that your time and effort will bring rewards!

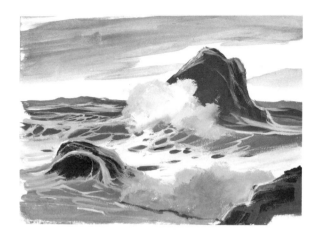

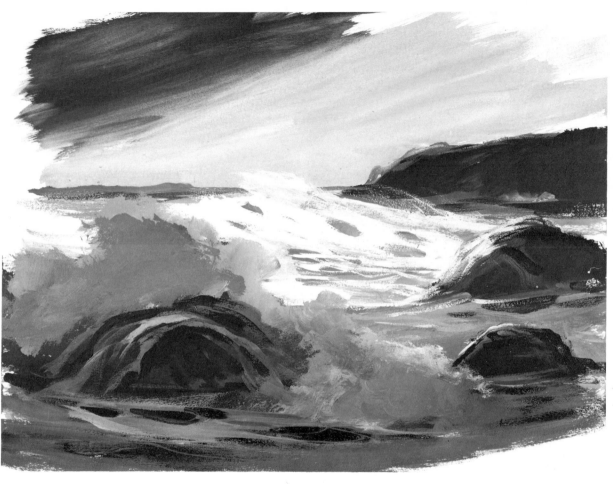

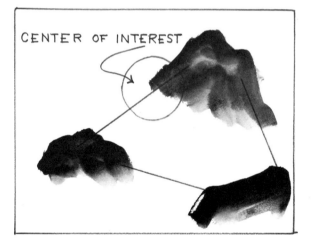

CENTER OF INTEREST

**Figure 124.** *This is a standard pyramid composition, in which three dark areas form a triangle. In the line diagram, notice that the three dark areas differ from one another in size. Placing the center of interest within the pyramid near the most prominent dark area insures that it will draw attention.*

**Figure 125.** *The five dark areas here make this an almost circular composition. Again, the center of interest lies within the dark areas and contains the lightest light and darkest dark.*

**Figure 126.** *Here, the middle ground is light in both compositions. The background on the top is middle-toned, and the foreground is dark; below, that placement is reversed.*

**Figure 127.** *Here, the middle ground, or center of interest, is dark, and there is a full step between it and the light values in the foreground (top) and background below.*

**Figure 128.** *When the center of interest is a middle value, there's only a half-step between it and either the light or dark. To attract the viewer's eye to the center of interest in this case, you must either add a new color or pay much more attention to detail in this area.*

## CHAPTER 9

# A NEW BEGINNING

In this and each of the following five chapters, I'll discuss one of the six finished paintings that are reconstructed in step-by-step color demonstrations beginning on page 145. I based the themes of most of these paintings on particular moods, and I used composition and color, as well as setting itself, to convey each mood.

*Summer Morning* (demonstration, page 145–147) is based on the theme of beginning, and the mood is one of newness, expectancy, and warmth. The scene is set on the West Coast; it's morning and the sun is just breaking over a bluff behind the viewer. Ahead, the sea rises from the last shadows of night, and the warm sunlight plays over the foam patterns on the cresting wave. There's a promise of a beautiful day as the surface mist dissipates in the warming atmosphere.

A morning scene such as this—in which the sun rises behind the viewer as he looks out to sea—doesn't occur on eastern coastlines, where the sun first becomes visible over the ocean. As far as the position of the sun in *Summer Morning* is concerned, I could also give this painting a title such as *Summer Evening, East Coast*. However, the mood of this painting is specifically morning and would not lend itself to an "evening" title; it's unlikely that the setting sun would create the feeling of a new beginning!

There's a great deal of atmosphere in *Summer Morning*. The air is full of moisture, and a mist that can almost be called fog rises from the surface of the water. In the background, touches of blue sky are visible where the mist becomes thinner. Although much of the foreground is in shadow, it's actually quite light, filled with sunlight reflected by the atmosphere.

Overall, *Summer Morning* is a pale blue painting, with orange and lavender highlights, and accents of green and dark neutral colors. The touches of warm color in the cool areas and the cool touches in the warm areas not only help to create a harmonious color scheme but also add to the effect of atmosphere.

I matched the color to the mood of the new day in the final step by overpainting the cool tones at the bottom of the composition and gradually blending them into warmer tones toward the top. The contrast between pale yellow and its complement lavender wasn't intense enough by itself, so I warmed the yellow with a touch of orange and cooled the lavender with a touch of blue. These complementary colors set the mood for the composition, and a third color, green, provided a subtle accent. I personally don't like to use orange and green together, but here they appear harmonious because they're combinations of the three primaries, all of which I used in the preliminary steps.

Although the rocks appear to add still new colors to the painting, they're actually rendered in orange and blue tones. The low value of the burnt sienna—which is actually within the orange range—and the touches of undiluted orange and blue on the rocks are very important. It's this contrast between the dark colors and the stronger, undiluted colors that gives the painting its "punch." If you place your hand over the rocks, you'll see that the colors in the rest of the painting appear weak; the weaker areas draw their strength from the vivid colors in the rocks.

In spite of the careful attention I paid to color, I would have lost the mood of this painting if I hadn't been equally concerned with lines and values. I built the entire composition around the theme of rising, or beginning, and planned the lines and values so as to suggest this feeling psychologically as well as visually (Figure 129). Jerky, nervous lines and depressing, downward motion would not have been in keeping with this light, delicate theme.

As I've already described, the rising curve is a symbol for birth or beginning; like the rising sun, it appears to have "just begun" and promises more to come and is therefore the perfect motif for *Summer Morning*. As you can see, the rising curves in this painting are very well defined in the foreground rocks, continue more gently through the leading edge of the cresting wave, and are almost lost in the background

mist. Notice also the secondary curves in the close and distant swells. These are less important than the major curves, but they keep the major ones from appearing staged. A few downward curves form the troughs in front of the wave and smaller swells to balance the rising curves and create a bit of contrast.

The values in the painting are generally middle tones, leaning toward the light (Figure 130). They're lowest in the foreground and become higher toward the top, adding to the feeling of airiness and upward movement. The dark rocks in the foreground contrast with the higher values in the wave. The center of interest, the wave, is reached by following the rising curves of the foam and rocks and the gradations of dark to light (Figure 131).

What saves the center of interest from becoming subordinate to the powerful colors

and contrasts in the rocks is the simplified rendering of the rocks. If I covered them with textural lines, cracks, and trickles instead of merely suggesting their mass and covering them with water, I would have assured them the honor of being the focal point of the painting. However, I let the wave draw the viewer's interest by adding to it the foam patterns, the touch of green, and the lightest light in the painting, as well as by placing it higher than the rocks in the composition.

Contrast doesn't always have to be simply a contrast between high and low values. Contrasts in colors, textures, sizes, and shapes can also be used to add interest to a painting, as well as to draw the viewer's attention to a particular area. In this case, I created contrast by placing the most textured area, the wave, against the least textured area, the atmosphere.

**Figure 129.** *The linear composition of* Summer Morning *is built around a series of rising curves. These follow the rocks to the wave and then the sky to create a feeling of buoyancy.*

**Figure 130.** *Overall,* Summer Morning *is a middle-tone painting with dark accents and a light center of interest. To add to the feeling of buoyancy, I confined the darks to the lower areas of the canvas.*

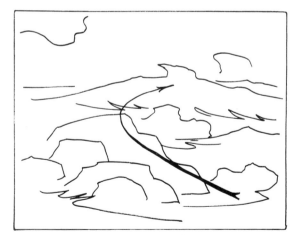

**Figure 131.** *Because the composition of* Summer Morning *is based on a rising curve, the lead-in to the center of interest also follows this line.*

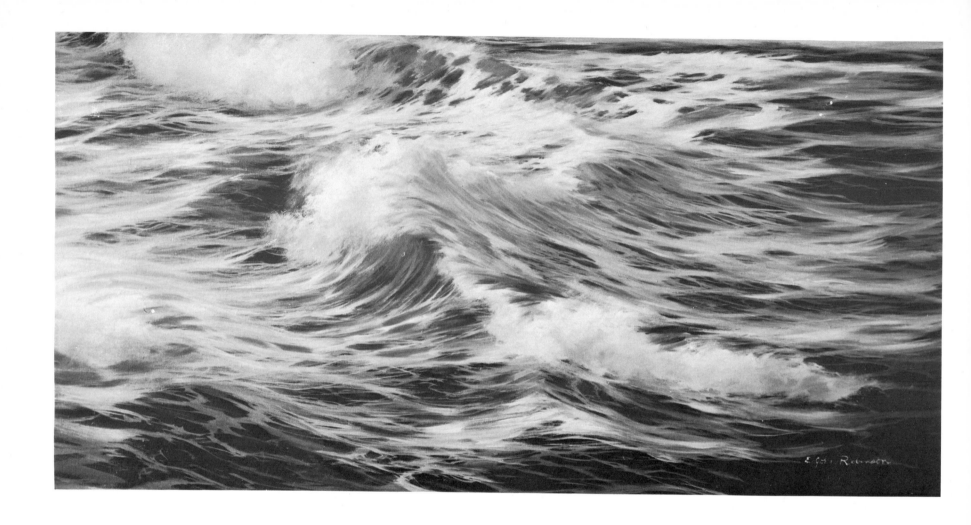

**Opposing Currents.** *(Above) Oil on canvas, 24″ x 48″. Collection of Jim Campbell, Oakland, California. This is an example of a painting entirely of moving water, without land or sky visible. The implied lines in the waves, as well as the patterns created by the foam trails, keep the eye moving continuously within the composition.*

**Bursting.** *(Right) Oil on canvas, 8″ x 10″. A foam burst should be described by an irregular shape, should be connected with the wave or swell from which it originates, and should also be in contact with the wave or rock that causes it. The edges of this foam burst are primarily soft, and the somewhat harder line suggested at the edge of the burst contrasts with and consequently accents the overall softness.*

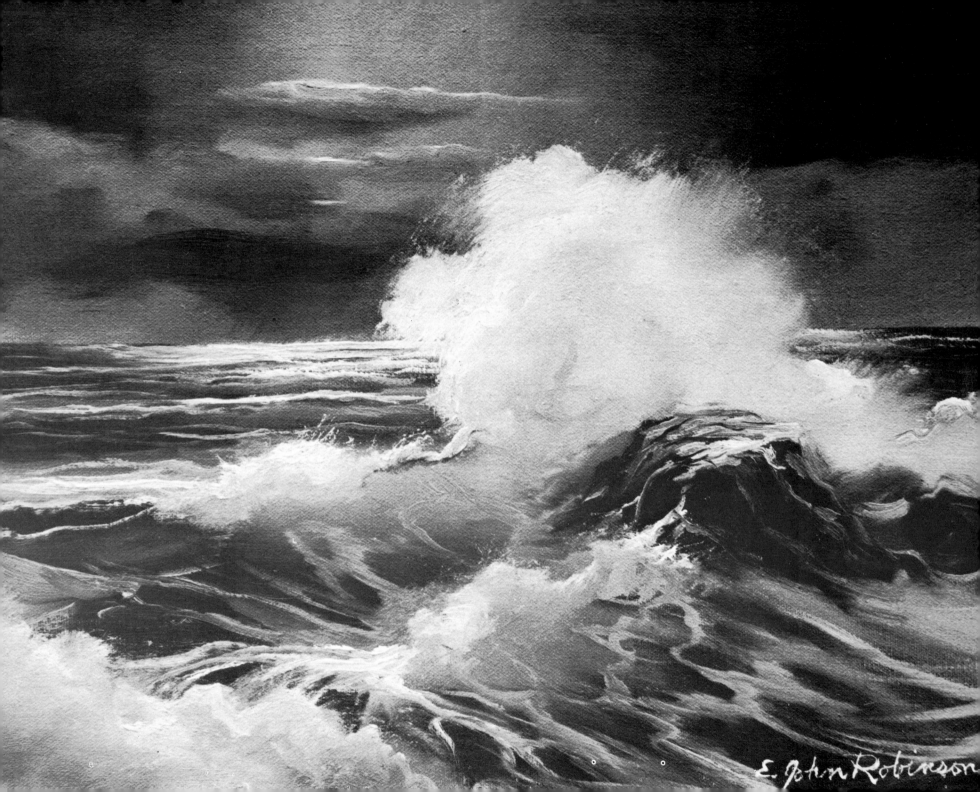

# THE MYSTERY IN FOG

When mystery is to be the theme of a seascape, nothing can describe it better than fog. What really creates the mystery is not what is said, but what is not said; you can control what is said and unsaid in a painting by controlling the density of the fog, as well as the amount of detail you allow the viewer to see within it.

In *Quiet Moments,* (demonstration, page 148–150), a substantial portion of the scene is visible through the fog, especially in the foreground and middle ground. However, it's a soft painting whose colors and details gently fade toward the edges. The fog obscures the entire background, leaving the viewer to speculate as to how far the rocks extend into the distance and whether there may be more rocks, as well as waves, whitecaps, and even headlands lost in the fog. It's also difficult to determine the time of day in this painting—although the sunlight seems to come from the west, the actual position of the sun isn't obvious. The element of mystery, then, is created by the question, "What is concealed?"

Although the atmosphere in *Quiet Moments* is heavy with moisture, it contains enough reflected light to make the areas on each side of the center of interest visible. So that the atmosphere would seem to be moving in closer, I kept detail at a minimum in these areas and also made use of the old theory that warm colors seem to advance while cool colors seem to recede. Usually, cool colors are used in the background to create the effect of distance, while warm colors are used to bring the foreground closer to the viewer. Here, however, I wanted the fog in the distance to appear to be advancing, or rolling in, so I used warm colors in the background and strengthened

the effect by applying cool colors in the foreground.

The colors in a fog painting should be quite low in key—that is, grayed down and diluted. *Quiet Moments* is basically a middle-tone, gray painting (Figure 132), and as in any painting in which neutral colors are predominant, the bright hues immediately command attention. Since there's very little contrast between light and middle values, I used contrasts of color instead of value to make the sunlight appear brilliant. The pale yellow sparkles on the surface of the water contrast with the lavender shadows to make these areas of sunlight quite intense.

To make the sunlight stand out even more, I confined it to one area of the painting and concentrated the texture in this area. To create the texture, I dragged a brush loaded with the sunlight color over the canvas, allowing the paint to build up unevenly on the natural texture of the surface. I "broke" the edges of each stroke by removing the brush from the canvas rather abruptly, in order to create the effect of scattered highlights and sparkles.

The lines in this painting also contribute to its sense of mystery. Rather than letting them converge or indicate definite directions, I let them "whisper" along, then faded their edges out completely (Figure 133). I made the lines in the fog particularly soft and gently curving, and I softened their edges as I made them swirl, rise, and then become lost.

The intense light and sharpness of detail in the central area make it the center of interest. There's hardly any lead-in from the bottom of the picture to this area, but the lines of light and the colors in the rocks become more in-

tense as they approach the center and then fade as they recede (Figure 134). Curiously enough, when the viewer's eye does leave the focal point to wander along the minor paths, it quickly returns to the center of interest because there's little to hold its attention elsewhere.

I paid very little attention to detail on the rocks, although I carefully constructed the upper and side surfaces. The upper surfaces reflect the atmosphere and are nearly the same value as the fog. Only subtle, lighter and darker edges separate rocks from background.

Those who still believe in using pure white paint for foam should take a special look at the foreground foam in this painting. It's darker than the fog, except for the highlights at the top—and even there, I blended pale yellow with the white. What make the foam stand out and appear so bright is the darker color immediately behind the leading edge. If not for this dark area, the foam would have been lost in the sparkle behind it.

It's not easy to convey a mood of mystery. When you try it, remember that the by-word is simplicity and the key is what you leave

unsaid. In my opinion, no painting should say everything, down to the last detail, even though I do admire the skill it takes to render so much detail. Such paintings leave the viewer no opportunity to use his imagination. In the days of radio, imagination was an integral part of visualizing and putting together the story. You'll see what I mean if you compare listening to radio with watching television, where everything is said for you. Try to leave something for the viewers of your paintings to imagine, and they'll feel a personal involvement as they fill in the details.

**Figure 132.** Quiet Moments *is basically a middle-tone painting. The darks are rather weak, but the lights in the center of interest are very bright.*

**Figure 133.** *The lines in* Quiet Moments *rise gracefully from the lower area to the middle ground, where they fade away. Because they don't describe a definite direction, these lines add to the feeling of mystery.*

**Figure 134.** *There's very little actual lead-in in* Quiet Moments. *Rather, the eye follows the glints of light directly to the center of interest, then follows the implied lines around the composition.*

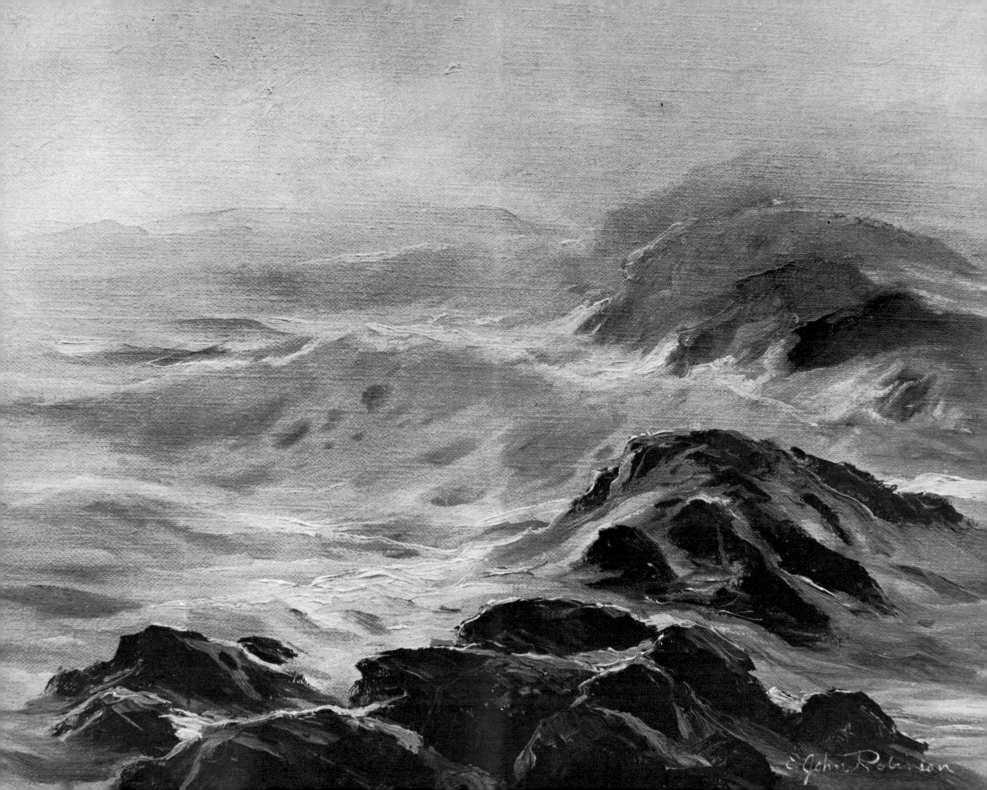

E. John Robinson

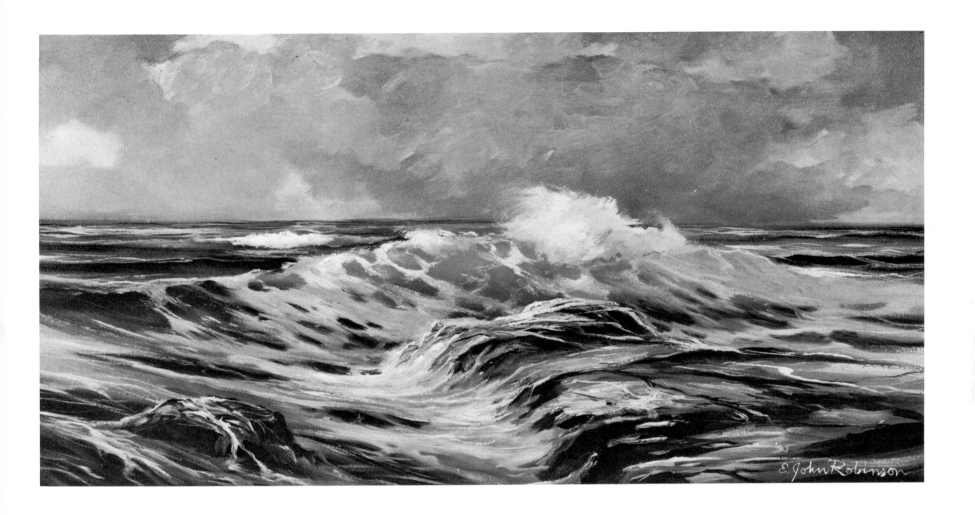

**Fog Glare.** *(Left) Oil on canvas, 18" x 24". I call this lightiing situation "down lighting." It produces glare, or glints of light that are reflected by the surface of the water into the viewer's eyes. Here, I used the glare to describe the form of the distant swells.*

**Touch of Morning.** *(Above) Oil on canvas, 15" x 30". On the West Coast, the rising sun sometimes creates warm light that shines through the clouds and onto the sea. When the artist depicts this form of spotlighting, he is free to choose which areas of the painting will be in light and which will be in shadow.*

133

# CHAPTER 11

# OPPOSING FORCES IN THE STORM

Storms can be beautiful spectacles, full of violent assaults, struggles, power, and unleashed energy. If they're frightening, it's only because we find ourselves weak and overwhelmed in the face of so much action. *Storm Fury* (demonstration, page 151–153) illustrates some of these features and gives the viewer a chance to decide how he feels about the scene. This is a painting of element against element, of sea and sky against earth, and the viewer may find himself anticipating the assault of the wave either with pleasure or with awe.

The theme of *Storm Fury* is opposition, force against force, and the composition is built around it. The time is probably around midday, and the sun is to the left of the scene. Like *Quiet Moments,* this painting displays the effects of. spotlighting—the clouds have temporarily separated to allow the sunlight to shine through. The sunlight is a weak yellow, just strong enough to warm an otherwise cold painting.

The atmosphere is neither clear nor laden with moisture, but is in transition as the storm approaches. The clouds are broken in some areas but are still dark enough to indicate that they hold a great deal of rain. This is the climax of the storm, with the promise of better weather to follow. Visibility extends as far as the clouds in the background, but the horizon line is obscured.

Color for a storm painting may be quite dark. However, darkness, especially in the sky, is depressing and does not necessarily convey the theme of opposing forces. The colors here are low-key, primarily blue-gray complemented by orange accents and yellow-green highlights. The green in the wave between the areas of yel-

low and blue is higher in value than the surrounding colors; small touches of lavender enhance the pale yellow. Each individual element —water, foam, rocks, sky, and clouds—has its own characteristic colors.

The linear composition is what gives this painting its strength and carries through the theme of opposition. Placing line against line, as I did here, is an ideal way to describe a storm theme. The lines used here not only seem to oppose one another by moving in many directions, they also separate the elements of air, water, and land, causing each area to appear well defined (Figure 135). The lines in the sky sweep down with mounting strength against the opposing lines of the rising wave. The sky seems to be pushing the water toward the rocks at the right. The wave slants menacingly into the rocks, which seem to be braced in anticipation of the next onslaught. Meanwhile, the rocks in the left foreground appear all but defeated. They do not face the attack, but lie low and broken, apparently as the result of many such storms.

There's contrast in the texture, as well as the direction, of the lines. They're harshest and most jagged in the rocks on the right, but those along the leading edge of the wave are a close second. While not so harsh, the lines in the foreground are nevertheless nervous and busy. The lines in the clouds as well as in the backward sweep of foam on the wave are soft and sweeping in comparison to the jagged lines in the ocean. The jagged lines command more attention than the softer ones, but both are necessary in order to create the contrast.

I continued the theme of opposition even farther by using a different value in each ele-

ment. The overall painting is dark to middle-tone, but the sky, water, and rocks each display different values (Figure 136). The strongest conflict occurs between the sea and the rocks, so this is where I placed the strongest contrast of values.

Again, the center of interest is in the water, on the wave, where I've isolated the lightest light by surrounding it with the darkest values. The center of interest can't be missed because of its intensity and the contrast around it, and the extra note of green as well as the added texture make it even stronger. The lead-ins to the center of interest come from every direction.

Those from the sky are strongest, but I've also used subtle lines throughout the lower area of foam, the rocks, and the spots of light (Figure 137). These lines add to the feeling of motion that's necessary in any seascape. The lines here create a strong diagonal, sweeping motion from the sky at the left down through the water and into the right foreground.

There are unlimited ways to portray a storm, and there are many themes besides opposing forces that lend themselves to the subject. Remember that the mood of a storm can be more than merely depression or anger. A storm can be a savage form of beauty, sheer motion,

or simply raw energy; something frightening, awe-inspiring, violent, or playful.

Whatever theme and approach you choose, try to make the composition follow. When you begin matching your compositions to your themes, avoid using colors, lines, or values that suggest a contradictory or simply a different feeling. While you can paint storms in nearly any color combination, some colors will suit your particular painting more than others. Linear composition can imply so much that it may be the first area in which you have trouble, while values will get out of control only when you ignore them.

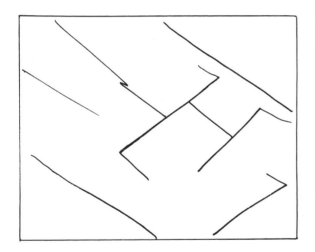

**Figure 135.** Storm Fury *is based on opposing lines. Here, you can see that the lines in the sky and sea slam into those in the rocks to symbolize power against power, total conflict.*

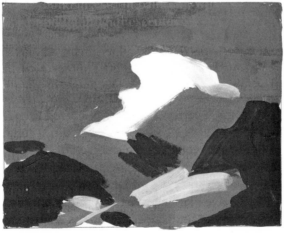

**Figure 136.** *The values in* Storm Fury *are primarily dark. Even the middle value is darker than usual, and only the center of interest contains a bright area.*

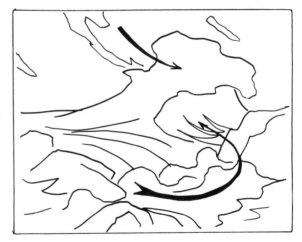

**Figure 137.** *The implied lines in the sky and throughout the light areas of the foreground lead the eye to the center of interest in* Storm Fury.

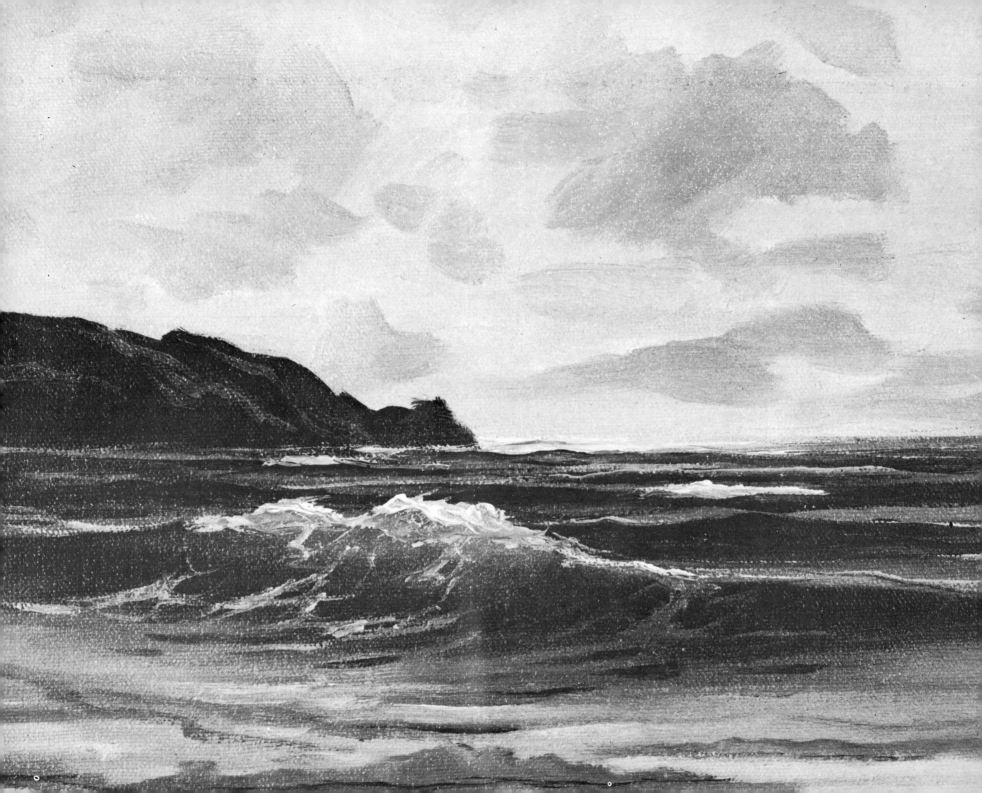

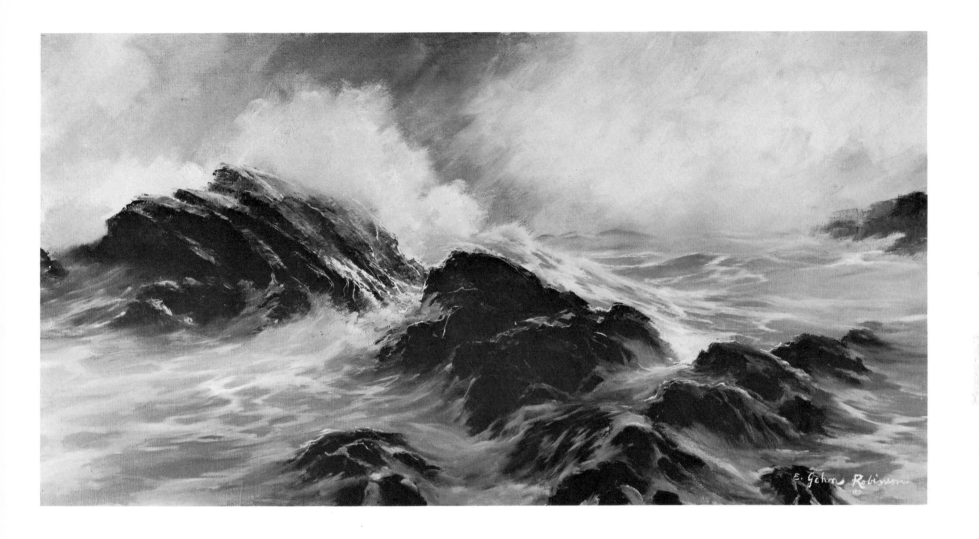

**Sky Shadows.** *(Left) Oil on canvas, 9" x 12". Here the sky seems to outshine the sea; I found the brightness of the sky and the sea in shadow a fascinating study. Only the textures and color changes in the sea make it the center of interest.*

**Storm Front.** *(Above) Oil on canvas, 24" x 48". Collection of Mr. and Mrs. Bill Wallace, Fort Bragg, California. The rocks are the main areas of interest in this painting. Their dark values as well as their placement make them appear to be a strong force opposing the powers of the sea.*

# CHAPTER 12
# THE RHYTHM OF MOVING WATER

While an almost unlimited variety of moods can be used as seascape themes, mood is by no means the only basis for a theme. In some cases, the artist may be inspired by the beautiful colors in the scene, by the way the light plays upon the foam patterns, by the position of the waves in relation to the land, by the water flowing over rocks, or—as I was in *Cross Currents*—by the continuous movement of the water.

While *Cross Currents* (demonstration, page 154–156) incorporates transparent areas, displays opposing forces in the water and backwashes, and is also a careful study in reflected light, it is primarily a painting of rhythmic movement. It focuses on the water alone, and the composition needs neither land nor sky to tell its story. I added the hint of submerged rocks merely to suggest a setting close to shore, as well as to provide a bit of contrast against so much water.

The time of day is of little importance here; the theme and composition determined the position of the light source, and it's enough for the viewer to know that the sun is to the left and is strong enough to create highlights on the foam. The light is warm, a cadmium yellow lightened and cooled slightly with white. The shadows are lavender, but they play a subordinate role to the blue light reflected in the water.

I used the reflected light to describe the atmosphere without showing any sky. There is very little moisture in the air, and although visibility is limited by the point of view, the brightness of the painting indicates a clear day. The blue in the reflected light suggests that the sky is probably clear blue. Although there's a shadow over the lower foreground, the leading edge of the shadow is sharp enough to indicate that it's created by a nearby bluff rather than by a cloud, whose shadow wouldn't be so clearly defined.

Any color combination can be used to describe rhythm, and the one I used here was simply my own preference. It's basically a green painting, with a great deal of blue in it. The introduction of a neutral (burnt sienna) in the submerged rocks and the touches of yellow in the sunlit areas are the only additional colors. The overall color scheme is harmonious, as the green is a mixture of blue and yellow; like neutral colors, these are rarely out of key.

Colors that are adjacent to each other on the color wheel, such as the blue, green, and yellow in this composition, are the simplest ones to use in creating color harmony. Complementary colors are more likely to separate one area of a painting from another, thereby stopping rather than creating the effect of motion. True enough, color harmony can be achieved by using almost any combination of colors, including the complementaries. But because adjacent colors are so closely related to one another—for example, blue, green, and yellow are adjacent, and green is the combination of blue and yellow—there's no chance that they'll clash, or "fight."

Again, linear patterns are the backbone of this composition (Figure 138). The feeling of continuous movement is created by lines that move freely, yet eventually connect with other lines. Unlike the straight, unconnected lines used in *Storm Fury*, which oppose and slam into one another, the lines in this painting have no apparent stopping place. Of course,

they do stop at the edge of the canvas, but to contain them within the confines of the frame would have created an unnatural effect in the water. And because the eye is made to keep moving in the composition, the lines that lead out of the picture also lead back into it. It seems that the movement continues in every direction, even beyond the canvas, and that we've focused on only a small part of the activity.

Notice also that the lines in *Cross Currents* are gentle rather than jagged, soft rather than hard. It would have been quite possible to create the effect of movement by using jagged lines, but again, gentle lines were my personal choice.

The values, while not as important as the lines in this composition, also continue the theme of rhythm. If nothing else, the values are placed so that they don't interrupt the flow of the water or create hard edges that would destroy the feeling of motion. It's a middle-tone painting with strong lights and subtle darks (Figure 139). The area of sunlight is rendered in the strongest, highest values, but rather than creating a spotlight effect, the light seems to move out with the moving patterns. What saves the light area from being too harsh is the gradual transition from a high to a middle value and finally to a dark. There are one or two places where such transitions are a bit abrupt, as in the swells in the right of the painting, but these add a bit of contrast.

At first glance, the foam seems to be the center of interest, but the eye soon moves to the transparent water at the right and is thus carried onward to the moving lines (Figure 140). When you emphasize movement, remember not to make a focal point so interesting that the viewer won't want to leave it. Start with an interesting element, but place another element next to it that will attract the eye and start the movement.

The reflections of the sky in the water are extremely important, even though they command little attention. It was more difficult to paint them accurately than it was to paint the transparent areas and the foam. The blue of the unseen sky was the basis for the reflected light, which I applied in a linear, rather than a mass, pattern. It was necessary to create a sense of continuous motion with the lines, rather than break the pattern up into choppy areas. Technically, it was simply a matter of placing the reflected lights within the troughs and shadows, but maintaining the rhythm of movement was a study in patience.

**Figure 138.** Cross Currents *is based on continuously flowing lines that are graceful rather than harsh or jagged.*

**Figure 139.** *An overall middle tone is the major value in* Cross Currents. *The darks add weight to the moving lines, and the light value curves along the major line of movement.*

**Figure 140.** *The center of interest in* Cross Currents *is a combination of foam and transparent water. The eye follows the linear movement first to the bright foam and then to the middle-tone transparent area.*

# CHAPTER 13

# THE GOLDEN TOUCH

In more ways than one, *View from the Beach* (demonstration, page 157–159) deserves the description, the "golden touch." Not only is it filled with the effects of golden light, but the overwhelming popularity and demand for this type of seascape have certainly earned it that description on the market. In short, this theme has been overdone until it has almost become the trademark of seascape painting.

Too often, such golden-hued seascapes are painted with sales slip rather than artistic merit in mind. I include *View from the Beach* in this book in order to demonstrate the possibilities of displaying craftsmanship in, and giving some dignity to, a subject that has fallen to the level of a dime-store print.

*View from the Beach* has some technical aspects that are well worth observing. For example, the glow effect throughout the painting, as well as the glitter and the wave patterns, are important features even in quite reputable paintings. An overall effect of warmth and quiet is well within reason if it's not over-staged and is coupled with a composition that also follows the theme.

The sun isn't far above the horizon in this picture and is being acted upon by the atmosphere and clouds to create a deep yellow-orange glow. On the West Coast, this is a typical sunset. Those who have never seen such colors have my assurance that they are possible, and these are even muted in comparison to some that occasionally occur. In any event, the position of the sun provided a perfect opportunity to capture this back lighted scene.

The atmosphere is clear except in the farthest areas of the background, and visibility extends to the horizon line. The sunlight spreads through the moisture above the horizon line to create the glow effect, and the amount of glow in the painting is limited by the amount and location of the moisture.

The predominant color in this painting is cadmium yellow deep. In fact, *View from the Beach* can almost be called a monochrome — it's primarily yellow-orange, muted with touches of gray. The gray is a combination of yellow and purple, which are complementary colors that combine to create a neutral. I warmed and cooled the gray as necessary by adding red and blue to the purple respectively.

The effect of golden color in this painting was not created simply by applying gold mixtures of paint (I did try this once — unsuccessfully). Rather, the glow is created by the juxtaposition of different values and tones. Remember that the lightest and warmest are of glow is also the smallest portion and is located right around the sun. I lightened the yellow-orange mixture in this area by adding white, then warmed it by adding alizarin crimson. From here, colors become darker and cooler as they extend outward, with a few warm touches in the glow as it comes forward to the viewer. For these areas, I used the yellow-orange mixture again, but cooled it by adding blue and a touch of burnt sienna. I added the sienna to avoid the green color that would otherwise have resulted from mixing blue with yellow. However, if used undiluted in a painting of this type, either of the siennas will dull the effect of the glow.

After I painted the glow areas in the sky and water, I worked in the clouds, the shadows and highlights, and the reflected lights directly above the glow.

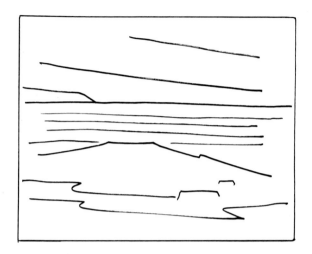

**Figure 141.** *The composition of* View from the Beach *is based upon horizontal lines, which are restful and quiet. I let some lines deviate slightly from a true horizontal position to avoid monotomy.*

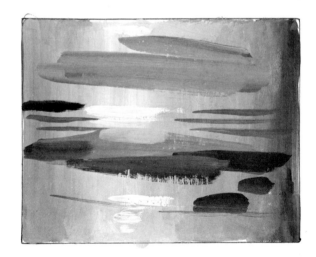

**Figure 142.** *In* View from the Beach, *there's no apparent lead-in. Instead, the eye sees the background glow and then explores the remainder of the composition. The center of interest, the central glow area, includes both light and middle tones.*

There's nothing spectacular about the composition of this painting; it's based on a theme of quiet and repose. As illustrated in Figure 141, the linear aspects—visible in the clouds, the swells on the horizon line, the wave, and the scud lines on the beach—are almost entirely horizontal. To avoid repetition, I let some lines deviate from the true horizontal. Though less obvious, these are also worth noticing. For example, look closely at the painting and you'll find a vertical line running right through the glow area left of center. This is broken only by the clouds and the major wave. Still more subtle are the diagonal lines below the clouds.

Although the values in *View from the Beach* are placed so that they continue the horizontal theme, they're more realistic than symbolic. The light is basically middle-tone and commands attention, and it's further accentuated by the darks (Figure 142). The very dark area in the foreground rocks contrasts with the wave and the distant headland.

There's some rhythmic movement in this painting, and the eye is led through a series of steps to the strongest area of glow. It may seem odd to focus on the horizon line rather than on the closer wave, but the background enhances the feeling of space and depth, and the detail in the wave insures that it won't be overlooked.

In the finished painting, notice the foam patterns on the wave. There are mass patterns at the base, linear patterns above the base, and silhouette patterns in the transparent area, all of which I rendered using the techniques described in the chapter on *Types of Foam*.

In the final analysis, while I've criticized the "golden" paintings, I must defend those in which the artist has tried to achieve an artistic rather than a decorative picture. To do these paintings well requires a great deal of craftsmanship and knowledge. The true artist will explore new ways to achieve these effects, as well as experimenting with many moods other than the one in *View from the Beach*.

141

## CHAPTER 14

# THE SEA
# AT NIGHT

Moonlight has traditionally been considered romantic subject matter, and like "golden" paintings, moonlight paintings are very popular. Usually the moon is placed somewhere over the horizon line to create a shimmering sparkle in the distant water and a silver lining in the clouds, as well as to provide back lighting for a quiet, restful scene of gentle breakers.

*Night Waves* (demonstration, page 160–162) represents a departure from this traditional approach by including an active sea lighted from the upper left. The painting is also without a theme, unless you consider line and the play of light and shadow a theme.

The atmosphere in *Night Waves* is clear except for some scattered clouds. The light suggests a full moon and an atmosphere free of clouds and moisture. The cast shadows in the foreground are too sharp to have been created by clouds, and we may assume that they're cast by a nearby bluff.

The basic color of this painting is deep blue, a mixture of ultramarine blue and burnt sienna. The moonlight is pale yellow with a touch of green added to cool it. (Moonlight is rarely warm light.) I added a bit of red to the blue shadows to complement the green in the moonlight and give warmth to an otherwise cold atmosphere. The dark color of the rock is also a combination of ultramarine blue and burnt sienna. The green in the wave is a combination of the yellow-green moonlight mixture and viridian green. The gray of the clouds is the basic blue-sienna mixture with white added. I also added pale yellow to the lighter areas of the clouds to indicate reflected, but not direct, moonlight.

I based this composition more on arrangement than theme, although a feeling of upward movement is created by the rising foam burst and the upward path described by the rocks. Otherwise, the line from the rocks to the clouds and back to the sea is based upon an imperfect circle (Figure 143). The jagged lines created by the edges of the waves, the rocks, and the sky also help to keep the painting from resembling the usual "peaceful moonlight" scene.

*Night Waves* is primarily low in value, balanced by middle tones, with the main light in the center of interest. I didn't try to create a clever arrangement of darks, but merely to maintain the linear pattern without distracting the viewer (Figure 144).

The center of interest is created by the contrast of the lightest lights and the darkest darks. It displays more texture than any other area of the painting, as well as the only yellow-green note. The lead-in is through the rocks, which I used as "stepping stones" into the center of interest (Figure 145).

The intensity of the cast shadow suggests strong light as well. As I described in the chapter on *Color,* complementary colors tend to appear more intense when placed together. Here, the lavender shadow appears quite intense, as does the yellow light. The shadow is darkest at its leading edge, and because it contains reflected light, it seems to fade as it recedes.

The spill-offs on the rocks are also worth studying. Since they were in shadow, it was impossible to create a strong contrast of light and dark in them, so I varied them slightly by using a few reflected lights. Had I added any more reflected light, the spill-offs would have been too distracting.

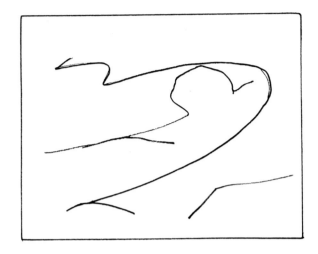

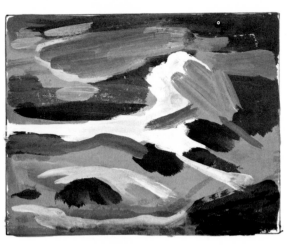

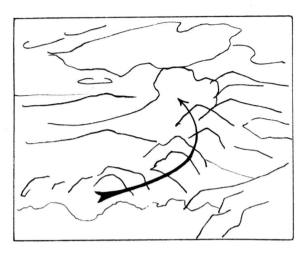

**Figure 143.** *There's very little theme in* Night Waves, *other than the rising movement suggested by the main linear patterns. The lines describe an imperfect circle, open on the side facing the light.*

**Figure 144.** Night Waves *is primarily a dark composition, with secondary middle tones. The lightest area is the center of interest.*

**Figure 145.** *The series of rocks are literally "stepping stones" that lead the eye to the center of interest. The lines in* Night Waves *are subtle and implied rather than stated.*

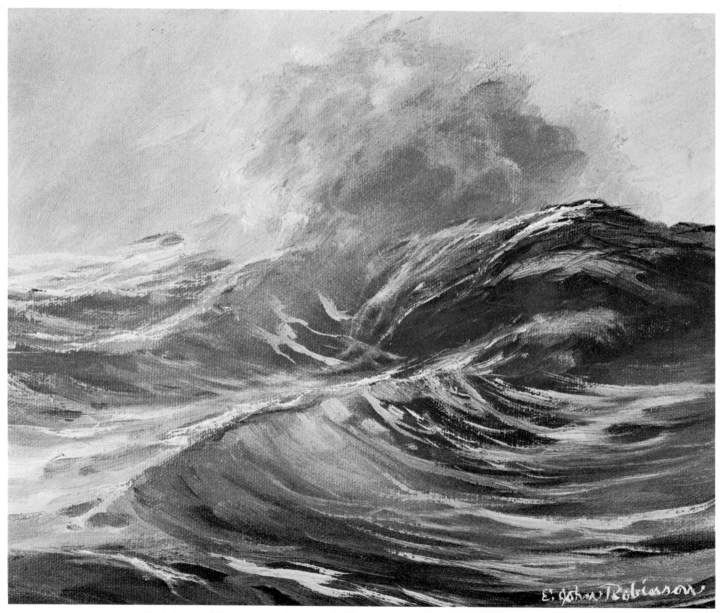

**High Spray.** *Oil on canvas, 8" x 10". Collection of Ruth Carlson, Mendocino, California. When I paint in the field, I often work quickly on small canvases, trying to catch the essence of the scene rather than a detailed rendering. In this painting, I was able to catch that moment when the spray was at its zenith, and the rest of the composition developed around it.*

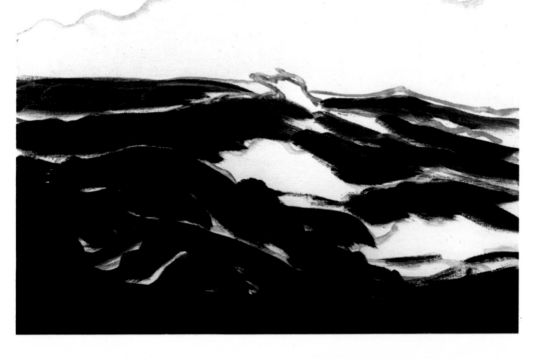

**Step 1: Local Color.** *After making the preliminary line and value sketches for* Summer Morning, *I applied the local colors as an underpainting. I painted the water, except the wave, in ultramarine blue with a touch of viridian green. I made the wave itself predominantly viridian with a touch of ultramarine blue. I used a combination of burnt sienna and ultramarine blue on the rocks, and left both the sky and the area of foam white untouched. Ordinarily, skies also have local color, but this particular sky was almost entirely atmosphere—a mixture of mist and sunlight—so I waited until I applied the atmosphere colors to paint in this area.*

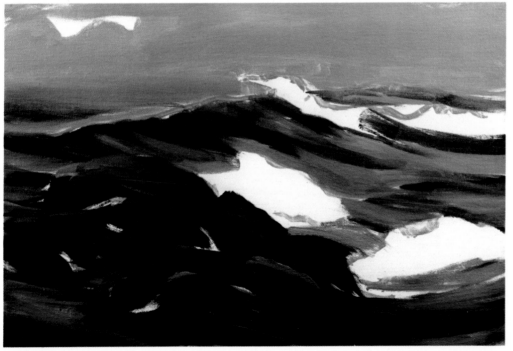

**Step 2: Atmosphere.** *I used a mixture of ultramarine blue, white, and a touch of alizarin crimson to paint the mist that nearly obscured the background sea. The colors of the atmosphere are always reflected in the local colors. Here, I worked the atmosphere colors into the foreground water, particularly into the horizontal surfaces that faced the sky and therefore contained a great deal of reflected color. I stopped blending as I approached the vertical surface of the wave. The rocks were wet from the activity of the water around them and also reflected the colors of the atmosphere, so I blended the mixture of atmosphere colors—ultramarine blue, white, and alizarin crimson— into the local colors of the rocks.*

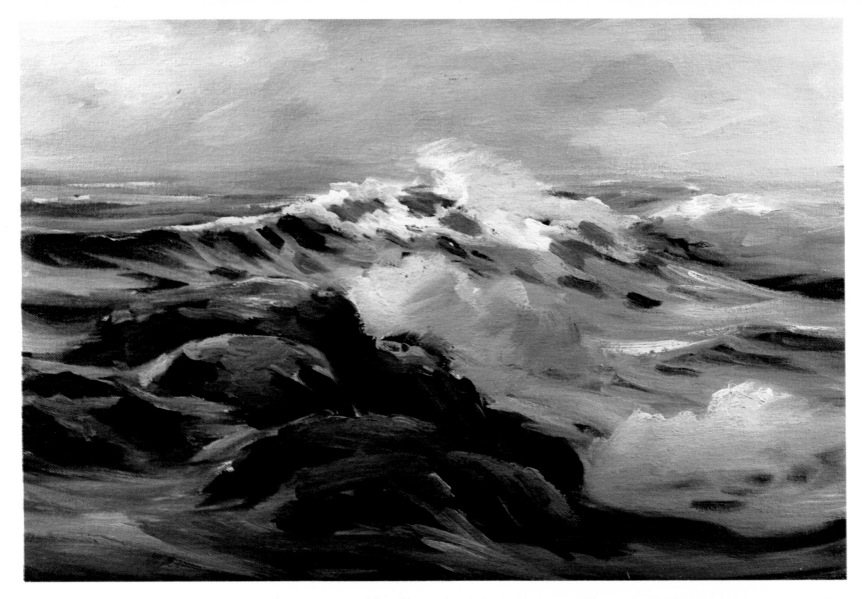

**Step 3: Sunlight.** *The addition of sunlight also means the addition of corresponding shadows. For the sunlight colors, I mixed pale yellow and white and added a touch of alizarin crimson to warm the mixture. I mixed the pale lavender shadow colors from ultramarine blue, white, and a touch of alizarin crimson, keeping the mixture on the blue side. I blended the sunlight mixture into several areas of the sky and foreground foam, applying it thickly on the major wave, then blended it into the shadows. The rocks received a different treatment: I first warmed them with a mixture of pale yellow and alizarin crimson (the sunlight mixture without white), then used the original sunlight mixture (with white) for the highlights. I brought out the pale green of the wave by blending in some of the sunlight mixture.*

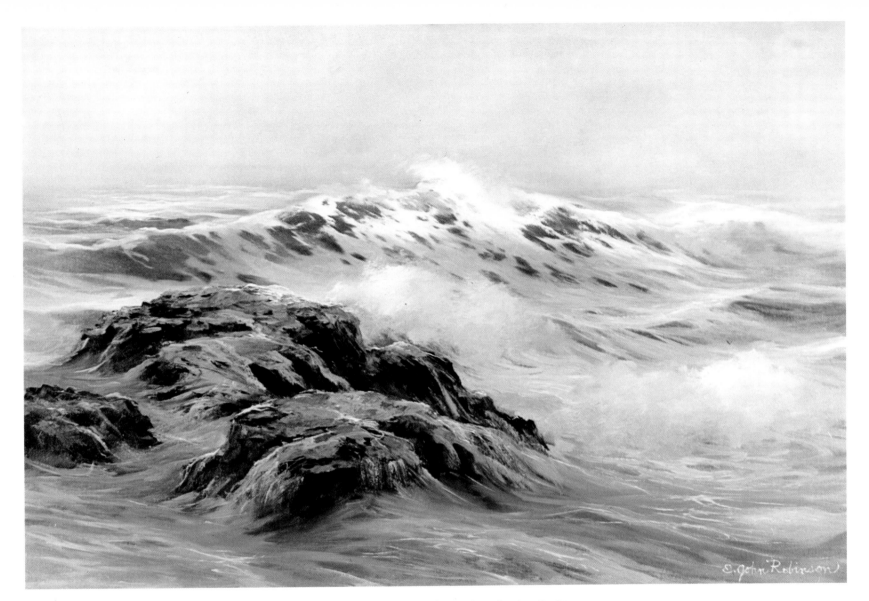

**Summer Morning.** *Oil on canvas, 24" x 36". The last touches added to a painting often make or break it. In this case, I had to know just when to stop or I would have lost the feeling of "newness." I added very little texture to the rocks, while I added quite a lot of texture to the foam patterns on the wave. This was necessary in order to minimize the importance of the rocks and make the wave the center of interest. I used a large, dry varnish brush to blend and soften the values in the sky, to decrease the amount of depth and create more of a misty effect. Finally, I whipped the foam on the wave back and forth and softened the edges of the foreground foam.*

## Color Demonstration:
## Quiet Moments

**Step 1: Local Color.** *In a fog painting such as* Quiet Moments, *very little local color remains visible after the atmosphere and sunlight are added. Therefore, it was necessary to apply only a small amount of paint to the canvas initially. Here, I used a mixture of ultramarine blue and viridian in the water, and burnt sienna with a touch of ultramarine blue for the rocks. I scrubbed these colors into the canvas. Since they were only the underpainting, I didn't want them to be so thick that subsequent colors would be lost when I added them; I didn't thin them, however, because then they would have been too weak. It was not necessary to paint in the local colors of the sky, because the colors of the atmosphere would be the only ones to show.*

**Step 2: Atmosphere.** *The atmosphere for* Quiet Moments *is primarily lavender-blue, made by adding ultramarine blue and a touch of alizarin crimson to white oil paint. The atmosphere filled the sky, except in areas where the sunlight was very strong, and was reflected by the background sea, the distant rocks, and the top surfaces of the water and rocks in the foreground. When you add reflections of atmosphere to water, be sure to follow the contours of the water's surface with your brushstrokes. Notice here how I curved each stroke and gave it a definite direction, even though they were quite sloppy at this stage of the painting. Remember, refining should be done in the last stage; it would be meaningless at this time.*

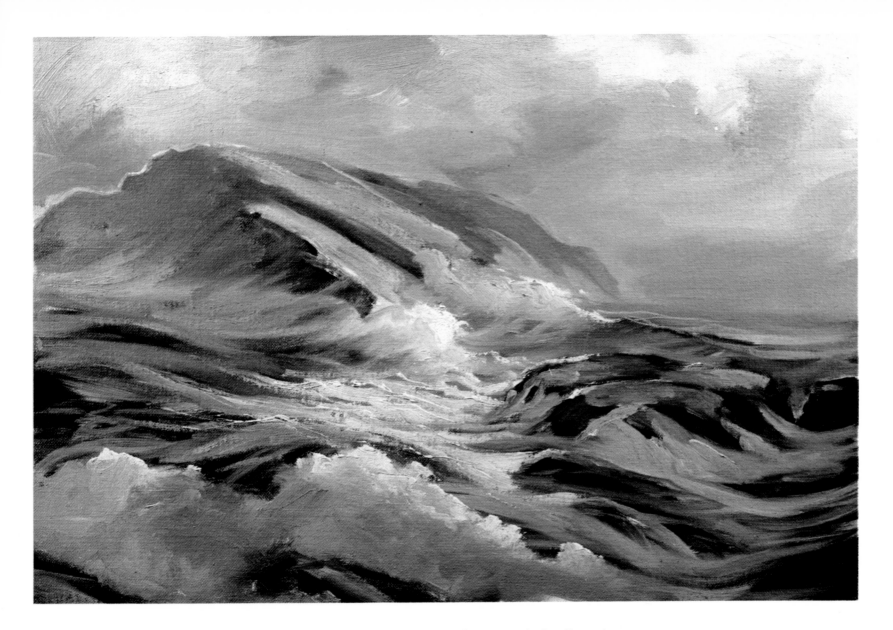

**Step 3: Sunlight.** *For the most part, it's the sunlight that grays down this painting. I used a mixture of pale yellow and white for the actual sunlight, adding very little white in the most brilliant areas and applying the paint very thickly in those areas so that it would not blend with and become lost in the underpainting. I applied pale yellow with more white added in the weaker areas of sunlight and used its complement, pale lavender, for the shadows. I whipped these colors into the wet atmosphere, and as they blended they produced a neutral, gray color. Notice that the addition of sunlight made the green areas of the water appear transparent.*

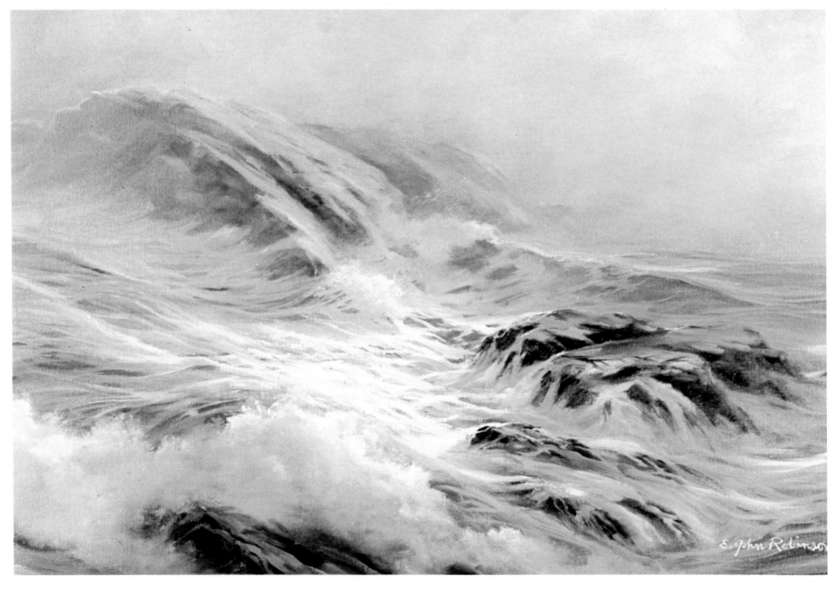

**Quiet Moments.** *Oil on canvas, 24" x 36". Collection of Robert E. Craig, Redwood City, California. At this stage, I decided too much detail was visible for the amount of fog I wanted to add, so I painted more atmosphere over everything except the highlights in the center of the canvas, which are the center of interest. I blended the sunlight color with the atmosphere color and added a bit more white to lighten the entire painting. As in Summer Morning, I applied very little texture to the rocks and added more texture, as well as the highest values, in the center of interest in order to draw attention to it. I whipped a dry varnish brush back and forth in the background to soften the edges and make the rocks appear to fade into the fog.*

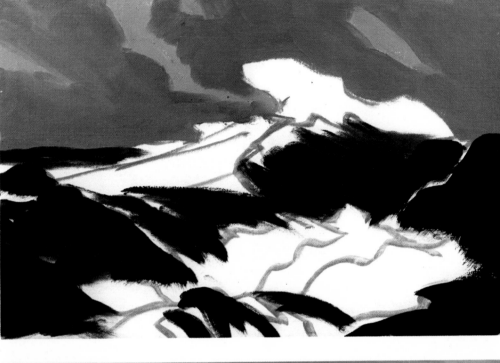

**Step 1: Local Color.** *I usually paint skies in the color of the atmosphere, but in Storm Fury, I decided to use local color in the sky and clouds so that they would be dark enough to suggest the storm. In the bit of sky between the clouds, I applied a mixture of cerulean blue and white. For the clouds, I made a dark blue-gray by blending ultramarine blue and burnt sienna with just a touch of white. The green in the wave and background water was viridian, grayed down with burnt sienna. In the foreground water, I used ultramarine blue, viridian, and burnt sienna; for the rocks, a half-and-half mixture of burnt sienna and ultramarine blue.*

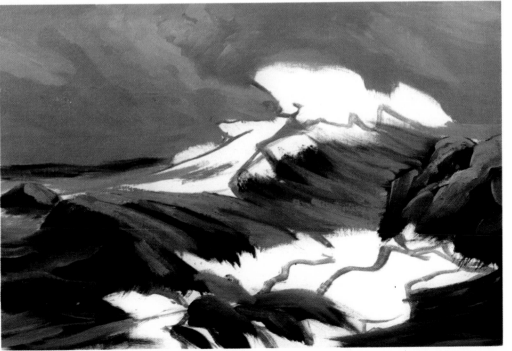

**Step 2: Atmosphere.** *The touches of atmosphere visible were quite purple, so I used a mixture of ultramarine blue, alizarin crimson, and very little white. I painted this into several areas of the sky and clouds, blended it with the local color of water, and applied it very heavily on the upper surfaces of the rocks. I also applied just a touch of cerulean blue to the rocks to create the effect of sky reflected in the water. Notice that I left the areas of foam unpainted. Undiluted color is more effective in those areas, and underpainting would undoubtedly have dulled the effect.*

151

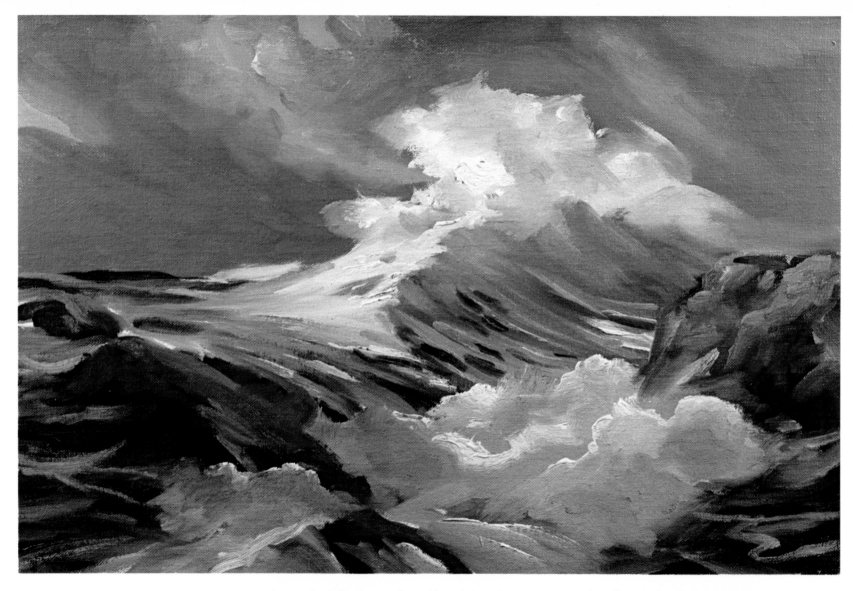

**Step 3: Sunlight.** *I wanted a cold sunlight color, so I mixed pale yellow with white to cool it. When I blended it into the green of the wave, this mixture created a bright, transparent effect. Next, I added a good deal more white to the yellow and painted it into the foam on the wave. I used the same mixture with still more white for the foam in the foreground, which received very little sunlight. I blended pale yellow into the burnt sienna on the rock to produce orange accents, a perfect complement to the overall blue effect of the painting. Although pale yellow suggests the use of its complement, pale lavender, for shadows, I deliberately added blue to the lavender to emphasize the coldness of the light. Lavender alone would have had too much red in it and would have warmed the painting.*

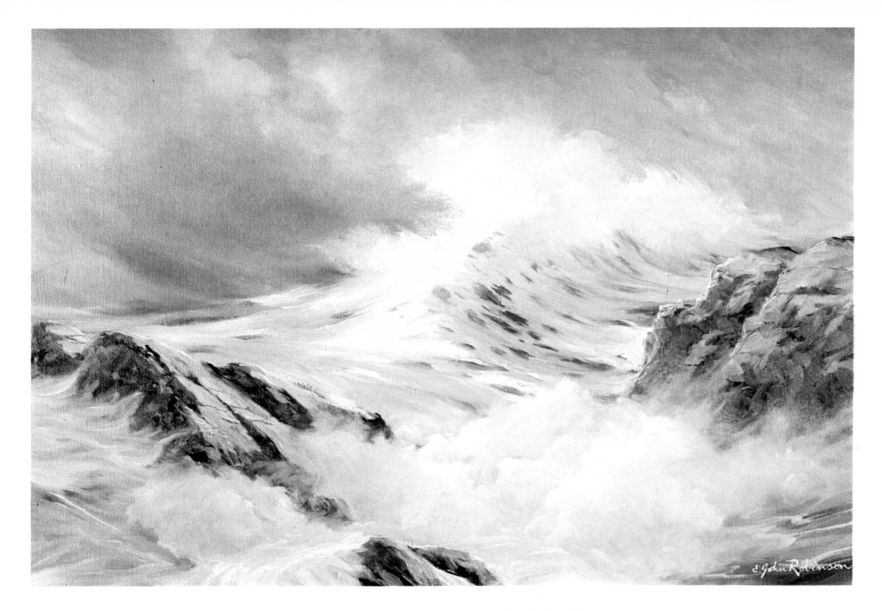

**Storm Fury.** *Oil on canvas, 24" x 36". I refined the painting rather meticulously. First I painted in shadowed foam patterns on the wave, then textured the rocks, and finally added more reflected light to the rocks and water. I reworked the foreground foam to create the impression of agitation. I used a blending brush to soften only a small portion of the foam on the wave. Otherwise, I left the natural brushstrokes as they were in order to retain the feeling of sharp, jagged movement, the almost electric quality that fit the mood of storm.*

## Color Demonstration:
## Cross Currents

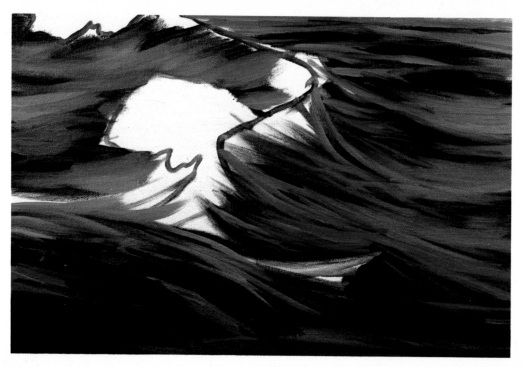

**Step 1: Local Color.** Cross Currents *is a painting entirely of water, with only a hint of submerged rocks below. I started at the top with undiluted viridian and added ultramarine blue to it as I worked downward. I used a mixture of burnt sienna and ultramarine blue on the rocks. Again, I left the areas of pure sunlight unpainted.*

**Step 2: Atmosphere.** *Here is an example of suggested atmosphere in a painting. Since there is no sky showing, only the atmosphere colors reflected on the surface of the water can be used to describe the atmosphere of the day. In* Cross Currents, *the atmosphere is clear, with what the viewer may assume is a blue sky. I followed the contours of the moving water as I added reflections of the unseen sky, using a mixture of undiluted ultramarine blue and white. In most areas, I allowed the atmosphere color to cover, rather than blend with, the water to suggest the clear atmosphere and indicate the nearly smooth, highly reflective water.*

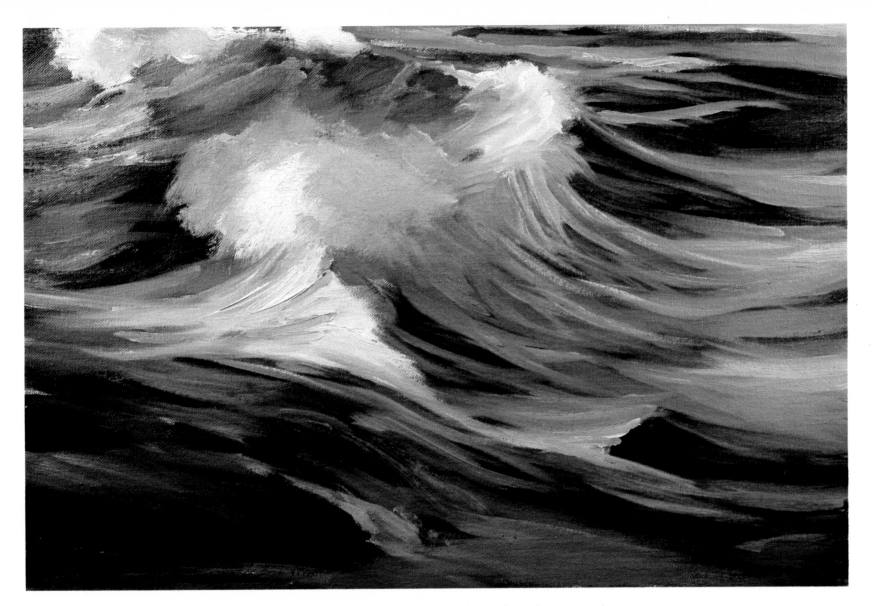

**Step 3: Sunlight.** *The sunlight here was warmer than that in the last demonstration, so I painted it with a mixture of cadmium yellow medium and white. I first painted the lightest areas—the foam and foam trails facing the sun. Next, I added the bounced, or reflected, lights throughout the composition, being careful not to lose the continuous movement suggested by the lines. For the shadows, I used a lavender mixture that contained just enough alizarin crimson to keep it on the warm side. I added shadows throughout the composition, in areas where the sunlight did not reach. I created the transparent area, which is part of the center of interest, by blending the cadmium yellow medium mixture into the viridian I had previously applied in the water.*

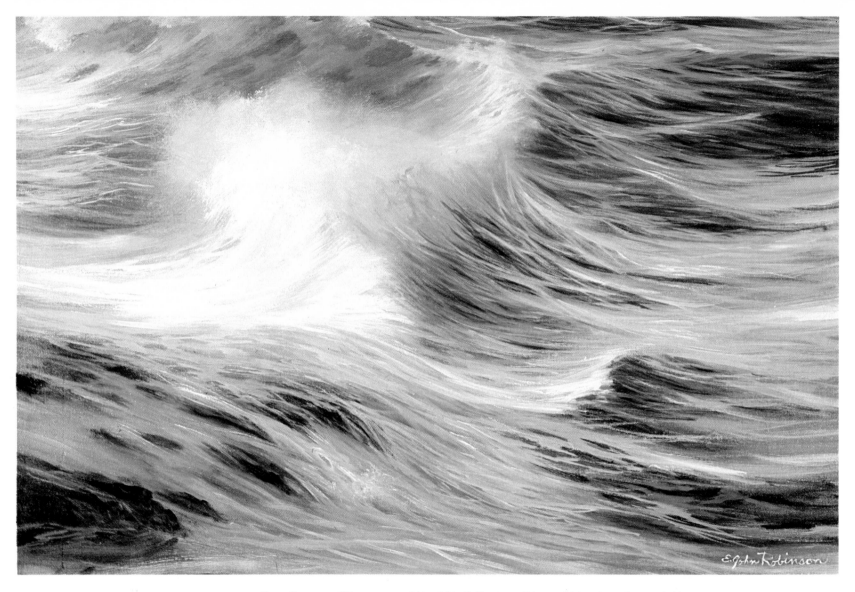

**Cross Currents.** *Oil on canvas, 24" x 36". Collection of Dr. and Mrs. S. Jack Kronfield, San Francisco, California. The refinement of this painting required a lot of patience. I first used a dry varnish brush to soften all the edges except for a few in the center of interest. Then I used the atmosphere color and the sunlight mixture to further define the contours of the wave and swells. As I did this, the entire painting became lighter and more reflected sunlight and atmosphere became visible. The subtle silhouette patterns in the transparent wave, along with my use of thicker paint in that area, kept the center of interest from losing importance as I added detail and color to other areas. I used the patterns over the submerged rocks merely to add textural interest and to deepen the shadows in the foreground.*

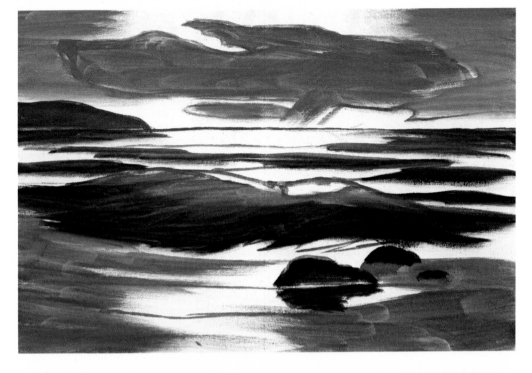

**Step 1: Local Color.** *My approach to* View from the Beach *differed somewhat from the one I used in the previous paintings. Knowing that the overall color would be the warm glow of the sun, I applied very little local color as an underpainting. I added pale blue on each side of the sky and painted in the gray cloud in the center using a mixture of burnt sienna, a touch of blue, and white. I used the same mixture with less white to paint in the headland. For the local color in the waves, I used viridian green and burnt sienna, which combined to create an olive green effect. To paint the sand, I mixed a thin wash of burnt sienna and cadmium yellow deep, then grayed it down by adding some of the mixture I used for the cloud. I used undiluted burnt sienna on the rocks.*

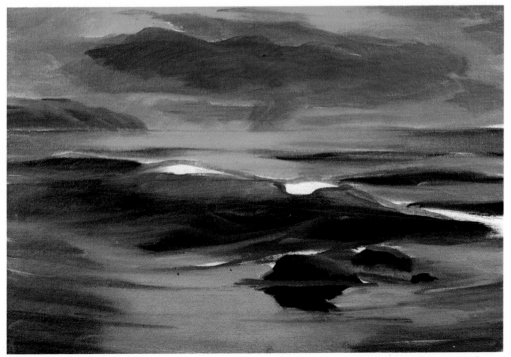

**Step 2: Atmosphere.** *In this painting, the atmosphere color was influenced more by sunlight than by reflected colors from the sky. I began painting the atmosphere in the center of the canvas, applying undiluted cadmium yellow deep in the background and down through the foreground and blending its edges with the gray of the sky, water, and sand. I mixed the yellow with burnt sienna and blue and added it to the clouds to give them more form. Then I used the same mixture to add reflected light on the headland and in some areas of the foreground. Notice that the addition of atmosphere colors to the back-lighted wave made it begin to look transparent.*

157

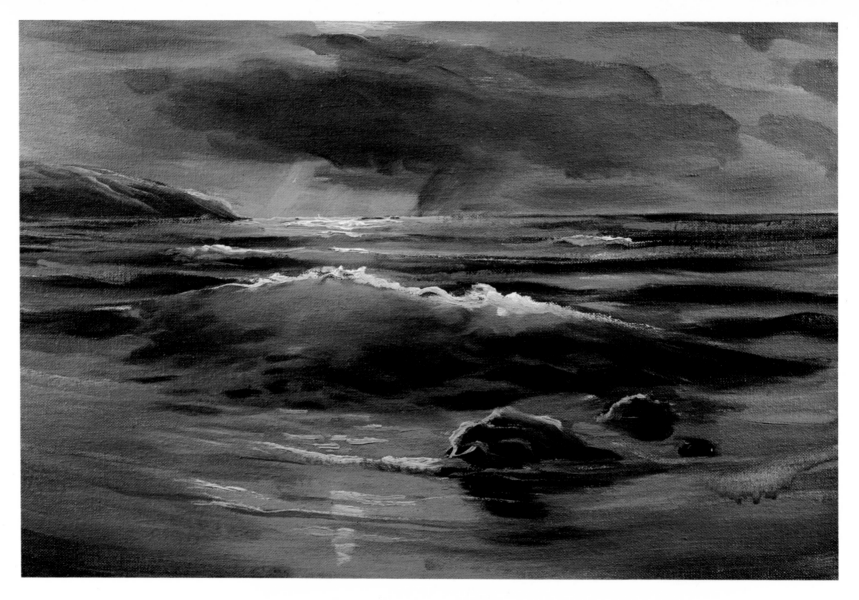

**Step 3: Sunlight.** *Since I had already applied most of the sunlight colors as atmosphere, I simply refined the glow effect in this step. I mixed cadmium yellow deep with white and applied it as highlights in the central area of the picture. I used this mixture very sparingly, so that I wouldn't dull the effect of the glow. The wave became somewhat opaque because of the addition of opaque white paint, but the transparent effect was still visible. Then I applied blue in the shadows. This did not disturb the color harmony, because blue is the complement of orange, and cadmium yellow deep is very close to orange. Mixed into the yellow underpainting, the blue caused some areas to appear green, so I added a touch of alizarin crimson to those areas to dull the green.*

**View from the Beach.** *Oil on canvas, 24" x 36". For the final step, I added foam patterns to the wave and foreground, a few more swells in the background, and more reflected light in the central area. The foam patterns were the most important addition here, because they gave texture to an otherwise flat wave and added enough interest to attract the viewer's eye from the areas of glow to the wave. The areas of scud and slick in the foreground would have been too broad if I hadn't added some texture to break them up. I did very little hazing with the varnish brush, just a bit in the sky area to make it recede.*

159

## Color Demonstration:
## Night Waves

**Step 1: Local Color.** *Moonlit skies are sometimes warm, sometimes cool, but never black. Because I had decided that the moonlight would enter Night Waves from the left and fill it with plenty of light, I used gradations of light to dark in the sky as I approached the right side of the canvas. The mixture I used was two parts ultramarine blue to one part burnt sienna, lightened with white and a touch of pale yellow. I added more white to the same mixture and filled in the clouds. For the water, I used a mixture of undiluted viridian green and burnt sienna; for the rocks, burnt sienna and ultramarine blue. I left the foam and the moonlit areas unpainted.*

**Step 2: Atmosphere.** *Because I wanted a warm, pale yellow moonlight, I chose its complement, violet, for the atmosphere. I worked the violet into the local color in the clouds, over the flat surfaces of the water, and into the tops of the rocks. Although I used much more of the mixture in the distant rock on the right than in the foreground rocks, I did not add enough to obscure the rock, because I wanted the atmosphere to be very clear.*

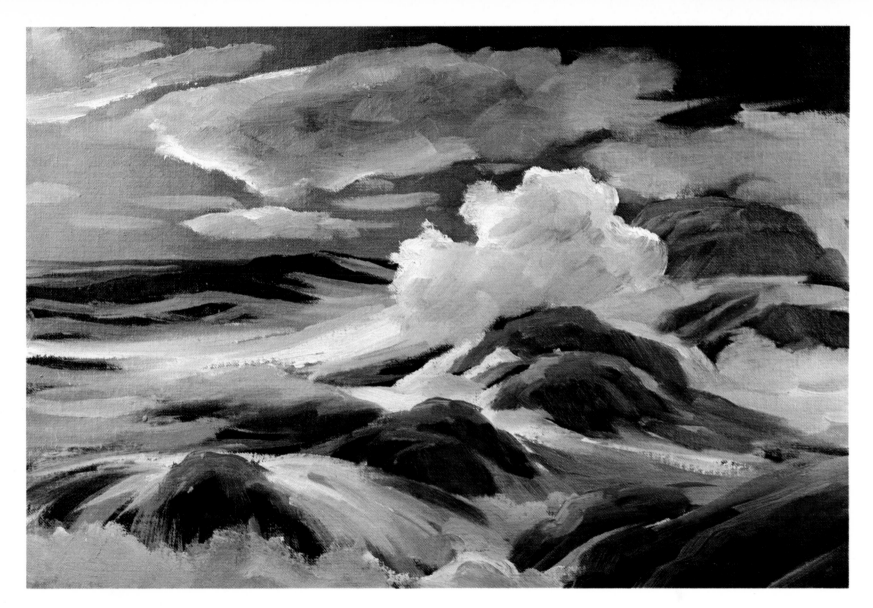

**Step 3: Moonlight.** *The intensity and color of moonlight vary greatly from one night to another. Sometimes moonlight is slightly green, at other times it is a warmer yellow. However, it is usually very white with a touch of pale yellow, and this is the mixture I chose for the moonlight in* Night Waves. *I first blended the mixture with the local green to create a transparent effect in the water. Then I used it to add highlights to the foam and clouds and blended the same mixture with the burnt sienna of the rocks to give them a near-orange hue. I painted the lavender mixture I used for the clouds in Step 2 into the darker portions of the white foam and worked more of it into the clouds as well. I used the same mixture without white to paint the shadows on the rocks and the shadows they cast on the water.*

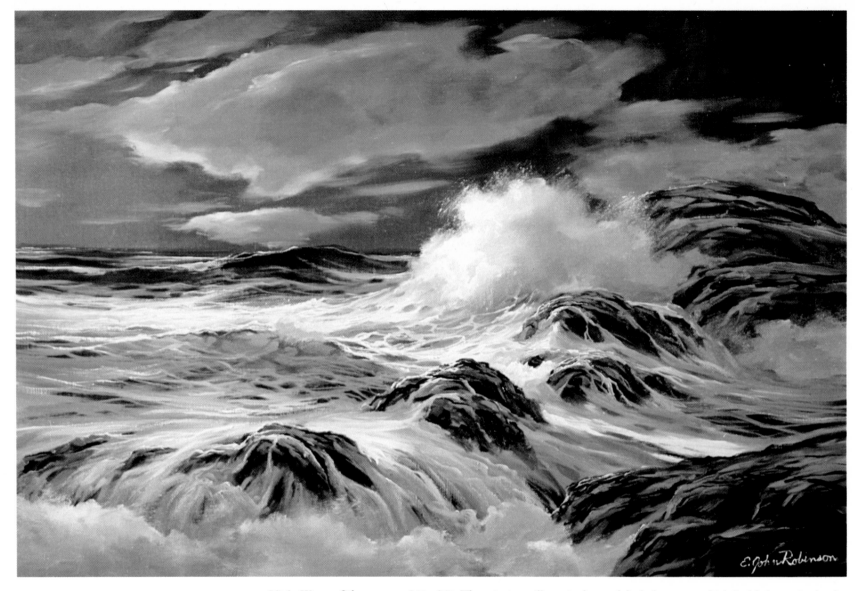

**Night Waves.** *Oil on canvas, 24" x 36". The painting still required a good deal of texture, which I added even in the distance to indicate that the atmosphere was clear enough to allow details to show up. I used reflected light to create an impression of movement in the spill-offs around the rocks. I added cracks and crevices on the surfaces of the rocks. Then I added more atmosphere and glints of moonlight to make the rocks more important and create enough interest in them to lead the eye from one to another and finally to the center of interest. I also added textured foam patterns below the foam burst to give the viewer a visual reward for following the lead-in to the wave. These highlights and textures suggest a lot of action, removing Night Waves from the usual placid, romantic category of moonlight seascapes.*

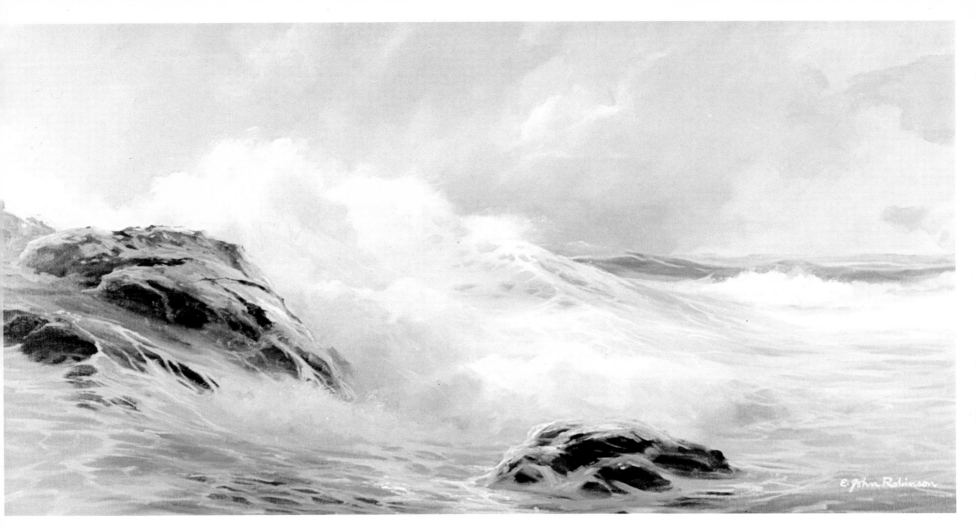

**Aftermath of the Storm.** *Oil on canvas, 24" x 36". Collection of Seldon McCallister, Sr., Sunnyvale, California. Although there is a somewhat circular movement in this painting, the composition is actually based upon opposing lines. Notice the slant of the clouds, which is in direct opposition to the lines in the wave and foam. These in turn are opposed to the lines in the rocks. The sky is also important here, because it continues the feeling of softness throughout the composition.The rocks are the only harsh element in this painting; their harshness provides a bit of contrast, while it continues the theme of opposing forces.*

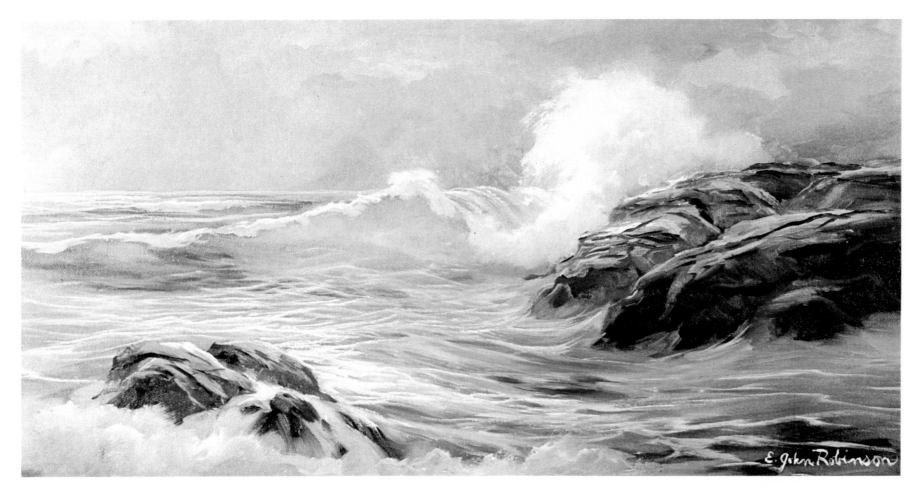

**Autumn Sea.** *(Above) Oil on canvas, 15" x 30". Collection of Moira Jackson, San Francisco, California. There is probably no such thing as an "ideal" wave, except in the mind of the artist. I have given the major wave in this painting all the characteristics I enjoy most in a wave. For example, notice the gradually changing values on the face of the wave, the transparent area, the breaking foam, and the foam patterns. Each of these elements represents months and years of experimentation and struggle on my part. And the ability to paint these is only a beginning, because the sea always has something new to teach us.*

**Wild Water.** *(Right) Oil on canvas, 24" x 36". Moving water is sometimes so fascinating in itself that it can be portrayed without the addition of sky, rocks, or land. In this painting, the eye moves along the foam trails in the foreground and over the contours of the swells to the patterned wave in the background. There, the sunlight playing over the foam creates the center of interest. Notice the use of both linear and mass foam patterns, as well as the reflected light that suggests the unseen sky.*

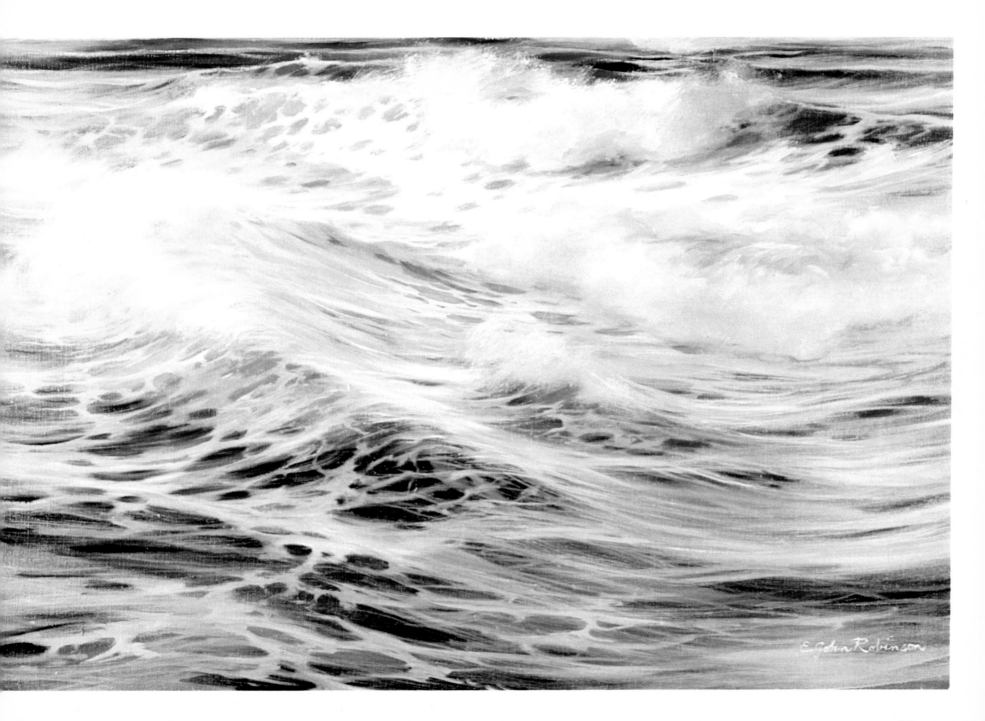

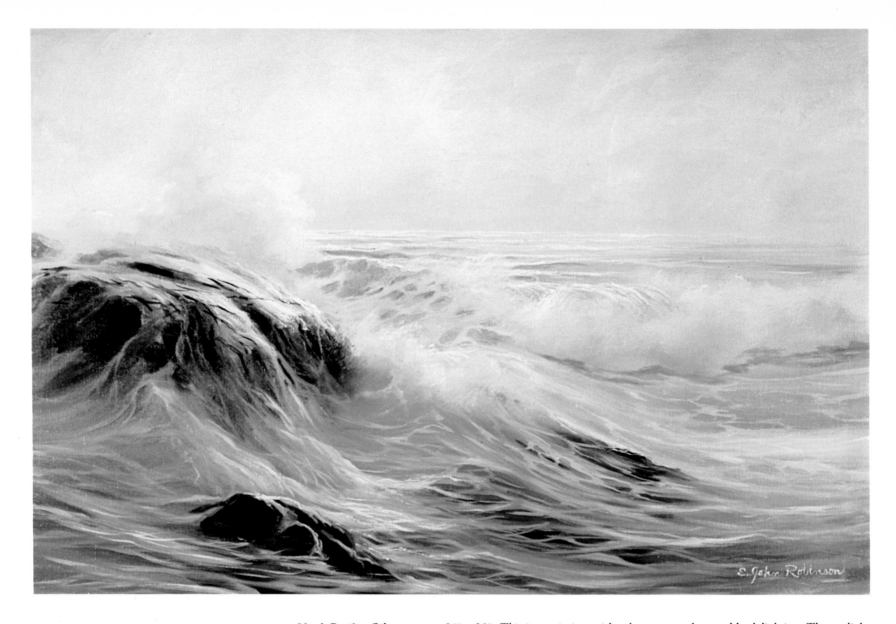

**North Pacific.** *Oil on canvas, 24″ x 36″. This is a painting with a hazy atmosphere and back lighting. The sunlight contributes very little color to the painting. The composition is primarily horizontal, except in the foreground where the diagonally placed swells suggest movement in the surf. The rock is the focal point of the picture, but the moving lines also lead the eye to the wave, the foam, and the surf. The overall color suggests a cold, cold sea.*

166

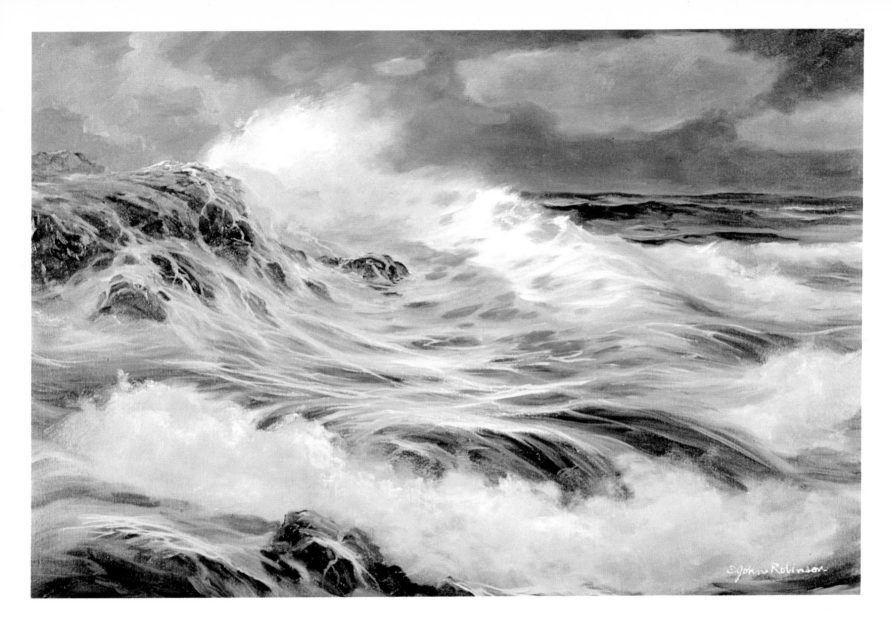

**Night Tide.** *Oil on canvas, 24" x 36". Collection of Mr. and Mrs. Alden Paine, Idylwild, California. This composition is based on an "S" curve that begins in the clouds at the right, follows them to the foam burst and wave, then sweeps around through the foam in the foreground. This is also an example of a moonlight painting without the traditional back lighting on a placid sea. Here, the moon is to the left of the picture and highlights the active, moving surf. The center of interest, the foam burst, is accentuated by the contrasts of light and shadow on the rock. The rock points directly to the foam burst.*

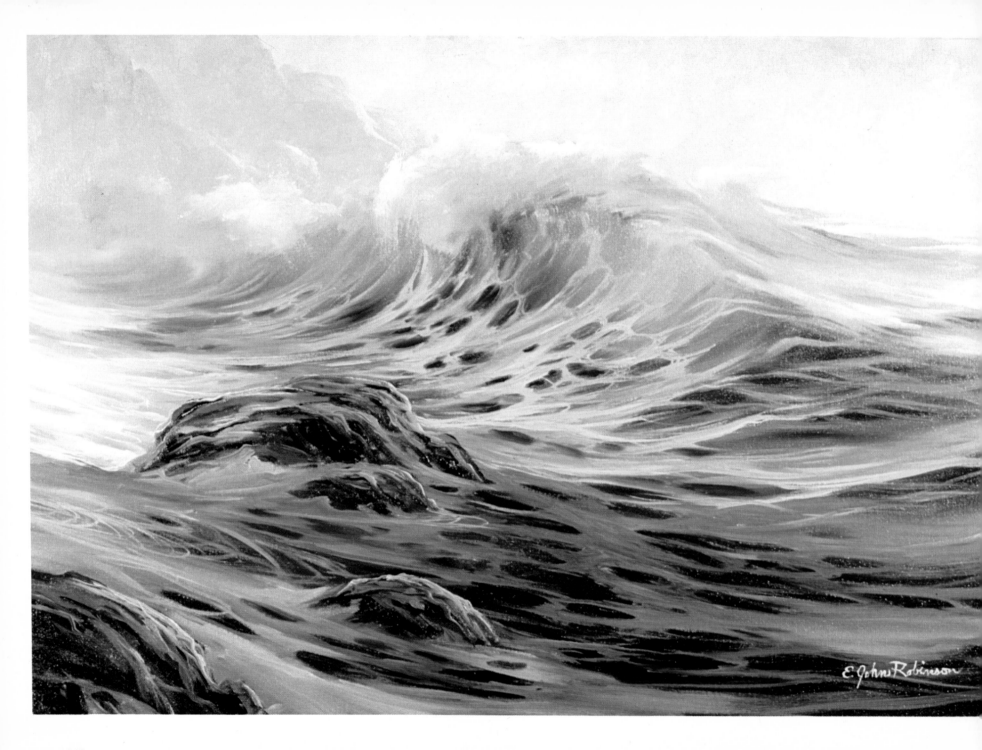

E. John Robinson

**Storm Giant.** *Oil on canvas, 24" x 36". Often during a storm, the sky clears for a time and the surf is filled with interesting patterns of light and shadow. In this painting, the atmosphere is heavy with moisture. The light is warm, but there is no promise of clearing skies. The wave is truly the center of interest, and the eye reaches it by following the irregular path described by the rocks in the foreground.*

# CONCLUSION

The most important conclusion to this book should be that it is not meant to be conclusive. My reason for writing it was to give you, the student, a beginning rather than an end. In the process, I hoped to whet a desire within you to look deeper, to try new ideas, and to develop the natural creativity that lies within us all.

My first attempts at painting the sea delighted me on the one hand and disgusted me on the other. It was a great feeling to have created an image of the sea on canvas, but I also knew the image was not what it should have been. Today, with over a decade of painting the sea behind me, those feelings have not changed.

That statement means three things: that I have enjoyed and continue to enjoy painting; that I have never "arrived"; and that being discouraged never created in me a negative reaction to my work. On the contrary, I see mistakes as "signals" that say, "Look deeper, try harder, and try again." It is then a question of proceeding until the next "signal."

You should be aware that too much self-satisfaction is as dangerous as too much self-criticism, and that comparing your work to that of others is often the cause of both. If you must compare, do so only against your own work: judge what you do today by what you did yesterday, then judge it against what you hope to do tomorrow. Rejoice in your triumphs and treat your errors simply as "signals."

Refer back to this book when you get into trouble, but don't rely on it. As I said before, these are the statements and studies of only one artist. There is no better way to develop your own approach than to begin with this book and progress completely beyond it!

In the meantime, I'll be trying to do the same. We may both use this book as a beginning, for with art and artistry there should be no end.

# AUTHOR'S BIOGRAPHY

E. John Robinson was born in Oregon and began painting the rugged sea while still in elementary school. In high school he won several Gold Key awards in National Scholastic contests, and one of his paintings went on to place among the top ten in the nation for high school artists.

He began his formal art studies on a scholarship to the Cornish School of Allied Art in Seattle, Washington, but completed his studies and received his bachelor of arts degree in education at the California College of Arts and Crafts in Oakland, California. He received his master of arts degree from San Francisco State College in San Francisco, California.

Mr. Robinson has had over 30 one-man shows since he began painting, the first of which took place while he was still in college. Over 1,000 of his paintings now belong to private collectors and galleries throughout the United States and abroad. At present, his paintings are exhibited continuously at the Ruth Carlson Gallery, Mendocino, California, the Bodega Gallery, Bodega, California, and the Lincoln County Art Gallery, Lincoln City, Oregon.

Although his paintings have won many awards, Mr. Robinson takes awards and prizes rather lightly and regards the opinions of the public as much more important. Since 1968, he has lived with his family near Mendocino, California, a location that provides as subject matter one of the most rugged sections of Pacific coastline.

# BIBLIOGRAPHY

Ballinger, Harry R., *Painting Sea and Shore.* New York: Watson-Guptill Publications, 1966.

Bascom, Willard, *Waves and Beaches: The Dynamics of the Ocean Surface.* pap. New York: Doubleday & Co., Inc., 1964.

Hoopes, Donelson F., *The American Impressionists.* New York: Watson-Guptill Publications, 1972.

Mathey, François, *Impressionists.* New York: Praeger Publishers, Inc., 1967.

Payne, Edgar, *Composition of Outdoor Painting.* Los Angeles: (dist. by C. Palmer Payne).

Pellew, John C., *Oil Painting Outdoors.* New York: Watson-Guptill Publications, 1971.

———, *Painting Maritime Landscapes.* New York: Watson-Guptill Publications, 1973.

Pool, Phoebe, *Impressionism.* London: Thames & Hudson, 1967.

Sargent, Walter, *Enjoyment and Use of Color.* pap. New York: Dover Publications, 1923.

# INDEX

Edited by Lois Miller
Designed by James Craig and Robert Fillie
Set in 11 point Fairmont by University Graphics, Inc.
Printed and bound in Japan by Toppan Printing Company, Ltd.